D1266618

America and the Daguerreotype

America and the

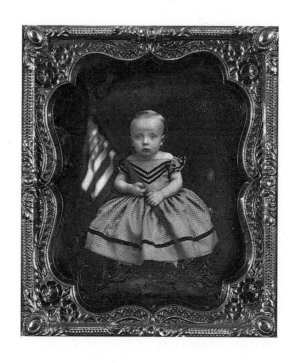

Daguerreotype

EDITED BY JOHN WOOD

UNIVERSITY OF IOWA PRESS IOWA CITY

University of Iowa Press, Iowa City 52242

Copyright © 1991 by the University of Iowa

All rights reserved

Printed in Japan

First edition, 1991

Design by Richard Hendel

No part of this book may be reproduced or utilized

in any form or by any means, electronic or mechanical,

including photocopying and recording, without

permission in writing from the publisher.

Printed on acid-free paper

Library of Congress Cataloging-in-Publication Data

America and the daguerreotype / edited by John Wood.—1st ed.

 p. cm.

 Includes bibliographical references.

 ISBN 0-87745-334-9 (cloth: alk. paper)

 1. Daguerreotype—United States—History. I. Wood, John, 1947-

TR365.A47 1991

772'.12'0973—dc20 90-25764

 CIP

TR
365
.A47
1991

FRANKLIN PIERCE COLLEGE
LIBRARY

TO

KENNETH NELSON

AND

ROBERT SHLAER

for having kept the light

Contents

Acknowledgments

This book would not have been possible were it not for the generosity, goodwill, and involvement of a hundred or more people—the scholars who wrote the essays, the individuals and institutions who allowed the publication of images from their collections, the museum curators and various staff members who searched their collections for me and answered my many questions, the photographers who made the copy prints, and the list goes on. I am especially grateful to Charles East, my editor, for his careful reading and superb suggestions. His fine critical eye has saved both this book and my previous one from many flaws. I want to thank Bruce Erickson for writing the note on the Eliphalet Brown image. I am also particularly grateful to Allen Phillips for the many hours he gave this book in making the copies of images from the French and Lundberg collections.

Lorah Dulisse, the assistant registrar at the J. Paul Getty Museum, was so generous in granting every one of my many requests that there is no way I can adequately thank her. Louise Stover at the Getty was also quite helpful. Bonnie Wilson, the curator at the Minnesota Historical Society, was generous and helpful and brought to my attention some of the treasures of their collection I was unaware of. Dona Sieden of the society's library very kindly provided me with several key facts about the images. Sara Beckner of the Henry Ford Museum brought my attention to the two remarkable images from their collection reproduced here. Sally Pierce of the Boston Athenaeum, Chris Steele of the Massachusetts Historical Society, Jo Ann Conklin of the University of Iowa Museum of Art, John B. Briley of the Campus Martius Museum, Scott Sheidlower of the Museums at Stony Brook, and as always the good people of George Eastman House were most helpful.

Dennis Waters, a fine copiest of daguerreotypes, deserves thanks for making the images from the Bruffee, Felix, Gaffin, Isenburg, Isaacs, Lenharth, and Waters

collections. Gray Little, another fine professional photographer, deserves my gratitude for both excellent advice and copy work.

I am also grateful once again to the administration of McNeese State University for allowing me time from my teaching in order to complete this book. President Robert Hebert, Academic Vice President B. E. Hankins, Dean Millard Jones, and my chairman, Joe Cash, have all been more than generous in their support of my research and work in a field outside of my academic discipline. And finally, I would like to express my special thanks to the distinguished American poet W. D. Snodgrass for permission to quote his translation of Rilke's "An Archaic Torso of Apollo."

Preface

At no time in the past 130 years has the daguerreotype spoken as eloquently to so many people as it does today. More books were published on the daguerreotype in photography's sesquicentennial year, 1989, than on any other photographic subject. Also in 1989, exhibitions of daguerreotypes were held at museums around the world and in every case proved to be among the most successful of exhibitions in the museums' histories. One of the world's newest and largest photographic historical societies is devoted exclusively to daguerreian studies, publishes a journal, and holds an annual scholarly symposium. And finally this lost and highly complicated art is attracting new practitioners whose works are finding their way to the walls of museums from Paris to San Francisco. There is clearly something contemporary and compelling about the daguerreotype, something that appeals to and speaks to men and women today.

The daguerreotype's great simplicity, its lack of artifice, and its archetypal rawness obscured it for many years from contemporary vision, a vision that had been defined by Alfred Stieglitz, first in a way that aped Impressionism and later in a way that aped Cubism. Stieglitz may have spoken of straight photography and the purely photographic and therein perceived something so modern, so contemporary even, that the world of art, including the world of painting, has only come to it in recent years, but he failed to see that it was an image like the daguerreotype he was describing.

Contrary to popular conception, the daguerreotype is not a quaint antiquarian artifact but an object of profound modernism, an object so avant-garde that it has taken a century and a half to begin to understand it. Its purity and lack of artifice, the fact that it is a work of art not "about" anything, unlike most nineteenth-century art, that it is pure description, that its content is left to the laws of random chance, of

who walked into the studio that day, have given it the texture of modernism. It is mere description, but description yoked to revelation, revelation stated in the vocabulary of the archetypal, and the archetypal structured in the pristine and elemental grammar of light. It is not that the daguerreotype any longer offers us a standard of vision, as it did both photographically and artistically until the triumph of Impressionism, but that our modern standard of vision circumscribes an area into which the daguerreotype once again falls.

America and the Daguerreotype

JOHN WOOD

The American Portrait

The human face is the most provocative and haunting design we know. There is nothing we so care to see or to contemplate. We stare into the face as if it were a riddle to be solved through a look. But more than an object of mere fascination, the face is the dynamo of desire—and repulsion as well. It can generate lust or loathing before the mouth has shaped a syllable. Its power is like a spell from an imaginary world only Perseus or the Cinderella Prince should be able to understand, but which all of us can. It can so blast reason, so compel and so demand, that for a look alone we may fall into love, marriage, or the web of certain tragedy. We have romanticized this fever for a face, ennobled it through the irrational name of "love at first sight," turned it to fairy tale and myth, the plots of art and trash, the countless landscapes where no birds sing but the eyes of Helen of Troy or Manon Lescaut, of Don Giovanni or Double O 7, gaze out waiting.

Our obsession with our face is boundless; we've given it to our gods, but also twisted it and grotesqued it into the shape of our fear, of devils and death, the gargoyles of graves or distant stars, and even ourselves in a radiated future. From the calm of Simone and Fra Angelico to the frenzied grins of Goya and Ensor and now Bacon, it is always still ourselves we worship and fear.

The fact that we, unconsciously of course, made the face the focus of ecstasy and awe secured its place at the center of our art, because most of what we have come to call art originated in our attempts to give form to those emotions. The face,

*Figure 1.
Anonymous, sixth
plate. Collection of W.
Bruce Lundberg.*

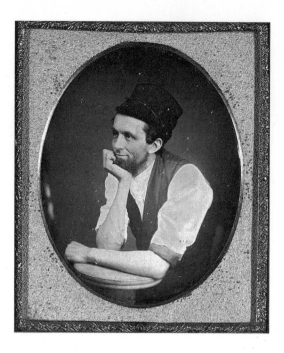

therefore, looms out from and dominates the visual arts like no other design, and the portrait has come to be the keeper of both the mundane and the mythic.

The mark of the great portrait is threefold—we are convinced we know the sitter, that he or she has been captured in some essential or revealing way, and that as personal as the portrait might be, something common to us all is represented there too. Our trust in this revelation is our measure of that artist's greatness. Just as the portrait dominates the world of painting and sculpture, it also dominates the world of photography.

Photographs are objects of profound eccentricity. They are the stuff both of art and icon, of the graphic and the sculptural, of the insignificant and the archetypal. In our role as historians we become caught up in the historical and documentary aspects of photography, but what a gold mining town in California, the charred rubble of Hamburg, or the face of Gladstone might have looked like will in five thousand years be of no more relevance to our descendants than the events recorded in the reliefs of the Ramesseum or the features of a minister of Hatshepsut are to us. The thing that speaks to us over those centuries, that moves us even today in a world that would be incomprehensible to the most comprehending of ancients, is the eloquence resident in those objects from the past—not in their facts but in their forms, not in their history but in their artistry. History eventually slips from us in the cluttered

tumble-down of the ages and is finally of little importance because at long distance from the past we are no longer touched by either its crimes or its joys. What from the past retains relevance to us, we discover, is found elsewhere, as the great German poet Rilke tells us in a poem about an ancient and battered statue.

> We will not ever know his legendary head
> Wherein the eyes, like apples, ripened. Yet
> His torso glows like a candelabra
> In which his vision, merely turned down low,
>
> Still holds and gleams. If this were not so, the curve
> Of the breast could not so blind you, nor this smile
> Pass lightly through the soft turn of the loins
> Into that center where procreation flared.
>
> If this were not so, this stone would stand defaced, maimed,
> Under the transparent cascade of the shoulder,
> Not glimmering that way, like a wild beast's pelt,
>
> Nor breaking out of all its contours
> Like a star, for there is no place here
> That does not see you. You must change your life.[1]

You must change your life! That is the explicit injunction of religion and the implicit injunction of art. It is not the battered statue's incompleteness Rilke shows us; it is our own. And this is the point at which art transforms into icon, the point at which we reverence the object for more than beauty's sake alone, the point at which it transcends representation and begins to partake of the world of archetype and symbol.

Centuries from now, when California is only a memory, an image of miners on a river bank poring over their pans will still speak of quest and the possibility and fruits of failure, will still remind us we steer our Argos out, still drive to the golden fleeces of our desire. Even today a little less than a century and a half after their making, some of the most historically and politically charged of images by Southworth and Hawes have lost almost all of their historical meaning. Who but the specialist now knows anything of the decisions of Justice Lemuel Shaw? Who knows or even cares if he was a great jurist? But in his famous daguerreotype no one doubts

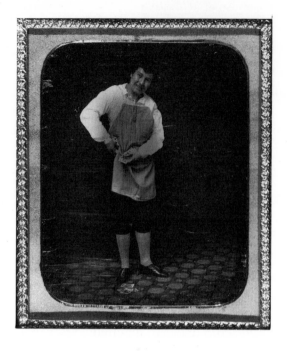

Figure 2.
Anonymous, sixth
plate. Card Trickster.
Collection of Larry
Gottheim.

there is greatness, and it speaks to us, as it will continue to speak, of the indomitability of the human spirit. He is clearly Promethean and as resolute as stone. In fact, he even looks like stone, looks far more sculptural, more like a statue than like any painting.

The same is the case with Hawes's great portrait of Daniel Webster. It is, of course, Webster, but it is just as much Augustus or the *Pater Patriae* of any state. When one looks at that portrait, what is most amazing is the realization that Webster, in fact, never was president. These are no allegorical portraits; Webster is not toga clad and no eagle tears at the breast of Justice Shaw, but we still feel something of that, and it is because the aesthetic of those images is drawn from observed nature.

The great daguerreotypists, like the great classical sculptors, instinctively restricted themselves to the most powerful and signifying of gestures—the open hand; the handshake; the figure that leans toward another, that touches another; the mother cradling her child; etc.—in other words, to that atavistic and symbolic language of archetypes buried deep within us all. The great daguerreian portrait, like a Roman tomb figure or portrait bust, immediately presents a possible narrative, immediately drives us to read a narrative into it. And what we are reading is, of course, nature, our own natures, things we understand at a glance without being told, gestures that must go back to the very beginning of human socialization. And to the

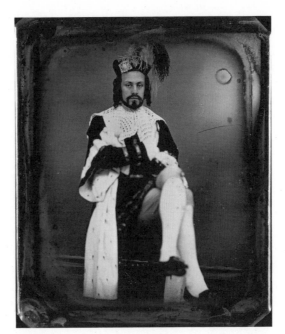

*Figure 3.
Anonymous, sixth
plate. Collection of
Frank Molinski.*

extent that daguerreotypes breathe this air of archetypes, they partake of a kind of grandeur and are transformed from little mirrors reflecting the long-dead into significant expressions of the human condition—expressions significant enough to merit our deepest aesthetic and intellectual consideration.

As I said, their aesthetic is one drawn from the deepest observation and innate understanding of nature, and it is achieved technically more as a sculptor might achieve effects than as a painter might. The mechanics of the daguerreotype itself produced that intense realism found nowhere more similar in art than in the Roman portrait bust. In the great daguerreian portrait we can see how the sitter was treated like living sculpture. The artists had little more than the direction and intensity of light to work with, and with light, a few chemicals and some copper and silver, and an understanding of the language of archetypes they created the sense both of emotion and of movement. The figures in a great daguerreotype energize the space they fill, just as a great piece of sculpture energizes its space. To some extent this sculptural energy of the daguerreotype is due to the near three-dimensional quality it can often possess, but primarily it is due to the daguerreotypist's approach both to light and to psychology.[2]

And it is to that psychology which we respond. Only sentimentalists are moved through the clutter of old clothes or the tools of dead trades, though they may reveal an interesting fact, a historical footnote, a grub in amber. The people are all dead,

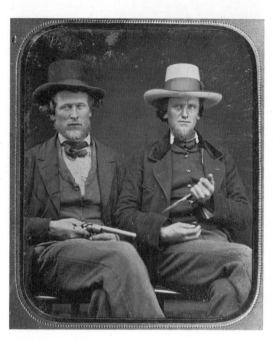

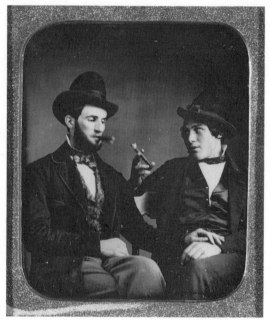

*Figure 4.
Anonymous, sixth
plate. Collection of
John McWilliams.*

*Figure 5.
Anonymous, sixth
plate. Collection of
Julian Wolff.*

are all dust today, and are remembered, if at all, distantly, not as we remember Grandfather but as we remember Caesar. Nothing in the content of the daguerreotype possesses any kind of relevance, except in the narrowest sense of that word, to anyone alive today, yet still we are moved—and it is because of that primitive vocabulary of gestures, because of the archetypes to which the great daguerreotypes refer, but also because of something else.

The daguerreotype's form is the vehicle of a potent sexual charge. It indulges our voyeurism more blatantly than any other art; it permits us to do what society does not allow us to do; it allows our gaze to go unrestricted. To some degree this is the case with all photographs, but to a lesser extent in the other processes because they cannot render reality with such precision. The desire to look long at our fellow human beings, especially their faces, and to scrutinize every detail seems to be a basic human characteristic, as old and primitive as the sources of the archetypes. The terrain of the face is still the most fascinating of frontiers and one that obsesses us deeply and fundamentally and is somehow at the core of our humanity. It is as if the face is the key to the heart, and the daguerreotype, more so than any other object or art form, allows us the most intimate approach to that symbol of what we are.

Though the effects certain archetypal gestures have on us may go deep into roots of human psychology and have little to do with anything we have any control over—and thus we are moved as if by magic—the achievement of those effects is hardly so inexplicable. Great daguerreotypists, like all other great artists, knew *exactly* what they were doing. We may be embarrassed at the terrible tableaux of a Gabriel Harrison, the occasional kitsch of Hawes, and so forth, but to assume because their eye and the eye of their century was ill focused for our taste that they were anything but serious artists is sheer nonsense and betrays an ignorance of the technical literature of the period.

We understandably mistrust the emotion of much nineteenth-century art because so much of it was generated through cliché and founded upon that emotional fakery we call sentimentality. Such work is deservedly damned, and in that respect our taste is simply superior to the nineteenth century's; however, our justified aesthetic embarrassment at such art, coupled with our own preferences, taste, and modernist eye, has unfortunately led to a kind of intellectual embarrassment at the nineteenth century as well. To assume that someone making bad art is stupid or that a society is stupid because it delights in bad art is to confuse intelligence, which is native, and taste, which is cultivated. A fool may have superb taste while a genius may be a bumpkin. Though much nineteenth-century art, especially prior to the Im-

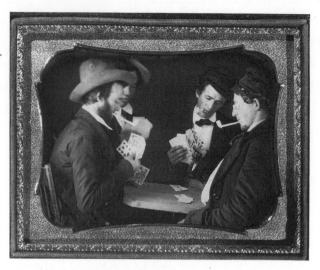

Figure 6.
Anonymous, sixth
plate. Collection of
Grant Dinsmore.

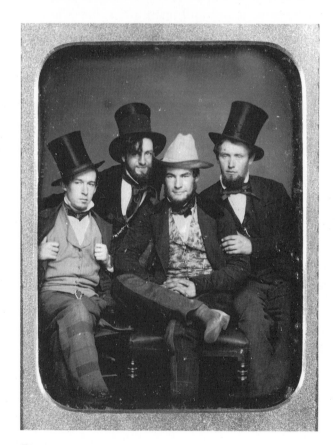

Figure 7.
Anonymous, quarter
plate. Collection of
Julian Wolff.

pressionists, may not be to our taste, its audience was every bit as bright as we, and its artists, including its daguerreotypists, knew exactly what effects they were achieving, even though they might have begun their careers as dentists, lamp makers, chemists, and the like.

One need only look at Marcus Root's *The Camera and the Pencil* or H. H. Snelling's *Dictionary of the Photographic Art* to be convinced that these early daguerreotypists understood posing, lighting, composition, and color in an art historical context. Of course, that is not the context out of which a photograph is necessarily made. A photograph is not a painting, it is not like a painting, and there is no reason why it should look like a painting. The photograph's context is its own, but all photographers, especially the English daguerreotypists, did not immediately recognize this or realize that the photograph had a relevancy apart from the history of drawing and painting. Photography's own unique and specific context can be seen quite clearly defined in the daguerreotype. What photography does best is produce objects that look like photographs; therefore, objects that look like photographs constitute photography's context. The daguerreotype defined that context and still defines it.

Two basic kinds of photographs are possible: those which emphasize detail and those which suppress it. And the daguerreotype was capable of both. We usually think the main characteristic of the daguerreotype is its capacity for hyperrealism. That realism is, of course, immediately noticeable; we can often count the individual hairs of a head or the freckles of a face. But just as often the daguerreotype's power derives not from its capacity for detail but from its capacity to suppress detail. The Lemuel Shaw daguerreotype is once again a case in point. Its force is not its clarity but shade and shadow carved by light, and we are as moved by the indistinct, those shadows on Shaw's face and the dark ranging behind him, as by the distinct. They are bold and large forms that define Lemuel Shaw. There is nothing minuscule about him, and he stands there like Rodin's Balzac.

It has become a cliché to define the daguerreotype in terms of its precision, but it is equally definable in terms of its imprecision. The fact that it was capable of both is the reason it defined photography's context. The other early process, the calotype, did not become the standard of photographic seeing because it was less versatile; its beauties were only the beauties of the indistinct.

Much of what distinguishes the American daguerreotype from the European is this degree of suppression or definition of detail. In general, the American portrait is more clearly defined than the European, though, of course, examples to the contrary

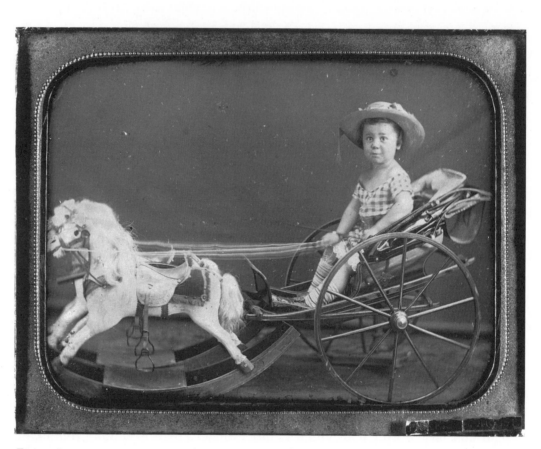

Figure 8.
Anonymous, half plate.
Collection of Matthew
R. Isenburg.

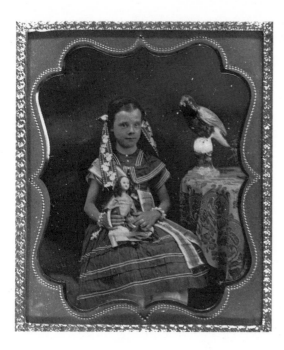

Figure 9.
Anonymous, sixth
plate. Collection of
Frank Granger.

can be pointed out, but generally this is the case. The obvious difference in the look of
the American and the European image is often attributed to the more highly buffed
American plate, but it probably has more to do with lighting and the construction of
the American studio. "The better the buff, the better the black," according to Ken-
neth Nelson, one of the best modern American daguerreotypists. To achieve a deep,
rich, and inky black, one needs a highly buffed plate, and some of the richest of
daguerreian blacks can be found in French and German daguerreotypes, which still
retain that distinct European look Americans usually refer to as flat. It is probably
the result of flat, uniform light on all sides of the sitter. The American portrait has a
far more "relieved" look because of the manipulation of light. In *The Camera and
the Pencil* Marcus Root is very precise about height of skylights, the use of overhead
curtains, and the exact angles of light "to obtain good artistic shadows." He writes:
"A skilful management of the lights and shadows is also essential to the portraitist
who would produce a well rounded, distinctly 'relieved,' and lifelike face."[3]

The power of the American daguerreotype was not solely derived from its light-
ing; other factors were also at work. However, the superiority of the American da-
guerreotype was recognized as early as 1851 at the only international competition of
daguerreotypists, which was held at the Great Exhibition in London. "In Daguerreo-
types . . . we beat the world," was the way Horace Greeley put it.[4] The jury of the

*Figure 10.
Anonymous, sixth
plate. Collection of
Harold Gaffin.*

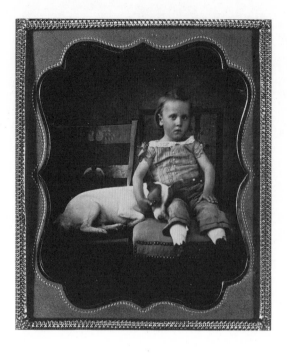

Crystal Palace Exhibition responded with equal enthusiasm. "On examining the da-
guerreotypes contributed by the United States, every observer must be struck with
their beauty of execution, the broad and well-toned masses of light and shade, and
the total absence of all glare which render them so superior to many works of this
class. Were we to particularize the individual excellences of the pictures exhibited,
we should far exceed the limits of space to which we are necessarily confined." The
jury, however, tried to mitigate its praise by going on to say, "It is but fair to our own
photographers to observe that, much as America has produced and excellent as are
her works, every effort has been seconded by all that climate and the purest of atmo-
spheres could effect; and when we consider how important an element of the process
is a clear atmosphere, we must be careful not to overrate the superiority of execution
which America certainly manifests."[5]

I doubt that the air of Boston or New York was purer than that of France's coun-
tryside. People have been trying to give simplistic explanations for the American
success at the Crystal Palace Exhibition since 1851. Writing in 1890, John Werge,
an English daguerreotypist who visited the United States in 1853, was the first to
claim that Americans "employed the best mechanical means for cleaning and pol-
ishing their plates, and it was this that enabled the Americans to produce more bril-
liant pictures than we did. Many people used to say it was the climate, but it was

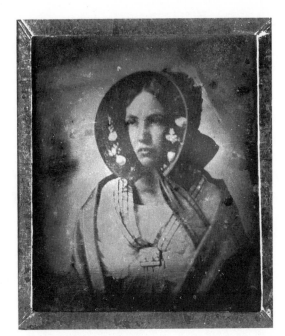

Figure 11.
Anonymous, sixth
plate, circa 1839–
1840. Asenath Brewster
Coffing, descendant of
William Brewster, of
Mayflower fame.
Collection of Carl J.
Gennette.

nothing of the kind. The superiority of the American Daguerreotype was entirely due to mechanical appliances."[6]

The American success has curiously continued to be bothersome to at least one critic over a hundred and forty years later. Helmut Gernsheim, after reciting that old canard about the steam-driven buffing wheels, proceeds to write, "Another reason for the great prominence of the Americans at the Crystal Palace is the fact that none of the leading German daguerreotypists such as Stelzner and Biow was represented." I should hope not, considering Biow was dead at the time. Gernsheim continues, "To avoid any erroneous impression we would add that two of the highest awards went to daguerreotypists active in London."[7] These, of course, were Antoine Claudet and W. E. Kilburn, whose heavily over-painted, and at least in Kilburn's case often garish, portraits merely aped miniatures; they were often nothing but glorified examples of paint-by-numbers whose photographic qualities had all been submerged under the paint, often even under clouds, rising suns, forests, or lakes which were simply painted onto the daguerreotype's surface.

To explain American daguerreotypy in terms of American air, Yankee ingenuity, or what it was not judged against is to misunderstand the nature of the American vision prior to the Civil War. The American daguerreotypists had a vision right out of Whitman; of course, it was not really "out of Whitman" but was a vision Whit-

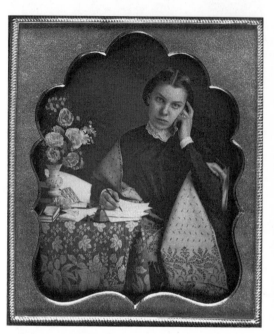

Figure 12.
Anonymous, sixth
plate. Collection of
Wm. B. Becker.

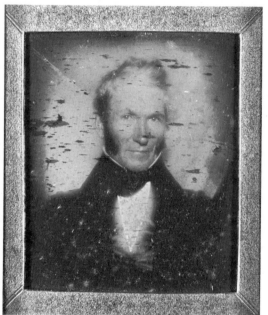

Figure 13.
Anonymous, sixth
plate, circa 1839–
1840. Collection of
Dennis Waters.

man and other artists, such as George Caleb Bingham, Albert Bierstadt, and Horatio Greenough, as well as the daguerreotypists also had—a vision of America singing, of the open road, and "Democracy's lands," the "Land of the pastoral plains, the grass-fields of the world! land of those sweet-air'd interminable plateaus! . . . Far breath'd land! Arctic braced! Mexican breez'd! the diverse! the compact!" It was a vision both social and artistic that Whitman invited us to see "steaming through [his] poems," and it is there to be seen in paintings and in daguerreotypes too:

> See, in my poems immigrants continually coming and landing,
> See . . . the wigwam, the trail, the hunter's hut, the flat boat, the maize-leaf,
> the claim, the rude fence, and the backwoods village, . . .
> See, pastures and forests in my poems—see animals wild and tame—see,
> beyond the Kaw, countless herds of buffalo feeding on short curly grass,
> See, in my poems, cities, solid, vast, inland with paved streets with iron and
> stone edifices, ceaseless vehicles, and commerce.
> See, the many-cylinder'd steam printing-press—see, the electric telegraph
> stretching across the continent, . . .
> See, the strong and quick locomotive as it departs, panting, blowing the
> steam-whistle,
> See, ploughmen ploughing farms—see, miners digging mines—see, the
> numberless factories,
> See, mechanics busy at their benches with tools—see from among them
> superior judges, philosophs, Presidents, emerge, drest in working dresses.[8]

What Whitman described is Vision in the highest sense of the word, in its spiritual sense even. But vision literally is "seeing," and the American daguerreotypist's way of seeing was different from the European's. That difference of both Vision and vision marked the difference in their work. A moral and social agenda inspired by a boundless faith in America's promise lay at the heart of artistic vision prior to the demoralizing carnage of the Civil War. We saw ourselves heroically and classically, like Greenough's massive, Olympian Washington. That was the Vision, and artists with a vision will find the means to express it. The daguerreotypists, without ever actually framing such a question, obviously did ask: how can I make my sitter look heroic; how can I imbue this visage with hope, promise, and a strength reminiscent of the classical? Whether they phrased the question or not, that was the look they sought to attain; it was the look that accompanied their vision, and consequently they evolved a technique to create the look.

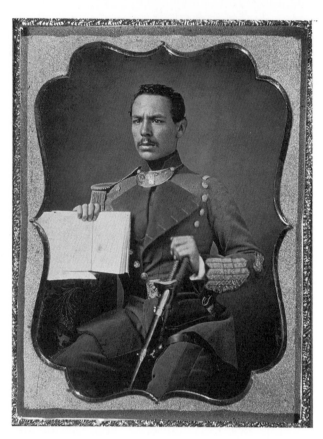

Figure 14.
Anonymous, quarter
plate. Collection of
Grant Dinsmore.

The technique obviously did draw heavily on lighting, on using it to sculpt, and cast the figure into relief. And, of course, the quality of a highly buffed plate could only add to this effect, but Yankee ingenuity probably played less a role in that respect than it did in the actual organization of a studio. Floyd and Marion Rinhart juxtapose an account—by Werge, as a matter of fact—of a visit to a cheap four-for-a-dollar American studio where he received three portraits "as fine . . . as could be produced anywhere" and a trip to a typical Paris studio, which appeared in *The Knickerbocker* the same year Werge visited the United States.[9] What is quite clear is that a French studio, compared to even the cheapest of American studios, was, to put it kindly, far less professional; every aspect of the work was shoddy from start to finish. There are, of course, many great French daguerreotypes; one need only look to Françoise Reynaud's magnificent catalog of the 1989 Musée Carnavalet Exhibition, *Paris et le Daguerréotype*, but there are few portraits there. Great French portraits do exist, but they are rarities. Where French daguerreotypy is indeed often great is in its depiction of buildings and naked bodies.

The excellencies of the American studios were in part due to the great popularity and demand for the daguerreotype and the fact that there was a far larger class here who could afford them. With greater demand and greater amounts of money being spent here than anywhere else in the world, the daguerreotype business was lucrative, and so there was far more incentive for experimentation and the perfection of technique. The efficiency of the American studio was in part the result of its assembly-line operation. Though we have come to associate assembly lines with dehumanization, they could easily be seen as part of that vision Whitman described, a vision of camaraderie and of people working and building together. It is, in fact, the extremely high quality of American studio work that makes the task of the photo-historian difficult. It is next to impossible to isolate the work of certain skilled American daguerreotypists from that of their studios. The situation is similar to that of the Russian goldsmiths where the famous names Fabergé, Ovchinnikov, and Khlebnikov do not so much designate the work of an individual as that of a studio. The names Brady, Gurney, and Whitehurst mean much the same thing and designate similar excellence in the world of daguerreotypy.

The inner workings of the American studio are an as yet still unresearched chapter in the history of the daguerreotype. When one reads accounts of the studios and studio practices, what is most striking is that so many of the great daguerreotypists worked for so many other great daguerreotypists at different points in their careers. This obviously played a crucial role in the spread of technical information and

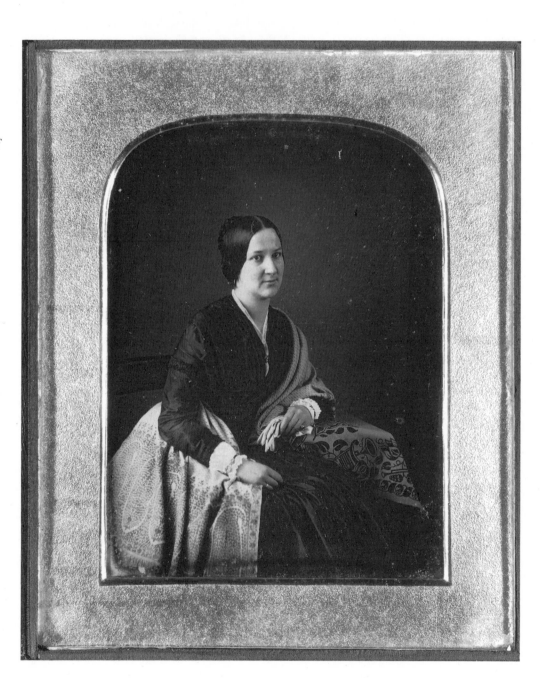

*Figure 15.
Anonymous, three-
quarter plate. Mary
Abigail Fillmore,
daughter of President
Fillmore. Collection of
Bill Flaherty.*

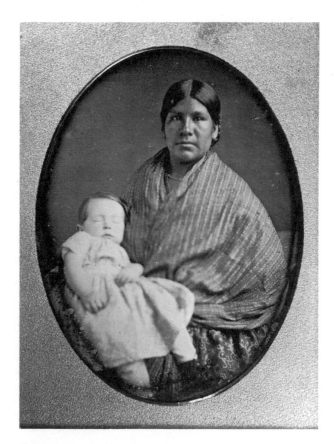

Figure 16.
Anonymous, quarter
plate. Collection of
John McWilliams.

expertise. From city and business directories, contemporary journals, and similar materials, Floyd and Marion Rinhart in the "Biographies" section of *The American Daguerreotype* pieced together much of this interplay between daguerreotypists, but on the basis of testimony by assorted daguerreotypists before the Circuit Court of the United States, Massachusetts District, in the case of Simon Wing versus Charles Richardson, I am led to believe this interplay was more extensive than has been previously supposed.

The Rinharts discovered, for example, that Charles Williamson, one of the finest daguerreotypists of mothers and children, was employed by Marcus Root between 1849 and 1850, but in his testimony we learn he began daguerreotyping in April 1845, at the age of nineteen, and worked under Martin Lawrence, another of the great masters, for a year. Then he taught and helped establish a Mr. B. Smith on Broadway, then worked for Philip Haas for about a year before moving to Springfield, Massachusetts, where he worked for Otis Cooley.[10]

Root's peregrinations were even more far-ranging. In a deposition he stated:

I was an amateur when Paul Beck Goddard and Robert Cornelius introduced the taking of daguerreotype portraits from life into Philadelphia. Then I made it a profession in '43. I commenced in Baltimore, with J. C. Robinson, in the fall of '43. During the winter I went to Mobile and bought out John A. Bennett in '44. In March and April, I practised with James Maguire in New Orleans; in May, June, and first of July, practiced with S. P. Miller in St. Louis, Missouri, firm of Root & Miller; established a gallery there. In the autumn of '44, opened in Philadelphia with D. C. Collins, firm of Root & Collins. I remained there about a year. In June '46 bought out J. E. Mayall, corner of Fifth and Chestnut, and practiced the art there till '56. I also established a gallery at 363 Broadway, corner of Franklin street, New York, and placed it under the care of my brother. In 1849 I established one in Washington, near Brown's Hotel, and placed it under the care of John Clark, one of my pupils.[11]

The high rate of turnover in the studios and the fact that daguerreotypists were traveling from North to South could have only had a positive effect on the development of daguerreotypy as a whole. This also means that in very few cases can one discern the actual touch of the master, but that is probably irrelevant; daguerreotypy was simply a more democratic, more Whitmanesque art than photography. With Southworth and Hawes, we are actually seeing the artists' own work. They claimed they did not use operators, but our knowledge of the assembly-line nature of the

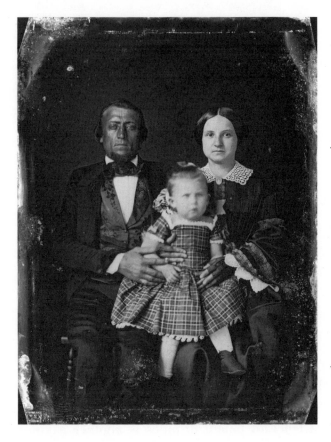

*Figure 17.
Anonymous, quarter
plate. Maude, Becky,
and Broken Nose
Charly Creek. A
newspaper clipping
found in the back of
the image called Creek
"a bad man" who had
"killed . . . and was
proud of it" and who
had "seven notches on
[his] gun stock." "His
nose was once broken,"
the article continues,
"by a man who had
slashed him across the
face with the big bowie
knife; the man is now
dead." Collection of
Alan Johanson.*

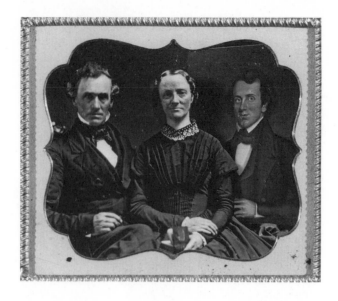

Figure 18.
Anonymous, sixth
plate. Collection of
Julian Wolff.

studio has in this century led us to question their claim and wonder if it were not mere advertising hyperbole. However, in that same Wing versus Richardson case, which dealt with Southworth's patent battle over a frame for taking more than one daguerreotype on a plate, John Pasco, who was employed by Southworth and Hawes from 1845 to 1850 as an errand boy and plate polisher, under cross-examination happened to state, "There was no one in the rooms at the time the pictures were really taken except Mr. Southworth and Mr. Hawes. I was in and out of the rooms, and could see as much as any one could see."[12]

The very existence of patent disputes is another example of the vitality of daguerreotypy in America. The daguerreotypists were constantly experimenting, inventing, and attempting to improve the art. Here Yankee ingenuity and American gadgetry did make a contribution. The Rinharts list fifty patents taken out between 1842 and 1862 for inventions related to the daguerreotype,[13] though their list only includes those patents actually using the words *daguerreotype*, *daguerreotypes*, or *daguerreotyping* as part of them. Southworth's frame, by the way, did not use the word *daguerreotype* in its title, and so it is not among those fifty, as are probably a great many other daguerreian inventions. But from those alone it is clear that Americans were quite serious about refining and perfecting the daguerreotype.

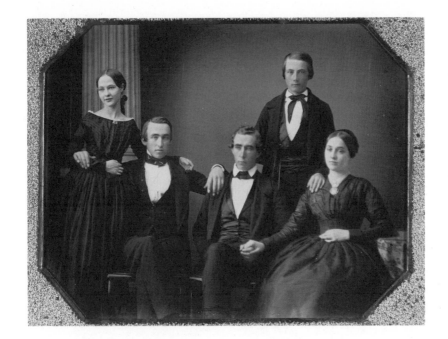

Figure 19.
Anonymous, quarter
plate. The Williston 5.
Collection of Dennis
Waters.

Another part of that desire to refine the American daguerreotype expressed it-self as a greater inventiveness in the actual image making than was found in the European daguerreotype. There was far greater variety of posing in the American image. Southworth and Hawes, for example, seemed particularly driven not to re-peat themselves, whereas the mark of many European daguerreotypists, as if it were the sole characteristic of style, was the repetitiveness of their posing. J.-B. Sabatier-Blot, who did create a monumental and justly famous portrait of his wife, is a case in point; his sitters were all posed in roughly the same way at that same little table with the same little cloth on it. His work does not have to be signed to be recognized; most of it is stamped with the mark of boredom. Gernsheim in fact publishes an unidenti-fied image that is so clearly the work of Sabatier-Blot (see *The Origins of Photogra-phy*, plate 48) that no one could deny it.

Two of the finest European daguerreotypists were Carl Biewend and that anony-mous individual we know as "Cromer's Amateur." The great charm of their work and what is its most recognizable feature is the naturalness of their posing; however, that single most exceptional feature of their work is commonplace in the American daguerreotype. In addition to its naturalness, American posing is marked by an inti-macy not usually seen in the European daguerreotype. The American camera was

Figure 20.
Anonymous, half plate.
Blowing machine for use in
a foundry. Collection of
Matthew R. Isenburg.

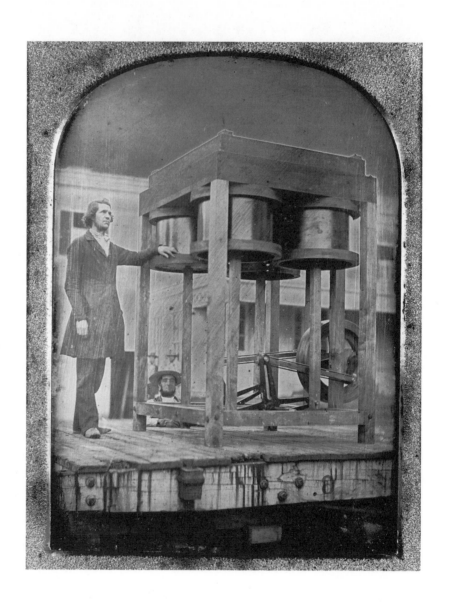

placed closer to the sitter than its European counterpart, and that greater closeness resulted in an image which intensifies our rapport with the sitter.

Inventiveness in American posing even extended to the creation of a new kind of portrait, the occupational portrait in which the sitters were posed with some object from their work that served to symbolize or suggest it; the invention of the vignetted portrait, which suggested something of the classical bust; and the development of elaborate vignetting in the form of starbursts, magic rings in varied colors, delicate mats, and so forth, all virtually unknown in European daguerreotypy. Even something as obvious and dynamic as the profile is rare in European daguerreotypy. A few, such as Adam-Solomon's often reproduced and anonymous woman or Stelzner's profile of Molly Busse, stand out and are easily recalled because such imagery is so seldom seen. Though profile portraits are not the most common of American daguerreotypes, it is easy to recall dozens and I know of one taken as early as 1840. American daguerreotypists were quick to recognize that the profile carried with it the connotation of Roman gems, that strength of the classical cameo, and they used it to great effect.

What the American daguerreotypists evolved was a vocabulary for rendering the mundane heroic. And that look of heroism, faith, and promise—be it on the face of the country peddler, the miner with his pick, or the well-dressed city man—is the mark of American daguerreian portraiture. It reflected America's self-image—a grand, admirable, naive vision of our own destiny. But it was a vision that began to waver and crumble under the weight of the chains and shackles we suffered on our own brothers and sisters.

Henry Clay's Compromise opened the final decade before war, a decade marked year by shameful year with one moral outrage after another until we were thrust into the most tragic episode in our history. The Great Vision had failed, the moral republic was a sham, and we were to pay a price.

Art offers a reflection of society and is at the vanguard of those social activities which serve to explain us to our own bewildered selves. It is more immediate than history and more perceptive than social commentary. It seizes us as we are nearly at the instant of our act, and so it seems avant-garde, being nearly an immediate mirror, while everything else is explanation after the fact. And of the arts, none is more immediate than photography. It catches us the quickest and shows us to ourselves for what we are before anything or anyone else can.

The passing of the daguerreotype is usually explained in terms of Cutting's ambrotype patent of 1855, the 1856 invention of the melainotype, the popularity of the

carte de visite, the development of multitube cameras, and so forth. But photography, I would argue, was the first witness to the Vision's failure. Before painters, before poets, before politicians saw it, the heroic had withered; the promise had perished. Had the daguerreotype survived, after Gardner's and O'Sullivan's pictures of the blasted, rotting bodies of the slaughter pens, its heroic dimensions would have been irrelevant, absurd, mocking even. The daguerreotype was simply no longer our fitting image. Our faces had found their way to the tintypes. That is what we had become. That was the image we had earned.

NOTES

1. Rainer Rilke, "An Archaic Torso of Apollo," trans. W. D. Snodgrass, in *After Experience* (New York: Harper & Row, 1968), p. 86.

2. Several of the ideas expressed in this paragraph and the previous one developed out of conversations and correspondence with Paul Katz, a brilliant and insightful photographic critic.

3. Marcus A. Root, *The Camera and the Pencil* (Philadelphia: J. B. Lippincott, 1864), p. 98.

4. Horace Greeley, *Glances at Europe* (New York: Dewitt & Davenport, 1851), p. 26.

5. *Exhibition of the Works of Industry of All Nations, 1851* (London: William Clowes & Sons, 1852), pp. 63–64.

6. John Werge, *The Evolution of Photography* (London: Piper & Carter, 1890), p. 54.

7. Helmut Gernsheim, *The Origins of Photography* (London: Thames & Hudson, 1982), p. 120.

8. Walt Whitman, "Starting from Paumanok," in *Poems* (New York: Modern Library, 1921), pp. 20, 22–23.

9. Floyd Rinhart and Marion Rinhart, *The American Daguerreotype* (Athens: University of Georgia Press, 1981), pp. 138–39, 145–46.

10. *Circuit Court of the United States, Massachusetts District. In Equity. Simon Wing, Complainant, vs. Charles F. Richardson, Respondent. Additional Testimony* (Boston: Alfred Mudge & Son, 1864), pp. 5, 14.

11. *Circuit Court of the United States, Massachusetts District. In Equity. Simon Wing, Complainant, vs. Charles F. Richardson, Respondent* (Boston: Alfred Mudge & Son, 1864), pp. 88–89.

12. Ibid., p. 52.

13. Rinhart and Rinhart, pp. 426–27.

DOLORES A. KILGO

The Alternative Aesthetic

THE LANGENHEIM BROTHERS AND THE INTRODUCTION

OF THE CALOTYPE IN AMERICA

With the growing body of literature now devoted to the daguerreian era, we have begun to glean a much more precise picture of the unique role that Daguerre's invention played in the American visual experience. Contemporary accounts confirm America's unmatched enthusiasm for the miniature pictures on silver and the preeminent position that native daguerreians earned in international circles.

Reflecting these conditions, the early history of American photography has assumed a distinctly narrow dimension. During the period of the daguerreotype's dominant and pervasive presence on the American scene, experimenters abroad were making significant strides in extending the parameters of "heliography." What is now deemed "the golden age of paper photography" occurred as a result of these efforts.[1]

In contrast, the daguerreotype reigned supreme on this side of the Atlantic with no competition during the years preceding the wet-plate era. It is generally concluded that legal restraints, which limited the practice of the calotype process to licensed practitioners, played a primary role in effecting native indifference to the advantages of a paper-negative system. Since America was widely acknowledged as the home of Daguerre's most loyal supporters, it is reasonable to assume that photographers here had little incentive to invest in alternative processes that offered no guarantees for financial success. Although these are legitimate observations supported in the literature of the time, they fail to reflect the full range of issues involved, especially in regard to the role that William and Frederick Langenheim and

their work played in introducing paper photography to America. For a better under-standing of some of these issues, it is worth looking beyond familiar explanations and more closely at the Langenheims' efforts to promote the merits of the calotype process.

In 1841, Henry Fox Talbot patented his technique for producing salted paper prints from "Calotype" negatives. His calotype or "Talbotype" process, as it was more commonly known in America, created images quite distinct from those pro-duced by Daguerre's technique. Because of the irregular paper fibers present in the negative and on the print surface, Talbot's method diffused forms and amplified contrasts to create an aesthetic distinguished by soft chiaroscuro effects. Talbot's original process required lengthy exposures generally exceeding one or more min-utes in outdoor sunlight.[2] Until the late 1840s, when modifications on that method were introduced in France, the Englishman's technique remained the principal sys-tem for photographers working with paper. Following the example of Daguerre, who had obtained patent rights for his invention in England, Talbot placed legal restric-tions on his invention, hoping to profit from his discovery through the sale of li-censes. He first obtained patents protecting his process in England and France in 1841. It was not until 1847 that the inventor took similar measures to restrict the production of calotypes in America.

Talbot's action laying claim to his process on American shores seems to have generated little response. The American press did not even bring the Englishman's discovery to the attention of the wider public until 1849 when the Washington, D.C., *Daily National Intelligencer* published a lengthy article describing the calotype pro-cess as a viable alternative to Daguerre's technique. For the vast majority of readers, the *Intelligencer*'s account was their first introduction to the potential of paper pho-tography and to the terminology that would prevail in later decades:

> Independently of each other, Daguerre and Talbot found out the art of fixing
> upon metal and upon paper the light of the sun. The former has obtained the
> more immediate success, but the other has, perhaps, hit upon the better form
> of the discovery. . . . In the Talbot-type, the picture is first obtained in a nega-
> tive delineation; and that from this, . . . positive pictures are taken at will. . . .
> If this seems, at the first glance a disadvantage, it is really the contrary. For,
> from one impression, without any further sitting, and at any distance of time,
> the original picture may, at little expense, be multiplied almost without end;
> while the Daguerreotype can be but imperfectly copied, and with no diminu-

tion of the original expense. Nor is this the only superiority of the Talbot-type already apparent: its effects are, in many respects, more pleasing; it is capable of larger representations; the pictures occupy less room; and its application to paper permits them to serve for illustrations of books.[3]

Two readers of the *Intelligencer* article had reason to be particularly pleased by the positive publicity given to Talbot's invention. Only weeks before that account appeared, William and Frederick Langenheim, operators of a successful daguerreian gallery in Philadelphia, had initiated their plan to bring Talbotypes into "general use" among their American colleagues. Undoubtedly the brothers were instrumental in inspiring the *Intelligencer*'s timely report on the merits of the process.

The daguerreians had first contacted Henry Fox Talbot three months earlier, in February of 1849. They wrote to the inventor, telling him that they had been inspired to experiment with paper negatives after seeing a copy of *The Pencil of Nature*. Issued serially between 1844 and 1846 and illustrated with the inventor's calotypes, *The Pencil of Nature* was Talbot's most ambitious effort to bring public attention to his discovery. In the same communication, the Langenheims stated their desire to act as Talbot's American agents. In this capacity, they would promote the inventor's process in America and manage the sale of licenses in his behalf. Patent rights sold to would-be practitioners would remain in the inventor's name. For their "trouble" and advertising expenses, the Langenheims would retain 25 percent of the income generated through the sale of licenses. The brothers assured Talbot that their proposition was submitted "not so much on account of our mutual pecuniary interest than to enable us to serve in bringing your brilliant discoveries into general use."[4]

The Langenheims were not the first Americans to approach the English inventor about expanding the practice of calotypy across the Atlantic. As early as 1846, one of New York's leading daguerreians and entrepreneurs in photographic supplies, Edward Anthony, had expressed a desire to purchase the American rights to the process if Talbot was interested in pursuing a United States patent. The inventor eventually acted on Anthony's suggestion, but by the time the patent was finally issued in June of 1847, Anthony had turned his interests to other pursuits.

Talbot moved more expeditiously to confirm an agreement with the Langenheims. When William Langenheim traveled to England in May of 1849, the inventor offered to sell his American patent outright. Although the Langenheims had originally hoped only to act as Talbot's agents, they were pleased at the prospect of having complete control over the Talbotype business in America. To act in this ca-

pacity they agreed to pay the Englishman a total of $6,000, with the arrangement that the sum would be paid in three installments over a twenty-four-month period. They planned to charge $30 each for licenses sold to their first two hundred subscribers, with a fee of $50 for later subscribers.

The Langenheims' purchase of Talbot's patent undoubtedly came as no surprise to their competitors in the American daguerreian community. From the outset of their partnership, which began with the establishment of their Philadelphia gallery in 1842, the German immigrant brothers sustained a wide reputation for remaining in close contact with European developments. In 1842, through family connections in their native Germany, the Langenheims became the American agents for the Voightlander camera. Their role as distributors of this superior apparatus, a commodity that quickly became standard equipment in first-class galleries, did much to boost the partners' standing in the business. While they were recognized among the most accomplished daguerreians in the country, they were even more admired for their aggressiveness as innovators and entrepreneurs.[5]

During their first months as proprietors of Talbot's patent, the brothers' own work focused on introducing the merits of "Portraits on Paper." However, in addressing potential licensees, they took immediate measures to communicate the wide range of uses for "the new and wonderful art." During the summer of 1849, newspapers in major cities across the country carried the following announcement "To Daguerreotype Artists":

> The undersigned, having purchased of Mr. Fox Talbot, the United States Patent for his admirable invention of obtaining PHOTOGRAPHIC IMPRESSIONS ON PAPER . . . are now ready to dispose of the rights to exercise the art in different states on reasonable terms. . . .
>
> The art is not only applicable to portraits and views from nature, but also to copies from all works that artists can produce as paintings, drawings, statuary, and to copies of all kinds of machinery to be sent to the Patent Office.
>
> At the same time, we caution everyone not to infringe on the Patent, as we are determined to protect it [to] the utmost intent and purpose of Patent Law.
>
> <div align="right">W. & F. Langenheim
Exchange, Philadelphia[6]</div>

If the Langenheims' past record of success in appropriating European advancements gave them reason to be optimistic about their arrangement with Talbot, they

were soon sorely disappointed. In a letter written to the inventor only six months after purchasing the patent, they requested postponement of remaining payments because of their precarious financial situation. If Talbot would not agree to a delay, they proposed that he keep the $3,000 already paid and reclaim his American patent rights. Should he elect the latter option, the Langenheims hoped to be able to retain the right to practice the Talbotype process in Philadelphia.[7]

It is not known if or how Talbot responded to the Langenheims' plea. We do know that the partners' financial situation continued to deteriorate, although from all indications the inventor made no further monetary claims on them, nor did he attempt to regain control of his invention in America. The brothers remained the principal legal custodians of the calotype technique here until Talbot's patent expired in 1855.

The Langenheims fell far short of their goal to sell two hundred licenses by the fall of 1849, but their promotional efforts did inspire commitments from a handful of venturesome colleagues. Although their communication with Talbot in November of 1849 stresses that sales had barely been a fraction of what they anticipated, they reported that they had sold licenses for the use of the process in Georgia, Florida, Alabama, Louisiana, and Texas, and it is quite possible that other would-be practitioners came forward during this period.[8]

During the early 1850s, legal disputes challenging Talbot's attempt to extend his patents to the practice of collodion photography generated considerable dialogue in American photographic journals. Discussion on Talbot's claims frequently evoked reflections on why the calotype had failed to attract practitioners here. Joining the nearly unanimous chorus of critics who felt obliged to condemn the inventor's pecuniary motives by 1853, the editor of *Humphrey's Journal* stated: "Should Mr. T[albot] ask why the public did not buy his process, he can be answered that they did not wish to pay the *exorbitant prices* charged for rights."[9]

In an earlier comment which focused more specifically on American practitioners, S. D. Humphrey had offered another perspective on that subject. In this remark on the patent's role in precluding widespread interest in the calotype here, he proposed: "We doubt whether it would be of any importance if there had been no reservation." Humphrey attributed the neglible impact of patent restrictions here to the fact that "American daguerreotypes are so superior to anything on paper that has been imported."[10] What he neglected to reflect on, presumably out of friendship for the Langenheims and sympathy for their financial problems, was the role that their

American-made Talbotypes had played in supporting the conclusion that "impressions on paper" could not measure up to native productions on silver.

Modern scholarship is generally more candid in deducing that the Langenheims' Talbotypes may have done much to confirm and prolong Americans' decided preference for the daguerreotype. Because so little work remains from this chapter in the partners' career, however, it has been difficult to provide precise observations either on the quality of their work in the calotype medium or on its role in affecting American attitudes toward photography during the daguerreian era. Salted paper prints bearing the partners' "Talbotype" imprint are among the rarest commodities in early photographic memorabilia. Through a little-known collection of Langenheim Talbotypes, we are afforded an opportunity to begin examining those issues.

The large cache of work made during the photographers' brief tenure as calotypists is preserved in an album in the collection of the Missouri Historical Society in St. Louis.[11] Including duplicate prints, the album contains 63 portraits, 101 views, and a small number of prints reproducing engravings and other artwork. The images are brown in tone and printed on smooth, starch-sized paper. Although there are substantial differences in image quality, which may in part be due to fading over time, many of the prints appear to have survived in conditions very close to their original appearance.

This rare collection was accumulated by Eduard Robyn, a German immigrant employed by the photographers in 1849 and 1850. Robyn is noted on a Langenheim broadside as "a very talented artist" engaged for the purpose of "coloring" portraits on paper.[12] Sometime in the fall or early winter of 1850, Robyn moved on to St. Louis, where he joined his brother as a partner in a lithography firm. In 1939 the artist's mementos of his work with the Langenheims, carefully affixed to the pages of a large album, were discovered at the Robyn family farm near Herman, Missouri. This unique assemblage of American Talbotypes reveals much about the aspirations that prompted the brothers' costly digression from the daguerreian fold.

As a commercial venture launched in a society that viewed its pioneer photographers primarily as likeness-makers, the Langenheims' successful promotion of Talbot's process depended on their ability to demonstrate its potential for studio portraiture. This was their first order of business when the elder Langenheim returned from England with the Talbotype patent in hand. An elaborate broadside focusing exclusively on portraits stated their intention to challenge the primacy of the one-of-a-kind daguerreotype portrait. Alluding to the reflective and fragile surfaces used in Daguerre's more "common method," the Langenheims emphasized that "Talbotype

pictures" could be seen "in any direction" and "could not be rubbed out," since the "pictures are not only on paper but even penetrate the mass of the paper itself." In addition to these advantages, plus the unique opportunity to obtain "perfect" copies from only one sitting, the Langenheims assured patrons that portraits on paper could be acquired "at a trifling expense," with prices "considerably lower than Daguerreotypes of the same size."[13]

Introducing a medium that *Humphrey's Journal* deemed "totally unavailable" to Americans in 1849, the Langenheims invested considerable energy in attempting to demonstrate their claims for "the new and wonderful art" as it could be applied in a gallery setting.[14] They summarized initial reactions to their portrait "specimens" in an early report to Talbot: "The productions are so new to everyone that they do not know whether to pronounce them good, bad or indifferent."[15]

Following the practice common in daguerreian galleries, the Langenheims used widely known faces to exemplify the potential of paper photography for recording the human likeness. Such well-known figures as Lewis Cass, General Winfield Scott, Millard Fillmore, and Zachary Taylor are among the political or military leaders whose faces appear in Robyn's collection. The Langenheims also produced "paper impressions" of showman P. T. Barnum and painter Asher B. Durand, president of the National Academy of Design in New York.

Most celebrity portraits in the Robyn album are calotype duplicates of works originally secured by the more "common method" of daguerreotypy. The large number of such appropriated images suggests that the photographers depended heavily on their daguerreotype collection to assemble America's first calotype display. Given the problems that the partners must have faced with patrons accustomed to the shorter exposures required for daguerreotyped faces, they undoubtedly welcomed the less trying task of working with an inanimate, prerecorded subject.

Native critics would soon determine that the production of "transcribed pictures, where prolonged exposures can be had," was one of the more acceptable applications for paper photography.[16] Without a strong romantic inclination, they might have revised this opinion on seeing the Langenheims' "transcribed" portrait of Durand, an image derived from a daguerreotype attributed to Mathew Brady's studio (fig. 1).[17] In the secondhand calotyped version, the precisely modeled forms of Brady's original have been obscured in the atmospheric haze that Sir John Herschel described as calotype "fog."[18] When copying one of their own daguerreotypes picturing Mrs. William Langenheim (fig. 2), the brothers came somewhat closer to retaining the aesthetic character of the original.[19]

Figure 1.
William and Frederick
Langenheim, salted
paper print copied
from daguerreotype,
image 12.9 x 9.7 cm.,
circa 1850. Asher B.
Durand. Collection of
the Missouri Historical
Society.

Figure 2.
William and Frederick
Langenheim, salted
paper print, image
14 x 10.2 cm., circa
1850. Mrs. Wm. Lang-
enheim. Collection of
the Missouri Historical
Society.

As the Durand image suggests, the most successful portraits preserved in Robyn's collection confirm what has become familiar dialogue on the visual distinctions between calotype portraits and those produced by Daguerre's technique. These differences are readily discernible in a comparison between a portrait of an unidentified woman, which bears the distinctive marks of an original Langenheim Talbotype (fig. 3), and a similarly elegant subject recorded by the St. Louis daguerreian Thomas Martin Easterly (fig. 4). Conveying that mixture of immediacy and intimacy that would rarely be recaptured in later photographic modes, the pristine clarity that distinguishes the daguerreotype invites the closest scrutiny. What Americans would have extolled as the magical beauty of exactitude in Easterly's portrait is replaced by an ethereal charm evoked by the warm brown patina and broad chiaroscuro effects of the Langenheims' more psychologically remote portrayal. With only the daguerreotype's standards of photographic veracity as a measure, one can suspect that the Langenheims' public found the subtle chiaroscuro renderings of the new "paper impressions" a poor substitute for the exactness of miniatures on silver.

Had the Philadelphia brothers been unique in failing to establish a clientele for their studio productions in Talbot's medium, we could legitimately blame America's exceptionally tenacious attachment to daguerreotype portraiture for their failure to attract sufficient patronage. However, the outcome of similar commercial ventures abroad suggests that this national bias only partially explains the Langenheims' unsuccessful efforts.

Preceding the sale of Talbot's American patent, Henry Collen and Antoine Claudet, who in turn acted as representatives for the inventor in London, had been forced to give up their commercial enterprises as calotype portraitists when patrons failed to support their efforts. After Claudet returned full-time to the practice of daguerreotypy in 1847, Talbot's close associate Nicolaas Henneman became the inventor's partner and last official representative in London. Henneman struggled for several years without a profit. Only because Talbot subsidized his establishment did Henneman survive to see a brief period of limited success with calotype portraiture in the early 1850s.[20] As these circumstances suggest, even in the hands of highly competent technicians like Claudet and Henneman, Talbot's process did not produce adequate results under normal studio light conditions.

By the summer of 1850, probably as a result of the disappointing returns on their studio work, the Langenheims were clearly determined to demonstrate other applications for the Talbotype. With this objective, they embarked on one of the most ambitious photographic projects yet undertaken in America, an extensive sur-

Figure 3.
William and Frederick
Langenheim, salted
paper print, image
12.5 x 9.5 cm., circa
1850. Unidentified
Woman. Collection of
the Missouri Historical
Society.

vey called "Views of North America." Presumably they intended to publish and distribute the views as a travel or souvenir album. Robyn's collection contains 101 positive prints made in the course of this impressive undertaking.

As the only sizable, intact body of work to recall this early documentary venture, Robyn's reserve is a uniquely valuable resource. In aggregate, these images clearly demonstrate that the failure of the calotype here was by no means the result of a half-hearted effort on the part of Talbot's American representatives. We can also learn much about the evolution of the "Views of North America" project as a result of Robyn's liberal attitude toward what was worth salvaging for his assemblage of mementos.

Perhaps because Robyn was aware of his role as an intimate observer of a significant experiment in the history of American photography, he preserved the rejects from the project along with those views deemed worthy of public perusal. If we as-

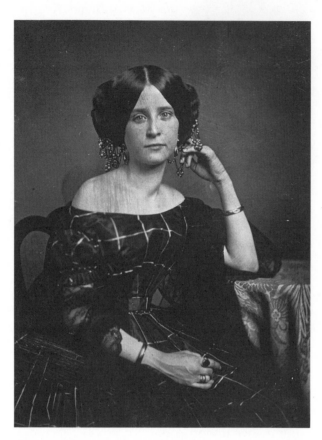

Figure 4.
Thomas M. Easterly,
quarter-plate daguerreotype,
circa 1850.
Unidentified Woman.
Collection of the
Missouri Historical
Society.

sume that only those images which met the Langenheims' standards received both titles and numbers, many scenes in the album failed to receive the photographers' approval. Suggesting the prominent role that trial and error played in the execution of this project, nearly a quarter of the views remain untitled and/or unnumbered.

Robyn's legacy also offers numerous examples of the Langenheims' moments of success with Talbot's process. Sites in their own Philadelphia locale provided subjects for some of their most accomplished work as early view-makers. Their record of the "New County Prison Debtors Apartment" (fig. 5) and panoramic "West View of Philadelphia" (fig. 6) exhibit uniform tonal structures and well-resolved detail throughout. Given the photographers' stated aim to match the "distinctness" of daguerreotypes with their works on paper, we can also predict that the partners were pleased with the outcome of works picturing Philadelphia's "U.S. Navy Yard" (fig. 7) and "U.S. Mint" (fig. 8).[21] Somewhat more characteristic of the calotype medium are the more dramatic value contrasts and bleached spaces that appear in their sun-drenched view of the "City Gas works," a scene showing Frederick Langenheim posed sedately in the foreground (fig. 9).

All of Robyn's records from "Views in North America" are circular images three and three-quarter inches in diameter, with the exception of two smaller images in the same circular format. Fully captioned views are dated either June or July 1850. The Langenheims projected at least five series for the project, each providing a pictorial survey of a different well-known locale. The majority of prints preserved by the colorist were made for "Series I: Penn.," which focused on architectural and engineering landmarks and prominent monuments in and around the photographers' Philadelphia area. The album contains no views from Series II, nor have calotypes from this series been located elsewhere.[22] Works for Series III pictured government buildings in the nation's capital, while Series IV provided an extensive inventory of sites at or near Niagara Falls. Originally, Robyn's collection displayed two views from "Series V: Virginia," "The Resting Place" and "The Mansion Home" of George Washington. In 1951 these prints were removed from the album and transferred to the Mount Vernon Association.

Since Robyn's inventory is incomplete, it is impossible to determine the total number of views that originally constituted the various series. For example, with notable gaps in the sequence, numbered works in the album from the Pennsylvania series range between 1 and 58c, suggesting that more than sixty views were executed for Series I. The Robyn collection contains prints and duplicates picturing twenty-

Figure 5.
William and Frederick
Langenheim, salted
paper print, image 9.5
cm. in diameter, 1850.
New County Prison &
Debtors Apartment.
Collection of the
Missouri Historical
Society.

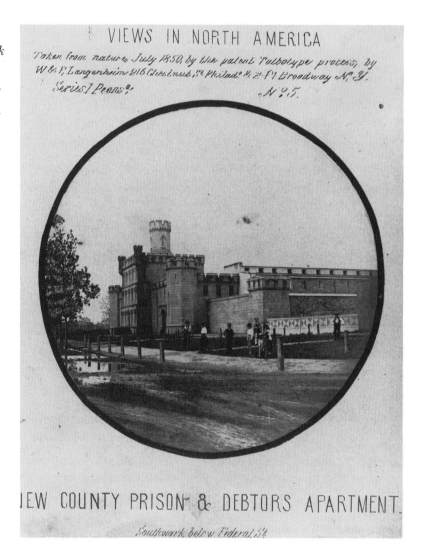

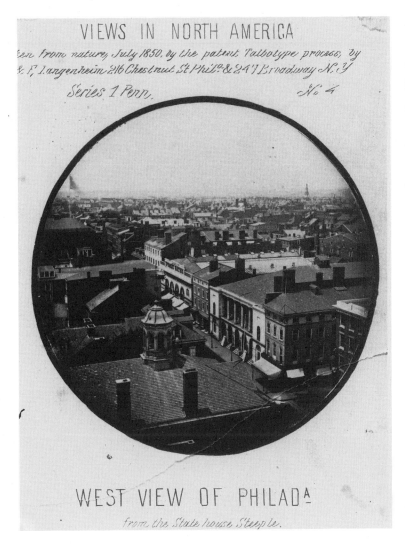

Figure 6.
William and Frederick
Langenheim, salted
paper print, image
9.5 cm. in diameter,
1850. West View of
Philadelphia. Col-
lection of the Missouri
Historical Society.

Figure 7.
William and Frederick
Langenheim, salted
paper print, image
9.5 cm. in diameter,
1850. U.S. Navy Yard.
Collection of the
Missouri Historical
Society.

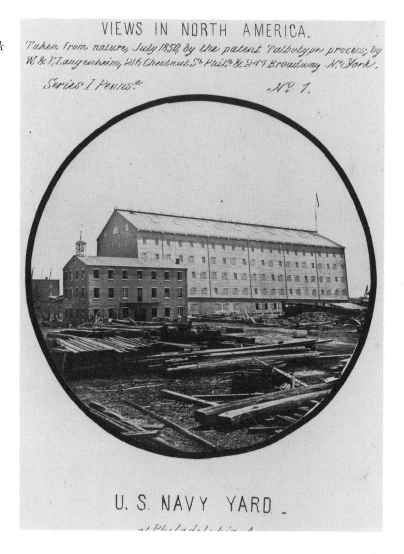

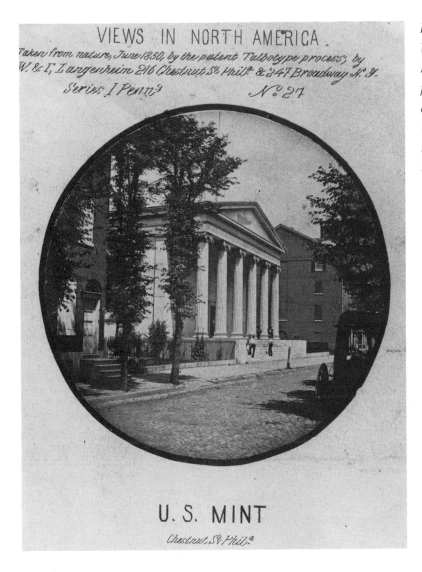

VIEWS IN NORTH AMERICA.

Taken from nature, June 1850, by the patent Talbotype process, by
W. & F. Langenheim 216 Chestnut St. Phila. & 247 Broadway N.Y.

Series I Penna No 27

U. S. MINT

Chestnut St. Phila.

Figure 8.
William and Frederick
Langenheim, salted
paper print, image 9.5
cm. in diameter, 1850.
U.S. Mint. Collection of
the Missouri Historical
Society.

Figure 9.
William and Frederick
Langenheim, salted
paper print, image 9.5
cm. in diameter, 1850.
City Gas Works. Col-
lection of the Missouri
Historical Society.

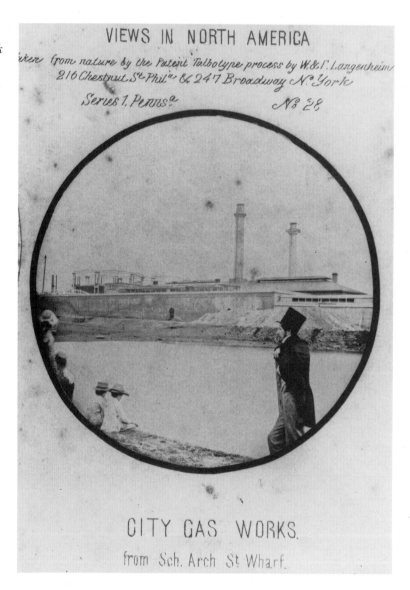

six different Pennsylvania sites. If the photographers devoted the same attention to other locales featured in "Views of North America," they invested considerable time and effort in the project.

When the Langenheims launched this monumental effort to produce an extensive photographic survey of Eastern sites, they were bringing a new initiative to American photography. In 1850 the vast majority of their daguerreian colleagues were quite content with their limited role as likeness-makers. Even in the upper echelon of the profession, where practitioners clearly possessed the technical skills needed to meet the greater challenge of working outdoors with Daguerre's technique, there had been few sustained attempts to explore the documentary potential of the camera outside the studio.

In their early interest in recording the urban scene, the Langenheims did have at least one kindred spirit in Thomas Easterly, who was well known in St. Louis for his exceptional skills as a daguerreian view-maker. Easterly's street scenes (figs. 10 and 11), which capture the fleeting moment and preserve it in pristine detail, demonstrate what the Langenheims could never hope to achieve with the calotype process. The partners recognized these limitations and composed their views accordingly by emulating the pictorial practices of the topographical printmakers whose architectural and scenic views had provided the model for their "Views in North America" series. In keeping with this tradition and with their aim to focus viewer attention on a single architectural monument, they selected distant perspectives that accommodated more formal and orderly compositional structures.

The Langenheims presumably hoped that a favorable response to their ambitious documentary effort would reverse their financial difficulties. Given the extensive travel involved, it is more likely that this venture contributed to the heavy losses that soon forced the brothers to abandon the "Views in North America" project and to temporarily close their Philadelphia gallery. However, lack of capital was probably not the only factor in the partners' decision to forego their plan to publish the "Views in North America" work.

As Robyn's mementos of the costly experiment show, technical difficulties, which continued to overshadow the potential benefits of duplication, posed significant problems for the Langenheims, even when working out of doors. While they aggressively promoted the advantages of copies, with "each subsequent copy as perfect as the first," views printed from the same negative are rarely uniform in quality.[23] For potential licensees, such uneven results were hardly convincing evidence

Figure 10.
Thomas M. Easterly,
half-plate daguerre-
otype, circa 1850.
Burritt's National
Daguerrean Gallery,
St. Louis. Collection of
the Missouri Historical
Society.

Figure 11.
Thomas M. Easterly,
quarter-plate
daguerreotype, circa
1850. German Youth
Band. Collection of the
Missouri Historical
Society.

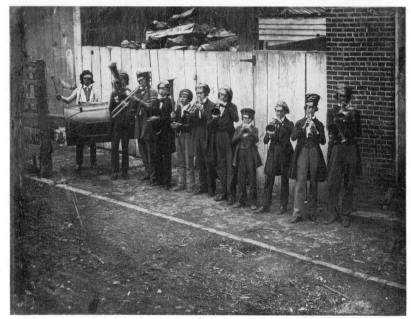

that "the new and wonderful art" was a feasible substitute for the more predictable daguerreotype process.

Works from the "Views in North America" series also give evidence of another aspect of paper photography that the Langenheims' public found troubling when measured against the attributes of Daguerre's invention. Seen as the perfect marriage of art and science, the daguerreotype was revered as "a picture painted by nature herself," free of interpretive intervention. In contrast, products of a paper negative process often revealed retouching. American critics made much of this feature as irrefutable evidence that paper photography could never measure up to the "superior finish and execution" that guaranteed the daguerreotype's "exquisite truthfulness."

Addressing readers of the *Photographic Art-Journal* in 1852, Henry Snelling typified criticism on this point as he praised recent glass-plate innovations of Whipple and Black of Boston: "These gentlemen have produced proofs upon paper far excelling any of those coming in either from English or French manipulators. We consider them superior, because they come from their hands in a finished state, . . . without the aid of the brush, which cannot be said of the European photographs, they being more or less retouched."[24] Although Snelling and other native critics tactfully avoided this issue when it came to the Talbotype productions of their Philadelphia colleagues, numerous works in the Robyn collection suggest that the Langenheims may have done much to foster the prevailing view that retouching and paper photography went hand in hand.

Native prejudice against signs of human intervention in the photographic process was wholly consistent with the high premium that Americans placed on the perceived objectivity of a photomechanical production. Heartily approving of hand-colored daguerreotypes, the public viewed such extraneous touches as a means of further enhancing the inherent faithfulness of the camera's record. The Langenheims hoped for a similar outcome when they directed Robyn to apply his brush to their negatives.

Numerous images in the "Views in North America" collection evidence the photographers' reliance on the artist's handiwork. As if deliberately inviting comparison between the "before" and "after," Robyn's album displays side-by-side views of "The Capitol at Washington" (fig. 12). The view on the left shows the artist's attempt to give textural variation and highlights to the opaque brown masses

Figure 12.
William and Frederick
Langenheim, salted
paper print, image 9.5
cm. in diameter, 1850.
The Capitol at Wash-
ington. Collection of
the Missouri Historical
Society.

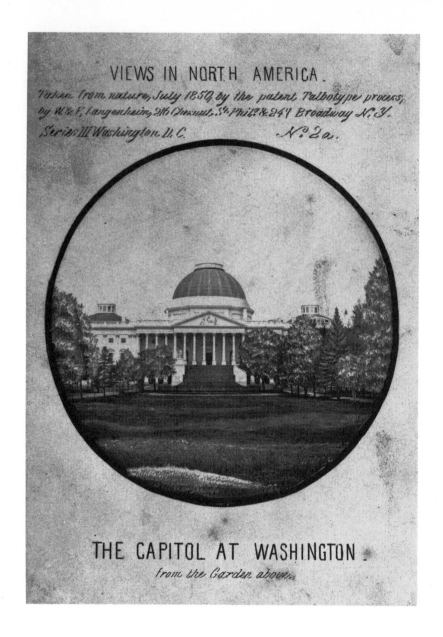

VIEWS IN NORTH AMERICA.

Taken from nature, July 1850, by the patent Talbotype process,
by W. & F. Langenheim, 216 Chesnut St. Phila. & 247 Broadway N.Y.
Series III Washington D.C. N.º 2 a.

THE CAPITOL AT WASHINGTON.
from the Garden above.

that define the trees in the unaltered print on the right. In the retouched image,
Robyn's paintbrush has also transformed the flattened, monotonous plane of the
lawn into an undulating promenade intended to move the eye back toward the ar-
chitectural focus of the picture.

Negatives prepared for the Niagara Falls sequence consistently display Robyn's
most elaborate contributions to the project. In several instances, the artist's finished
productions leave little to recall their origin in the camera. As can be seen in views of
the Horseshoe Fall, Terrapin Tower, and the American Fall (figs. 13 and 14), which

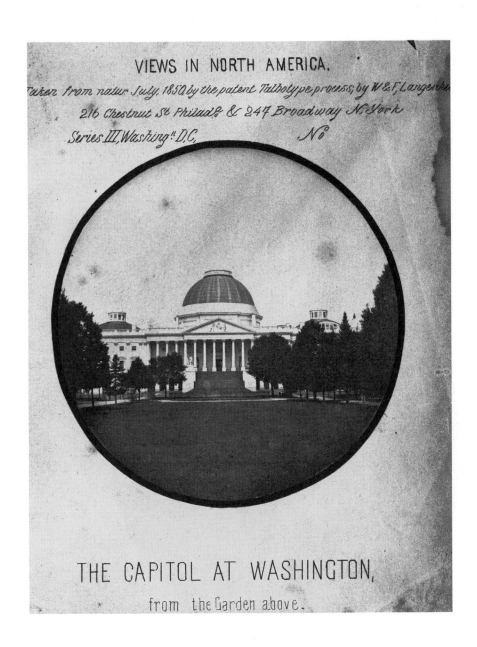

VIEWS IN NORTH AMERICA.

Taken from natur July, 1850, by the patent Talbotype process, by W.& F. Langenheim

216 Chestnut St Philad.ᵃ & 247 Broadway N. York

Series III, Washing.ⁿ D.C. Nᵒ

THE CAPITOL AT WASHINGTON,

from the Garden above.

could easily pass for monochromatic watercolor sketches, only the middleground portions of the pictures remain consistent with the camera's vision. While Robyn may have been pleased with the picturesque outcome of his creative brushwork, such readily discernible alterations to the essential facts of the scene undoubtedly did little to recommend the Talbotype process to patrons or potential licensees.

To American eyes, camera-made pictures that looked more like art than nature—and Robyn's Niagara views would certainly have qualified in this category—were completely out of line with commonly held views on the appropriate relation-

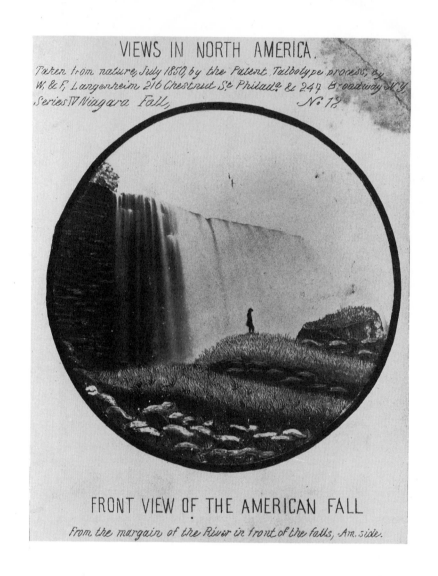

Figure 13.
William and Frederick
Langenheim, salted
paper print, image
9.5 cm. in diameter,
1850. View of the
American Fall.
Collection of the
Missouri Historical
Society.

VIEWS IN NORTH AMERICA.
Taken from nature, July 1850, by the Patent Talbotype process, by
W. & F. Langenheim 216 Chestnut St. Philada. & 247 Broadway N.Y.
Series IV Niagara Fall, *No 1º*

FRONT VIEW OF THE AMERICAN FALL
From the margain of the River in front of the falls, Am. side.

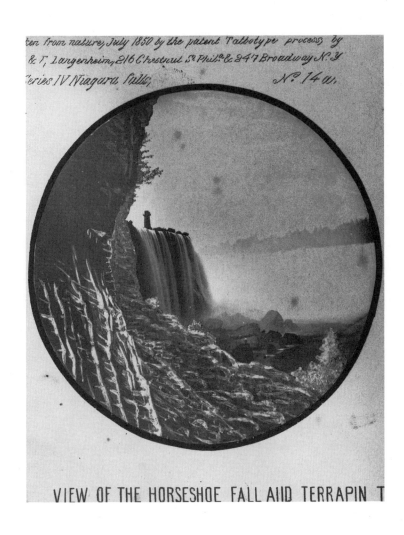

VIEW OF THE HORSESHOE FALL AIID TERRAPIN T

Figure 14.
William and Frederick
Langenheim, salted
paper print, image
9.5 cm. in diameter,
1850. View of the
Horseshoe Falls and
Terrapin Tower.
Collection of the
Missouri Historical
Society.

ship between nature and photographic representation. One of the most candid declarations on this subject came from an American "foreign correspondent" who wrote to *Humphrey's Journal* during a visit to Paris. Referring to the many "retouched" works on display in there, he stated: "For my part, although the colored specimens are beautiful . . . , I would prefer the plain ones; they look like nature—true with all its *faults*—while the painted ones look too much like pictures—ideal things with more beauty that truth."[25]

The same high regard for "truth" and the prospect of developing a more economically rewarding process by early 1851 had prompted the Langenheims to give up their effort to practice and improve on Talbot's method. By that time the brothers had refined and patented their "hyalotype" process, a technique that used glass as the support for both negative and positive images. The *London Art Journal* carried a favorable review on the new hyalotype "specimens from Philadelphia" that included a commentary by the Langenheims sharing their personal assessment on the shortcomings of the calotype process. Admitting a high record of failure with Talbot's technique, they stated: "The best paper is always a fibrous substance, and the texture of the negative paper is always imprinted on the positive picture, and very few Talbotypes were fit to be shown, except after touching them up by hand. In portraits particularly this process is very apt to destroy the likeness."[26]

In their overriding concern to preserve "the likeness," an objective that coerced the brothers into their uneasy alliance with the paintbrush, the Langenheims placed themselves firmly within the mainstream of American taste where the imitative virtues of the daguerreotype continued to dictate the requisites of photographic representation. Those individuals who initiated "the Golden Age of paper photography" abroad had very different goals for the camera.

In 1847, the same year that Claudet was forced to give up his commercial venture in calotype portraiture, England and Scotland were described as "a paradise for calotypy" for practitioners who saw more elevated applications for Talbot's process.[27] Possibly the Langenheims based their high hopes for the medium on such pronouncements. The Philadelphia partners may also have been encouraged by the wide reputation of the Scottish photographers David Hill and Robert Adamson, whose work in their outdoor studio in Edinburgh inspired others in Great Britain to pursue the potential of paper photography. Had the Langenheims been privy to Hill's views on the merits of the calotype and cognizant of the critical role that those views played in determining the Scottish partners' success, they might have reconsidered the wisdom of such a substantial investment in Talbot's patent.

Hill, a trained painter and lithographer who acted as artistic director in the productive five-year partnership, singled out as decided strengths the very qualities of the calotype process that most troubled the Langenheims: "The rough and unequal texture throughout the paper is the main cause of the calotype failing in detail before the daguerreotype . . . and this is the very life of it. They look like the imperfect work of man and not the very diminished work of God."[28] Hill's sensitivity to the dramatic painterly effects possible in the calotype medium can be seen in their portraits.

As another avenue for personal interpretation, Hill and Adamson welcomed the opportunity to "touch up" the print or negative as yet another avenue for expressive interpretation.[29] While Robyn's extraneous delineations were intended to redress the loss of "truthful" detail on the Langenheims' negatives, the Scottish partners used pencil shading to adjust tonal relationships in the interest of enhancing general effects and amplifying contrasts in the picture.

The Langenheims would have found themselves equally at odds with the Scotsmen on more practical matters. Although Hill and Adamson were practicing professionals focusing on portraiture, monetary gain was less important than artistic recognition. In 1848 Hill wrote: "I think the art may be nobly applied—much may be made of it as a means of cheap likeness making—but this my soul loathes, and if I do not succeed in doing something by it worthy of being mentioned by artists with honor—I will very likely soon have done with it."[30] In a conclusion based on these comments and on the reported financial losses of the Scottish partners' studio in Edinburgh, Sara Stevenson, curator of photography at the Scottish National Portrait Gallery, contends that "the possibility that Hill was interested in calotype portraiture as a money-making scheme can be dismissed out of hand."[31] In contrast, shortly after the sale of his overseas patent to William Langenheim, Talbot reported that "the American gentleman expects to make a fortune with the purchase."[32]

With Hill and Adamson's goals as a model, "the paradise" of the paper negative on British soil developed through the efforts of individuals attracted to its inherently expressive photographic language. Talbot had also demonstrated the artistic and interpretive possibilities of the medium in the plates and text of *The Pencil of Nature*. In this ambitious effort to publicize the varied applications for his discovery, the inventor introduced the suggestion that the photographic vision could function like "the painter's eye" to recognize subjects that might "awaken a train of thoughts and feelings, and picturesque imaginings."[33] These sentiments, illustrated by scenes consciously consistent with the romantic tradition, established the philosophy and thematic guidelines that attracted many who took up the practice of Talbot's process.

For eyes sensitive to its expressive potential, the close relationship between the medium's distinctive pictorial qualities and the aesthetic language of traditional printmaking techniques further enhanced its ability to conform to the ideals of the romantic tradition.

Sharing these assumptions, Talbot's most serious followers in Britain were amateurs who took up the new medium as others in their social class would pursue watercolor or sketching as a pleasurable and creative avocation. These well-educated professionals—physicians, scholars, and members of the clergy—had the means and leisure to experiment with the process and the cultural background to recognize its artistic merits. They were most attracted to the process because of the relative ease with which it could be employed on trips abroad or to appropriately romantic or rustic sites in their own locale. Talbot encouraged the development of his process in amateur circles by offering a special reduced license fee designated "for amusement only." In 1852 he relinquished all legal controls except for the practice of commercial portraiture.

By 1850, when the Langenheims were working to promote the calotype in America, France had become the center of achievement in paper photography. Interest in working with paper-negative processes there had been stimulated when French experimenters made significant improvements on Talbot's method. The most widely practiced variant technique was Gustave LeGray's waxed-paper process, which he made public in 1850. LeGray's method differed from Talbot's in waxing the paper before rather than after sensitizing. Because LeGray's process offered sharper detail and shorter exposures, the inherently poetic qualities of paper-negative photography could be fused with greater "truthfulness."

While the achievements of devoted amateurs contributed to the florescence of paper photography in France, innovations in paper-negative processes there also attracted a small group of talented, well-trained artists. In the hands of its versatile practitioners in France, the calotype process served multiple purposes. While its naturally grainy, atmospheric effects could be exploited to imbue seascapes, ruins, and forest scenes with appropriately picturesque or idyllic overtones, the capability for fine detail in the waxed-paper process could be given greater emphasis when recording architectural views or other subjects that demanded more discernible specificity. For these reasons, France led the way in developing the camera's potential outside the studio.

Valued primarily as a means of extending the ideals of the older, traditional arts into the realm of outdoor photography, calotypy flourished abroad as an elitist cur-

rent nurtured outside the confines of public taste and commercial enterprise. The Langenheims, who would have been puzzled by the modern-day contention that "calotypy civilized photography,"[34] could never have understood, let alone re-created on American soil, the conditions under which paper photography developed abroad. From a perspective shaped by their experience with the daguerreotype, the very idea of an elitist mission for photography was in itself contradictory to prin-ciples basic to America's appreciation for photomechanical productions. To a society imbued with the egalitarian spirit of Jacksonian democracy, the camera was cele-brated for its unprecedented ability to make affordable art accessible to the masses.

In addition, there was nothing in the Langenheims' background or in their profit-seeking professional milieu that would have prepared the brothers to recog-nize the virtues of a photographic aesthetic that deviated from the prevailing convic-tion that the worth of photography was inextricably bound to its reputed "closeness to nature." Had they somehow managed to develop an appreciation for works that "looked like the imperfect work of man," and followed in Hill and Adamson's footsteps to fully exploit the unique aesthetic character of paper photography, it is doubtful that such efforts would have had any impact in reversing ingrained native biases against camera-made images that looked "too much like pictures."

When we consider the full range of factors that contributed to America's disin-terest in the calotype, we can understand S. D. Humphrey's conclusion that the pa-tent "reservation" probably had little or no impact on restricting the practice of Tal-bot's process here. As evidenced by Robyn's rare mementos of the Langenheims' costly experiment, there is little question that it was the process itself, not the price of a $30 license, that guaranteed the continuing reign of the daguerreotype in America.[35]

NOTES

1. For the most comprehensive discussions on the calotype and its major practitioners, see Richard R. Bretell, with Roy Flukinger, Nancy Keeler, and Sydney Malett Kilgore, *Paper and Light: The Calotype in France and Great Britain, 1839–1870* (Boston: David R. Godine, 1984); An-dre Jammes and Eugenia Parry Janis, *The Art of French Calotype* (Princeton, N.J.: Princeton Uni-versity Press, 1983); and Janet E. Buerger, *The*

Era of the French Calotype, exhibition catalog, International Museum of Photography at George Eastman House (Rochester, N.Y., 1982).

2. William Crawford, *The Keepers of Light* (Dobbs Ferry, N.Y.: Morgan & Morgan, 1979), p. 36.

3. *Daily National Intelligencer*, May 12, 1849.

4. The Langenheims to Talbot, letter dated February 5, 1849, Fox Talbot Collection, Science

Museum, London, quoted in Gail Buckland, *Fox Talbot and the Invention of Photography* (Boston: David R. Godine, 1980), p. 98.

5. For the most thorough account of the careers of William and Frederick Langenheim, see William Brey, "The Langenheims of Philadelphia," *Stereo World* 6 (March–April 1979): 4–20.

6. *Missouri Daily Republican*, July 12, 1849.

7. Letter dated November 18, 1849, Science Museum, London, quoted in Buckland, p. 100.

8. Letter dated November 18, 1849, quoted in Buckland, p. 100.

9. *Humphrey's Journal* 4 (January 15, 1853): 301.

10. *Humphrey's Journal* 4 (October 15, 1852): 197.

11. For related information on the Langenheims and their "Views in North America" series, see Dolores Kilgo, "The Robyn Collection of Langenheim Calbotypes: An Unexplored Chapter in the History of American Photography," *Gateway Heritage: Quarterly Journal of the Missouri Historical Society–St. Louis* 6 (Fall 1985): 28–37.

12. Undated broadside, Sipley Collection, International Museum of Photography at George Eastman House.

13. Undated broadside, Sipley Collection.

14. *Photographic Art-Journal* 7 (September 1854): 288.

15. Letter dated November 18, 1849, Science Museum, London, quoted in Buckland, p. 99.

16. Marcus A. Root, *The Camera and the Pencil* (Philadelphia: J. B. Lippincott, 1864), p. 371.

17. See Harold Francis Pfister, *Facing the Light: Historic American Portrait Daguerreotypes* (Washington, D.C.: Smithsonian Press, 1978), pp. 47, 313.

18. Buerger, *The Era of the French Calotype*, p. 4.

19. Mrs. Langenheim's name, written in pencil, appears on the album page beneath the portrait. A number of the well-known figures pictured in the Robyn album are also identified in this manner.

20. Buckland, p. 105.

21. Although the Langenheims identify them as "Talbotypes," it is possible that some of the more sharply defined views in Robyn's collection were made from glass rather than paper negatives as part of their experiments with their hyalotype process, which they patented in the fall of 1850. This is the contention of Robert Eskind, who suggests that the partners "experimented with glass-negatives" in the summer of 1850. See Robert Eskind, "William and Frederick Langenheim," *Legacy in Light*, exhibition catalog, Philadelphia Museum, 1990 (Philadelphia, Pa.). This is a complex problem worthy of investigation. Most experts agree that it is difficult on the basis of visual evidence to precisely determine whether a salted paper print was produced from a glass or a paper negative.

22. Numerous sites and monuments recorded for the "Views in North America" series were also pictured in a later published series of "one hundred and twenty-six views" noted by Robert Hunt when he described the partners' "new magic-lantern pictures on glass" in 1851. Hunt's account indicates that scenes in this series focused on Washington, D.C., Philadelphia, and New York. This suggests that New York may have been the focus of Series II of "Views in North America," if the partners did indeed undertake this portion of the project. Hunt's comments, reprinted from the *London Art Journal*, appeared in the *Daguerreian Journal* 1 (April 15, 1851): 329.

23. Langenheim broadside quoted in Brey, p. 11.

24. *Photographic Art-Journal* 4 (July 1852): 62.

25. *Humphrey's Journal* 4 (March 1, 1853): 349.

26. Robert Hunt, "On the Application of Science in the Fine and Useful Arts," *London Art Journal*, n.d. Reprinted in the *Daguerreian Journal* 1 (April 15, 1851): 329.

27. Lock Cockburn to editor of the *North British Review*, letter dated November 22, 1847, National Library of Scotland, quoted by Sara Stevenson in "David Octavius Hill and Robert Adamson," in *British Photography in the Nineteenth Century*, ed. Mike Weaver (Cambridge: Cambridge University Press, 1989), p. 39.

28. D. O. Hill to Elhanan Bicknell, letter dated January 17, 1848, International Museum of Photography at George Eastman House.

29. Crawford, p. 37.

30. Quoted by Stevenson, p. 39.

31. Ibid.

32. Buckland, p. 98.

33. Henry Fox Talbot, *The Pencil of Nature* (London: 1844–46; New York: Da Capo Press, 1969), n.p.

34. Andre Jammes and Eugenia Parry Janis, *The Art of French Calotype* (Princeton, N.J.: Princeton University Press, 1983), p. xiv.

35. During 1851 and 1852 there are a few reported instances of "Talbotypes" and "calotypes" made by American photographers. Although some of these individuals may have been working with the Langenheims' Talbotype method as licensed "subscribers," others were undoubtedly working in LeGray's waxed-paper technique or other negative-positive processes that produced paper prints. The terms "calotype" and "Talbotype" were used very loosely during the early 1850s. For example, in May of 1852, the *Daguerreian Journal* used the term "calotype" to refer to John Whipple's positive pictures produced from glass negatives. Most references to activity in paper processes during this period focus on a few New York City galleries, although records of Franklin Institute exhibitions in Philadelphia denote "Talbotype" entries from McClees and Germon in 1851 and from D. B. Richards in 1852. Victor Prévost, a French painter who immigrated to New York City in 1848, became America's most devoted practitioner of LeGray's waxed-paper process. After returning to France to learn that process from LeGray in 1852, Prévost produced a large body of views of New York and its environs made in 1853 and 1854.

JOHN R. STILGOE

Landscape in Limbo

Landscape in daguerreotype is landscape in limbo. Not some mere frozen moment, some space captured with a sunbeam, the daguerreotype landscape hovers in something, beneath the glass. The images here assembled put to rest forever the casual charge that no daguerreotypist made a good landscape image, made even one worth more than a hasty glance. But these images raise questions beyond those asked of paintings, lithographs, and photographs. Especially they force the question of visual limbo, the skewed uses of landscape daguerreotypes at the end of the twentieth century.

In the halcyon years of the daguerreotype, *limbo* underwent a metamorphosis, changing in meaning rapidly, if vaguely, yet always shifting further from the taut definitions of medieval churchmen. What scholastic theologians once meant by *limbus*, as in *limbus infantium* (the limbo of the unbaptized infants), had begun changing even in Shakespeare's time. The "O, what a sympathy of woe is this, / As far from help as Limbo is from bliss" of *Titus Andronicus* keeps most of the old connotation of limbo as an other-worldly region, a borderland of Hell, as does Milton's use of the word in *Paradise Lost*: "A limbo large and broad, since call'd / The Paradise of Fools."[1] Both uses depart from the strict theological definition of *limbus*, however, and point toward the romantic use of the term, perhaps best exemplified in Coleridge's poem "Limbo":

'Tis a strange place, this Limbo!—not a Place

Yet name it so;—where Time and weary Space

Fettered from flight, with night-mare sense of fleeing

Strive for their last crepuscular half-being . . .

By 1817, when Coleridge published his poetic view of "a spirit-jail secure," *limbo* already flourished as a slang synonym for prison or other sort of confinement.[2] The romantics only hastened—and dignified—its transformation into a supratheological term.

The secularized word crossed the Atlantic easily. In 1828 Webster defined it as a place of general restraint and confinement, and in 1859 Worcester defines it as "*any place of restraint and confinement.*" Within a few years, certainly by the time of the 1864 unabridged *Webster's Dictionary*, it had acquired a solid nontheological denotation: "Any real or imaginary place of restraint or confinement; a prison; as, to put a man in *limbo*."[3] About the word still lingered a trace of mystery, as though it designated a zone confining unexplained phenomena, the "limbo of curious evidence" about which Oliver Wendell Holmes ruminated in the 1883 preface to his 1859 novel *Elsie Venner*.[4]

Holmes may well have understood more of the subtle complexities of limbo than his remark indicates. His mid-nineteenth-century *Atlantic Monthly* articles on early photography and stereography, now so often quoted and reprinted, reveal a more-than-passing interest in the spiritual element implicit in the techniques and contain a near-cryptic remark about the daguerreotype. "The Stereoscope and the Stereograph," an 1859 piece, begins with a lengthy analysis of classical thinking on perception, moving from the ideas of Democritus through those of Epicurus to Lucretius, emphasizing the continuity of a concept of seeing. Essentially, Holmes argues that the classical philosophers posit "effluences" given off by all objects and continuously striking the eye: "Forms, effigies, membranes, or *films*, are the nearest representatives of the terms applied to these effluences." According to Worcester's 1859 *Dictionary*, a more likely synonym, *aura*, referred only to flows of air, and Holmes struggles to translate satisfactorily, hitting on *films* to open his analysis of photography. The prefatory comments are of critical importance in two ways—both, however, easily missed. First, they introduce his statement about the daguerreotype, and second, they open his lengthy remarks about the three-dimensional nature of the stereograph viewed in the stereoscope.

Figure 1.
Anonymous, half plate.
Collection of Greg
French.

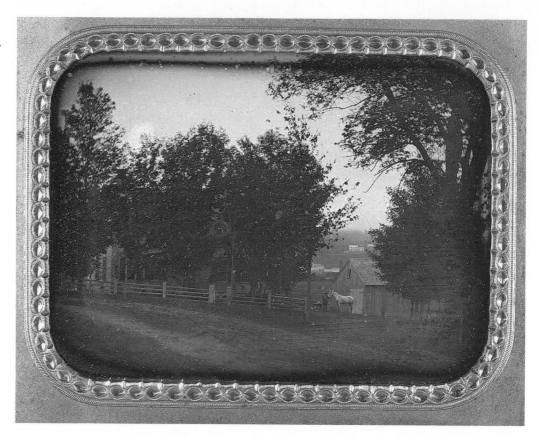

"This is just what the Daguerreotype has done," Holmes asserts of the power to transfix images. "It has fixed the most fleeting of our illusions, that which the apostle and the philosopher and the poet have alike used as the type of instability and unreality." While Holmes immediately remarks that the photograph "has completed the triumph, by making a sheet of paper reflect images like a mirror and hold them as a picture," the bulk of his essay suggests that the stereograph has restored something of the miraculous to the "everyday nature" of the paper-based photograph. Implicit in his argument is an understanding of the daguerreotype and the *viewed* stereograph image as different from the everyday photograph.

Holmes emphasizes repeatedly the fragility of the daguerreotype, speaking of its granular deposits "like a very thin fall of snow, drifted by the wind," the thinly sprinkled silver "as the earth shows with a few scattered snow-flakes on its surface," and the unfixed plate from which "a touch wipes off the picture as it does the bloom from a plum." Equally important, however, is the palpable three-dimensionality of the daguerreotype, something visible to the discerning eye, and to the discerning eye

aided by a "microscope magnifying fifty diameters or even less."[5] The daguerreotype is less fragile than the stereograph, whose illusionary power lasts only as long as a viewer sees it through the stereoscope, but both are vastly more magical than the photograph, which appears in the article as mundane, even pedestrian.

More than novelty made the daguerreotype entrancing to educated Americans. The daguerreotype fitted perfectly into the delicate world of the American romantics, and particularly into arresting questions focused on the usefulness of American landscape and history for the purposes of art.[6] Indeed the daguerreotype made palpable the visual concerns of romantics like Nathaniel Hawthorne, whose fiction juxtaposing historical and contemporaneous events insisted on new ways of seeing, of seeing into limbo.

Hawthorne asserts the prime necessity of seeing things slightly differently, of comparing things seen in "the white sunshine of actual life" with things seen by moonlight.[7] Moonlight makes everyday things different, makes a limbo of mundane places. "Moonlight, in a familiar room, falling so white upon the carpet, and showing all its figures so distinctly,—making every object so minutely visible, yet so unlike a morning or noontide visibility,—is a medium the most suitable for a romance-writer to get acquainted with his illusive guests," he argues at the beginning of *The Scarlet Letter*, remarking how "all these details, so completely seen, are so spiritualized by the unusual light, that they seem to lose their actual substance, and become things of the intellect. Nothing is too small or too trifling to undergo this change, and acquire dignity thereby." In the white light "the floor of our familiar room has become a neutral territory, somewhere between the real world and fairyland, where the Actual and the Imaginary may meet, and each imbue itself with the nature of the other. Ghosts might enter here, without affrighting us." Perhaps, he concludes, the ghosts might not need to enter. They might be always there, having never stirred from the fireside, but noticeable only in the "streak of magic moonshine" that illuminates the limbo coexisting in ordinary space.[8]

Hawthorne continually toyed with the possibility of fixing the images glimmering in moonlight. In "The Hall of Fantasy" he created a man who "had a scheme for fixing the reflections of objects in a pool of water, and thus taking the most lifelike portraits imaginable," and in "The Prophetic Pictures" he pried into the human love of portrait-making. "The looking-glass, the polished globes of the andirons, the mirror-like water, and all other reflecting surfaces, continually present us with portraits, or rather ghosts, of ourselves, which we glance at, and straightway forget

them. But we forget them only because they vanish. It is the idea of duration—of earthly immortality—that gives such a mysterious interest to our own portraits." Yet sometimes Hawthorne rejoiced that the glimmerings of the familiar moonlit chamber could not be fixed, could not be plucked from limbo. "God be praised," he asserted in "The Old Apple Dealer," "that the present shapes of human existence are not cast in iron nor hewn in everlasting adamant, but moulded of the vapors that vanish away while the essence flits upward to the Infinite."[9] Fixing images, fixing the Holmesian "films," might unbalance things, might wrench the powers of art and skewer the white sunshine with a shaft of limbo.

Hawthorne honored the visual arts—including the art of seeing—as the "image of the Creator's own," and in "The Prophetic Pictures" he probed deeply into the awesome significance of picture-making. "The innumerable forms, that wander in nothingness, start into being at thy beck," he wrote, speaking in the guise of a portrait painter. "The dead live again. Thou recallest them to their old scenes, and givest their gray shadows the lustre of a better life, at once earthly and immortal. Thou snatchest back the fleeting moments of History." But arrogance propels the

portraitist. "O potent Art! as thou bringest the faintly revealed Past to stand in that narrow strip of sunlight, which we call Now, canst thou summon the shrouded Future to meet her there?"[10] Such is the extrapolation of seeing in the moonlight, of seeing not only ghosts but presentiments.

Hawthorne wrote in the daguerreotype heyday, and in *The House of the Seven Gables* created a daguerreotypist, making him a mysterious descendant of ancestors rumored to be wizards. But Holgrave, the austere daguerreotypist associated with mesmerists and curious ideas, serves mostly to point up Hawthorne's concern with new ways of seeing, say, the fleeting views of landscapes outside the windows of a speeding train. It is he who sees not only into the secrets of the human heart and into the crankiness of American society but into the secrets of the old house and its decaying garden. Holgrave sees the value implicit in built form, and in the end he literally plucks a secret—the long-lost deed to vast acreage in Maine—from a recess hidden behind a picture.[11] Simply put, Holgrave sees more deeply into ordinary things, perhaps because he uses different slants of light and shadow to steer his inquiries.

In the years before the Civil War, American daguerreotypists moved through utterly ordinary landscape, a national landscape new, almost raw, almost always lacking the legends and traditions of the ancient castles and villages of Europe, much to the despair of American writers. "Europe held forth the charms of storied and poetical association," reflected Washington Irving in his 1820 *Sketch Book*. "Her very ruins told the history of times gone by, and every mouldering stone was a chronicle. I longed to wander over the scenes of renowned achievement,—to tread, as it were, in the footsteps of antiquity,—to loiter about the ruined castle,—to meditate on the falling tower,—to escape, in short, from the commonplace realities of the present, and lose myself among the shadowy grandeurs of the past."[12] Irving wanted to walk in a landscape of shadows, of ever-present moonlight, but he found some traces of a usable past in the bits and pieces of colonial Dutch landscape enduring in New York. And slowly other Americans argued that the contemporary landscape, acutely viewed, might provide the stuff of art too. America, asserted William Cullen Bryant in the *North American Review* in 1825, "is at least the country of enterprise; and nowhere are the great objects that worthily interest the passions and call forth the exertions of men pursued with more devotion and perseverance."[13] The poet, the painter, the novelist might find in the raw, bustling landscape something of genuine artistic value, if only they would scrutinize it deeply enough.

In 1841 Ralph Waldo Emerson glimpsed the significance of that raw landscape

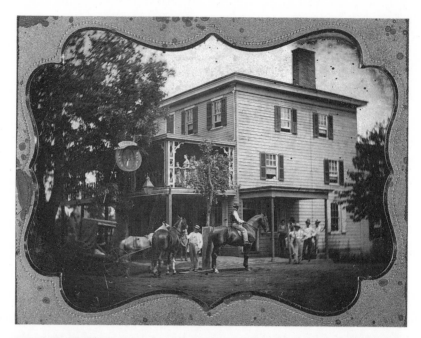

Figure 3.
Anonymous, quarter
plate. Penn Hotel.
Collection of Greg
French.

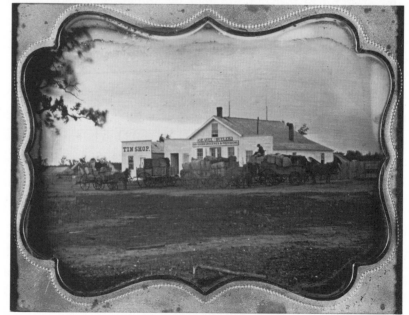

Figure 4.
Anonymous, quarter
plate. Rosemount,
Minnesota. Collection
of Matthew R.
Isenburg.

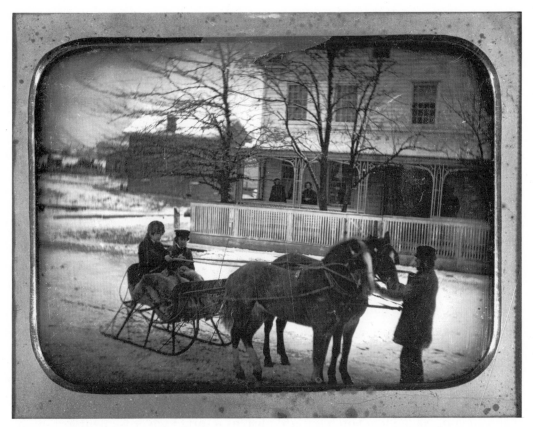

*Figure 5.
Anonymous, half plate.
Collection of Laddy
Kite.*

in the hearts of his compatriots and, perhaps, suggested that it meant more to some than the visages of loved ones. "And so why not draw for these times a portrait gallery?" he asked in his "Lecture on the Times." "Let us paint the painters." He argued that verbal descriptions of the congressmen, professors, editors, contemplative girls, reformers, and others would be documents of great historical value. But why the need of verbal description? Perhaps because contemporaneous daguerreotypists concentrated on landscape features, not portraits. "Whilst the Daguerreotypist, with camera-obscura and silver plate, begins now to traverse the land, let us set up our Camera also, and let the sun paint the people."[14] However puzzling the remark, it suggests that a landscape shaped from wilderness by enterprising Americans had a larger value than might be supposed, at least for the farmers, house-builders, and others who actually created fields and buildings, who took enormous pride in their work.

In the daguerreotypes assembled here nothing stands out more clearly than the importance of enterprise. The portraits reveal it, of course, the druggist with his mortar, pestle, and balance (plate 40), the miners with sluice box and pans (plate 4), the piano tuner with tuning fork (fig. 6), the farmer with hoe (plate 79), the bandsmen with instruments (plate 91). And beyond the portraits shimmer the action shots, the painter priming the scraped clapboards (plate 3), the steeplejacks high on their scaffolding (fig. 7). As Bryant so aptly pointed out, Americans lived to work, to build a strong, prosperous nation even as they advanced themselves. But so many of the other views demonstrate with equal strength the importance of structure, the forms erected from enterprise.

Consider that most ordinary of daguerreotype landscapes, that of the stable and daguerreotype studio (plate 19). Outside the stable stand the hands and horses and a water wagon. Nailed to a porch upright glistens a sort of advertisement, presumably daguerreotypes in frames, shielded only a little from the sun. What visual magic thrives in the scent of manure, the sound of champing horses? Were daguerreotypes often made in frame structures surrounded by litter? But it is this utter ordinariness that makes the view so potent. Something of genuine importance, and probably not the men or the horseflesh, stands built in the clearing. Two businesses, two enterprises.

So many of the views reproduced in this book depict immensely scruffy landscapes, landscapes seemingly beyond the power of moonlight, landscapes lit by whitest sunlight. The unpainted frame structures jammed together in a sea of loose boards (fig. 8) scream something of the rawness, the tenuousness of so much Ameri-

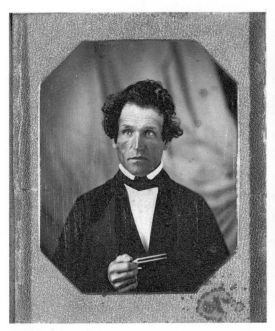

Figure 6.
Anonymous, sixth
plate. Collection of
Greg French.

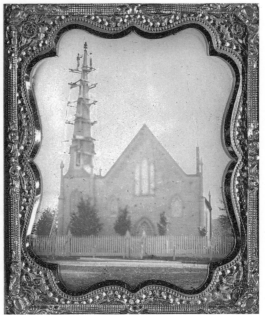

Figure 7.
Anonymous, sixth
plate. Collection of
Greg French.

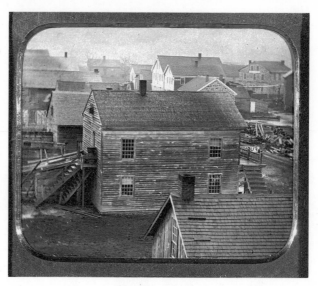

Figure 8.
Anonymous, sixth
plate. Collection of
Greg French.

can space in the 1850s, just as the winter street scene (plate 45) screeches with frigid starkness. Barrenness rules the New Hampshire valley (fig. 9) despite the flourishing orchard. The rocky hills loom over the farmstead, and few trees shade the road the traveler must follow. Against the sky and the leafless trees, the church building (plate 44) floats almost free of the bare ground, gigantic somehow, and detached from the nearby house. Where indeed is the magic of moonlight?

Thoreau found the magic in the very *depth* of the daguerreotype. "Nature is readily made to repeat herself in a thousand forms, and in the daguerreotype her own light is amanuenis, and the picture too has more than a surface significance,—a depth equal to the prospect,—so that the microscope may be applied to the one as the spy-glass to the other," he mused in a February 2, 1841, journal entry.[15] Here pulses the same energy of vision as that discerned years later by Holmes, an awareness that the daguerreotype rewards close scrutiny, almost begging for microscopic examination.

It is that vision which rewards us here, in spite of the fact that the daguerreotype landscapes are reproduced only photographically and cannot be held in our palms. After the 1860s, photographers caught only the surface of American landscape and often sought any but ordinary landscape to photograph. The photograph paled in importance, offering no magic at all, only accurate rendering. To be sure, the stereograph and stereoscope restored something of the magic of the daguerreotype to a

Figure 9.

Samuel Bemis, whole-plate. This is probably the best of the twenty-two landscapes Bemis made during the summer of 1840. Also ranking among the earliest of all photographic landscapes, it depicts the Mount Crawford House, Hart's Location, New Hampshire. It and a group of Bemis landscapes were discovered in 1980 at Bemis's home, which stands close to the spot where Bemis made this daguerreotype. Collection of Greg French.

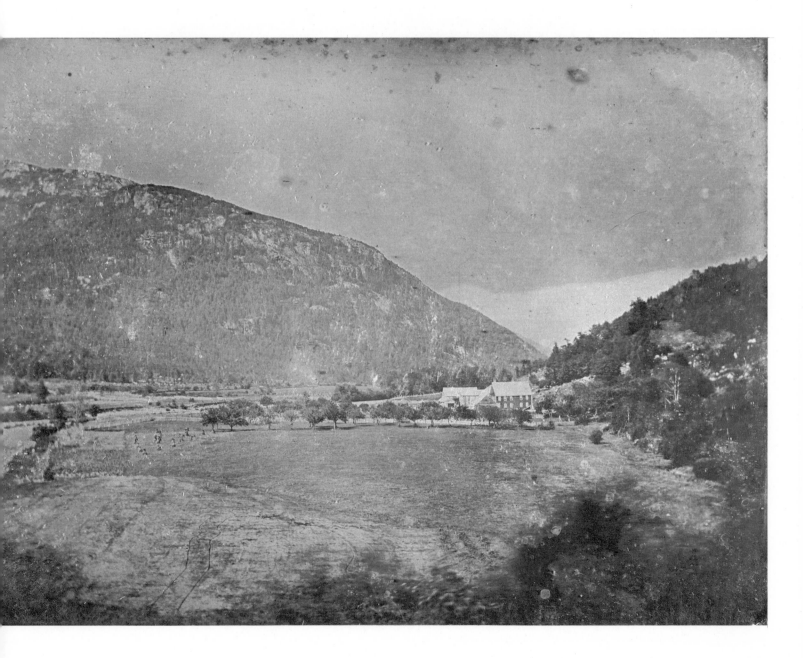

Figure 10.
Julius Brill, half plate.
Hudson River scene.
Collection of Matthew
R. Isenburg.

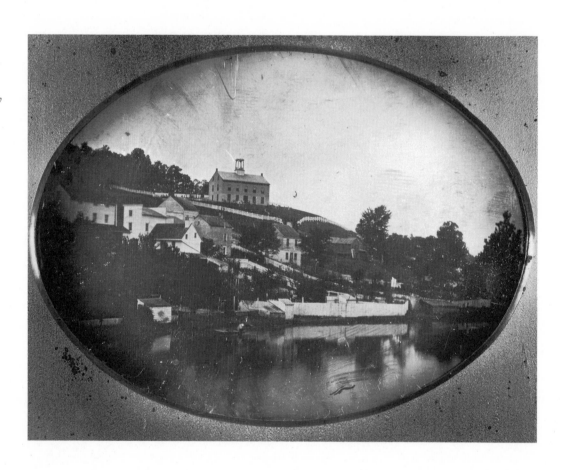

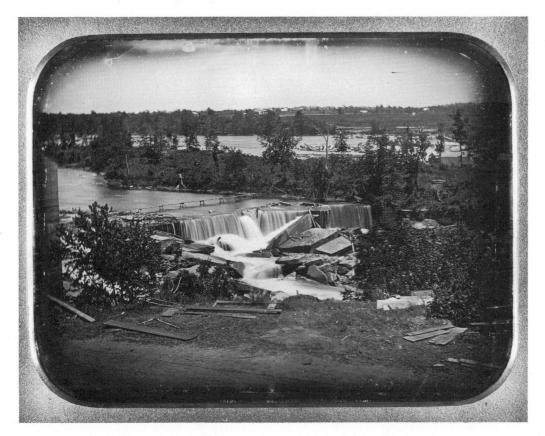

Figure 11.
Anonymous, half plate.
The St. Anthony Falls.
Collection of Charles
Isaacs.

public rapidly yawning over photographs, but the clumsiness of the stereoscope, even the hand-held one Holmes invented, failed to arrest the boredom.

Here these images remind us that the peculiar visual construct of the daguerreotype caught up landscapes every bit as uncannily as it caught visages, penetrating deeply into ordinary scenes and revealing the moonlit wonder of them. What the landscape images offer here is landscape in limbo, the stunning realization at the close of the twentieth century that in the middle of the nineteenth century photography became so ordinary that photographers avoided ordinary landscape. The photographic process blinded photographers to the moonlit limbo only the daguerreotypist perceived and, perhaps more frequently than we might ever have guessed, recorded.

NOTES

1. *Titus Andronicus*, III, 1, 149; *Paradise Lost*, III, 495.

2. Coleridge, "Limbo," *Poetical Works*, ed. James Dykes Campbell (London: Macmillan, 1898), pp. 189–90. *Dictionary of Buckish Slang... Eloquence* (London: Chappel, 1811).

3. Noah Webster, *American Dictionary* (Springfield, Mass.: Merriam, 1852), and Joseph E. Worcester, *Dictionary of the English Language* (1859; rpt. Boston: Brewer & Tileson, 1874) (italics added).

4. *Elsie Venner: A Romance of Destiny* (1859; rpt. Boston: Houghton Mifflin, 1891), p. ix.

5. "The Stereoscope and the Stereograph," *Atlantic Monthly*, June 1859, pp. 738–48.

6. This issue has received such extended treatment that only a mention suffices here. But see F. O. Matthiessen, *American Renaissance: Art and Expression in the Age of Emerson and Whitman* (New York: Oxford University Press, 1941).

7. "The Hall of Fantasy," *Works* (Boston: Houghton Mifflin, 1882), 2: 204.

8. *Works*, 5:54–56. See Darrel Abel, *The Moral Picturesque: Studies in Hawthorne's Fiction* (West Lafayette, Ind.: Purdue University Press, 1988), for a superb analysis of Hawthorne's understanding of the powers of light. See also Carol Shloss, *In Visible Light: Photography and the American Writer, 1840–1940* (New York: Oxford University Press, 1987), pp. 25–50, for an exceptionally cogent overview of Hawthorne's understanding of daguerreotypy.

9. *Works*, 2: 202; 1: 199; 2: 503.

10. *Works*, 1: 207.

11. *Works*, 3: 304, 374.

12. 1820; rpt. New York: Belford, Clarke, pp. 10–11. See also William Gilmore Simms, *Views and Reviews in American Literature, History, and Fiction*, ed. C. Hugh Holman (1845; rpt. Cambridge, Mass.: Harvard University Press, 1962), especially pp. 48–55.

13. William Cullen Bryant, "Review of Catherine Sedgwick's *Redwood*," *North American Review* 20 (April 1825): 245–72, especially 251–52. See also Emerson, "The Poet," *Essays: Second Series* (Philadelphia: McKay, 1892), pp. 23–24, 43–44, for another assertion of the usefulness of ordinary society and landscape for the poet.

14. Ralph Waldo Emerson, *Complete Works* (Boston: Houghton Mifflin, 1884), 1: 252.

15. Henry David Thoreau, *Journal*, ed. Bradford Torrey (Boston: Houghton Mifflin, 1906), 1: 189.

DAVID E. STANNARD

Sex, Death, and Daguerreotypes

TOWARD AN UNDERSTANDING OF IMAGE AS ELEGY

"Photography is an elegiac art, a twilight art," Susan Sontag has said, adding: "All photographs are *memento mori*. To take a photograph is to participate in another person's (or thing's) mortality, vulnerability, mutability. Precisely by slicing out this moment and freezing it, all photographs testify to time's relentless melt."[1]

In a sense—a somewhat different sense from what Sontag had in mind—all representational images of the immediate present, regardless of genre, are of course elegiac visions, are *memento mori* in that they become for future generations both reminders of the past and foreshadowings of what inevitably is to come. There is, however, a narrower definition of *memento mori*—the original meaning of the term—that is, the *purposeful* creation of imagery to serve as both memorial and harbinger. During the middle decades of the nineteenth century new forms of such imagery appeared all across America—on the rolling lawns of manicured cemeteries, in the parlors of the affluent, and in the pockets of the poor.

These elegiac images in statuary, painting, and daguerreotype seem peculiar to us today, even repellent. This is particularly true of the daguerreotypes, with their shocking clarity and immediacy, unfiltered and undisguised by any manipulative efforts of an artistic intermediary. No doubt our anxious reactions to these daguerreotypes are largely founded in the concealment and consequent invisibility of death—real death, not cinematic imitations of it—that have become the cultural rule in the late-twentieth-century world that we inhabit. Having institutionalized death and the final processes of dying, thereby banishing them as sensile phenomena from every-

Figure 1.
Anonymous, sixth
plate. Collection of
Julian Wolff.

day consciousness, we are appalled by any direct contact we are forced to have with them—contact that always was (and, indeed, still is) a common experience for most of humanity. Yet, to many viewers, even those living in this time and place where death and dying have become indecencies, these reproductions are not merely offensive. As John Wood has written, the daguerreotype images of the dead, especially those of children, also "haunt and disturb us like no previous time's images of death, other than perhaps the plaster molds of ash-engulfed Pompeians."[2]

Why should this be so? Why should the seemingly artless image of a corpse—reproduced on a few square inches of silvered copper plate by a mechanical mixture of iodine, chlorine, bromine, mercury, and light—in Wood's words, "so pain us and evoke our pity" despite our lack of any personal relationship with, or even knowledge of, the person so portrayed? Why, indeed, did the custom of daguerreotype postmortem portraiture arise in the first place? The answers to these questions reside in two places: the particular social and cultural world of nineteenth-century America, and—prior to that—the general history of funerary portraiture in the West.

Although neither culturally universal nor a constant even in the history of the dominant classes in Europe and America, explicitly created *memento mori* are among the most ancient examples of human artistic expression. At least nine thousand years ago people in the Jordan Valley and elsewhere used clay to remodel, and thereby memorialize, the features of the dead around the shape of the

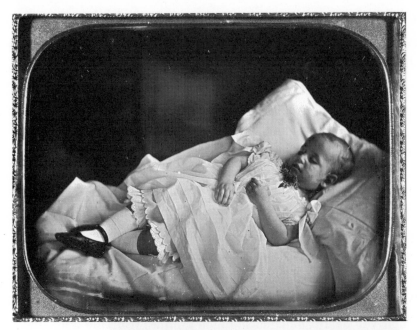

Figure 2.
Albert Southworth and
Josiah Hawes, quarter
plate. Collection of
Harold Gaffin.

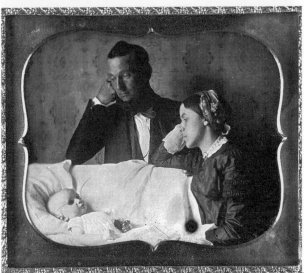

Figure 3.
Anonymous, sixth
plate. Collection of
Wm. B. Becker.

skull.[3] In Europe images of the deceased portrayed as they had been in life (some-
times at work, sometimes at play, often accompanied by representations of family
members and friends) adorned Roman tombs in the early centuries A.D. In a world
in which the individual mattered—at least the individual of consequence—the per-
sonal imagery on the tomb was intended, says historian Philippe Ariès, "to recall the
physical appearance of the man, the symbol of his personality."[4]

From the fifth through the twelfth centuries, a time characterized by Ariès as the era of "tame death," when the individual's fate had become subordinate to that of the Christian collectivity, this custom of tomb decoration largely fell into disuse. "No longer do the secular lines of kinship and family converge on the gravestones," writes Brent D. Shaw of this period when, as Machiavelli once said, "men who had been called Caesar and Pompey, now became Johns and Peters and Matthews."[5] Adds Peter Brown:

> No longer did the monuments of the dead use the tomb to speak volubly to the city about the things of the city. . . . No longer do Roman soldiers stolidly clutch the standards or ride down conquered barbarians. No longer does a lady toy with her jewelry as she reaches down a hand to pat a small dog. No longer do we see small boys, each dressed in a carefully folded toga, clutching their scroll with hand outstretched, solemnly orating, as they had once done, before the black envy of death snatched so much promise from the city.[6]

During the early centuries A.D., before what Ariès calls this culture of "anonymity" had taken hold, the Roman world had been sharply divided in its attitudes toward the body and sexuality. Although the notion of non-Christian Rome as, in one historian's phrase, an "Eden of the unrepressed" is now recognized as an exaggeration, it is understandable why it would seem to have been a world of open debauchery when viewed in contrast with the furious renunciation of the body and its uses that gripped the early Christians. An intense belief in predestination, combined with a repugnant attitude toward the pleasures of the flesh and of all worldly things compared with the glories for all saved Christians of the spiritual hereafter, led early Catholicism to a fanatical rejection of life and a joyous celebration of death, a combination whose outward manifestations ranged from monastic asceticism (including, in extreme instances, self-castration and flagellation) to what Saint Augustine was forced to condemn as the "daily sport" of suicide cults.[7] Clearly, there was no place in this world for celebratory, individualistic funerary monuments or for sorrowful artistic representations of those who had passed away. Thus, with the political and economic decline of Rome and the parallel rise to influence of this extreme form of early Christianity, came what Jacques le Goff has called *la déroute du corporel*—"the rout of the body"—in European thought and belief. In retrospect, then, it should not be surprising to find during this same era an absence of imagery of the dead across the length and breadth of the continent.[8]

By the middle of the thirteenth century, however, the teachings of church leaders had begun to suggest subtle changes in Christianity's attitudes toward the body. The routine ascetic rejection of the human body as an object of importance had paradoxically produced an extraordinarily sensual fascination with one particular body—Christ's. As one historian bluntly puts it: "They loved Christ bleeding." Thus, with evident rapture, Saint Bonaventure urged his readers to "contemplate the drops of blood, the blows in the face, the persistence of the whip, the crown of thorns, the derision and spitting, the hammering of the nails into the palms and the feet, the raising of the cross, the twisted face, the discolored mouth, the bitterness of the sponge, the head hanging with all its weight, the atrocious death."[9] Growing concern over the meaning of individual postmortem resurrection—was there to be an actual physical resurrection of the body, the despised body, at all?—had meanwhile forced Bonaventure's contemporary, Thomas Aquinas, to argue forcefully that, yes, following death the individual's "selfsame body" would indeed be united with his or her "selfsame soul."[10]

If the *memento mori* of the nineteenth century that we shall soon be discussing seem strange to us today, those that emerged during the centuries following Bonaventure and Aquinas—especially during the later Middle Ages—are at least doubly so. That is because of what one historian has called their "strange preoccupation with putrefaction."[11] Influenced, no doubt, by the horrific depredations of the fourteenth-century Black Death, in the world of artistic expression medieval Catholic theology expanded the early church's ascetic notion of the *contemptus mundi*, the ritualistic rejection of earthly vanities, but did so with a strange and almost prurient vengeance. Thus, in ritualistically demonstrating their public conviction that death was truly the great leveler and the flesh an object of ultimate insignificance and even repugnance, medieval sculptors, painters, and their patrons throughout fourteenth-, fifteenth-, and early-sixteenth-century Europe produced an orgy of *memento mori* that exhibited an obsession with the graphic details of postmortem decomposition.[12]

But why exhibit such an attitude—obsession or not—at all? Why not maintain the same silence on the subject that had shrouded Europe since the fall of Rome? At least part of the answer becomes evident when one recognizes that the fashion of the macabre in art and literature emerged not only in the wake of the worst epidemiological disaster in human memory, when many thought the world was coming to an end, it also occurred at the same time that artistic expression, and cultural behavior in general, was moving toward a new appreciation of the body that, in its near

Figure 4.
Mathias Grunewald,
fifteenth century. "The
Damnation of Lovers."
Collection of the
Strasbourg Cathedral
Museum.

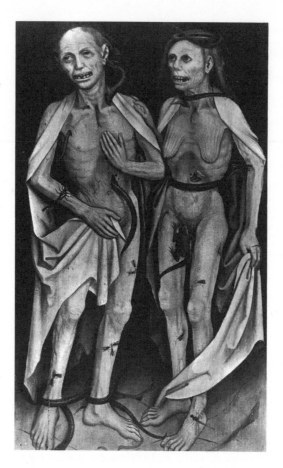

narcissism (consider, for one example among many, Dürer's numerous and un-precedented self-portraits, including graphic nudes), had not been seen in Europe for literally a millennium.

In the very same medieval era that found the fashionable Italian writer Poggio describing uninhibited public bathing in northern Switzerland, where naked men and women mingled together "singing, drinking, and dancing," and where "it was charming to see young girls, already ripe for marriage, in the fullness of their nubile forms . . . standing and moving like goddesses" in the water, England's John Brom-yard was describing the scene that awaited such people once their lives were ended: "In place of scented baths, their body shall have a narrow pit in the earth, and there they shall have a bath more foul than any bath of pitch and sulphur. In place of a soft couch, they shall have a bed more grievous and hard than all the nails and spikes in the world. . . . Instead of wives, they shall have toads; instead of a great retinue and throng of followers, their body shall have a throng of worms and their soul a throng of demons."[13]

Putting aside the obvious and important elements of national difference and class antagonism in such literature, there remains in such writings, as well as in the visual arts, a powerful contrast between prescribed sensual images of the body in life and in death that is remindful of the contrast in such attitudes that existed between Christians and non-Christians in the Rome of late antiquity. What we see here in miniature, then, are the lineaments of a dilemma that tormented Europeans in that historical moment, but one that, in other forms, has also afflicted other peoples at other times: the predicament of trying to reconcile powerfully opposing impulses regarding a fundamental problem that are emerging almost simultaneously from a common cultural tradition. In the present example, added to the enormous psychological burden created by the demographic disasters and religious upheavals of the thirteenth and fourteenth centuries, the people of this time and place were living through one of those monumental ages of social change that was then giving birth to nothing less than the modern idea of the individual.[14]

The era beginning in the twelfth and thirteenth centuries was the time Ariès describes as "the death of the self," in contrast with the preceding epoch's "anonymous" world of "tamed death." The Last Judgment, with its focus on the individual's responsibility through the exercise of "free will" to effect her or his ultimate fate, took on intense emphasis during this time. Masses for the dead were gradually converted from occasional ceremonies for the collectivity to everyday rituals designed to affect the fates of individual souls. And the Roman practice of leaving detailed, personal written wills reappeared in the secular culture of this time, though often such wills were used primarily only to guarantee that the desired expenditures for one's own lavish funeral would indeed be spent.

This, then, was the medieval world that gave rise to such peculiar—to us—funerary art. What now may appear as perverse and ghastly artistic portrayals of the dead may seem at least somewhat less troubling because more understandable, when they are recognized as the productions of a people in cultural and psychological crisis over the changing meaning of the most fundamental aspects of their lives: their religious beliefs, their survivability in a social world shattered by epidemic disease, their attitudes toward sensuality and the human body, and their basic sense of themselves as singular persons. These are matters, as we shall see, that came to weigh heavily on nineteenth-century minds as well.

Although occasional examples of macabre tomb sculpture and painting appeared in England as late as the eighteenth century, as a fashion the theme

began to wane with the fading of the later Middle Ages and, following the Reformation, with the weakening of Catholic asceticism's hold on European consciousness. But once the ancient practice of representing the dead in funerary portraiture had taken hold again, it would in different forms continue into the nineteenth century except, briefly, in England and North America under the influence of Puritanism. In keeping with the new importance of the unique individual following the Renaissance, however, whereas medieval representations of the dead in *memento mori* tended to rely on generalized imagery and rarely portrayed the visage of an actual and specific person (the exceptions being royalty), by the sixteenth century it was becoming common for artists to produce representational images of individual corpses in painting, sculpture, and death mask.[15] While death masks usually were executed as soon after death as possible, in time it became popular to have them made prior to death—perhaps because those that were taken following death were sometimes done later than one might hope: Dürer's body, for example, was exhumed by admirers three days after his death in 1528 to have wax casts made of his face and hands.[16]

Thousands of funeral portraits, realistic paintings of the deceased on his or her bed or bier or in the coffin, were produced in all the countries of Europe from the sixteenth through the nineteenth centuries by artists unknown and famous alike—from Van Dyck, who painted a number of postmortem scenes, to Van Gogh, whose early work contains a striking 1881 drawing of a dead woman. Similar though these paintings were in thematic content, the particular styles reflected not only individual artistic differences but also national tastes and the historical moment. Unique to sixteenth- and seventeenth-century Scotland, for instance, were so-called vendetta portraits representing (usually quite graphically) the postmortem image of someone who had died a violent death at the hands of someone else and carrying a legend urging relatives to avenge the death. Similar portraits, although without the written demand for revenge, appeared in seventeenth- and eighteenth-century Hungarian family portrait galleries: in an effort to honor the family dead who were killed in battle, the deceased were vividly depicted with their bodies slashed open or torn apart by cannonballs. In Hungary generally, however, a solemn formality required that postmortem portraits depict the deceased attired and posed with as much dignity as was possible under the circumstances. As Anton Pigler has observed: "While German, Netherlandish, and English examples frequently show their subjects in shroud, even in dressing-gown or night-cap, in dishabille, as it were, this feature is never met with on Hungarian representations."[17]

In many cases postmortem portraits were the only images of the deceased that family members would possess, in the absence of portraits painted during a lifetime. Oftentimes in such cases painted portraits were only a prelude to a sculptured likeness of the dead loved one for the family tomb. As one sixteenth-century husband wrote in a letter following his wife's death: "I wish to have a counterfeit of my wife who died in God, so that her form may be carved on her tombstone in the future; hence we sent for a painter to Kassa. . . . Only such resemblance is needed that there should be some representation of her face and condition, so that the sculptor could carve it in stone." For those families residing outside the urban centers of the continent, time often was of the essence in locating a portraitist. Thus the concern of the seventeenth-century mother who wrote to a correspondent after the death of her young son: "The painter has not arrived yet. I wish he would come soon, because the face of the poor little lord is changing mightily."[18]

The distinctive feature of this postmortem artistic fashion, compared with those of others in different times or places, is the very realistic depiction of the specific deceased individual as she or he actually appeared immediately following death. Tomb sculpture among pleasure-loving Romans, in an effort to capture for survivors the memory of the dead individual as he or she behaved when among them, portrayed the deceased retrospectively, engaged in the joyous or heroic activities of life. Medieval *memento mori*, in contrast, depicted the deceased as dead—indeed, often as long-dead and partially decomposed—but such works often reanimated these horrific images in order to show (as lessons for the living) their postmortem spiritual sufferings.[19] It is only in this early modern work—when the individual is recognized as unique, and the postmortem state of the individual as corpse (and not reanimated in some form or other) is acceptable for artistic memorialization—that such straightforward representations occur. They are artifacts of a time when religious belief was relatively secure, if somewhat somber, but when individualism was sufficiently intense (as contrasted, for example, with Ariès's "anonymous" centuries of late antiquity) that postmortem memorialization served in a sense as a hedge against personal annihilation and the eternal loss of a loved one.

In the Puritan-dominated American colonies during the seventeenth and early eighteenth centuries there is little or no evidence of postmortem portraiture resembling the type we have been discussing, presumably because of the Puritans' longstanding attitude of iconoclasm combined with their Calvinistic insistence on the irrelevance of the body following death.[20] In England the Puritans had campaigned vigorously against any "graven imagery" suggestive of Rome: raiding parties of self-

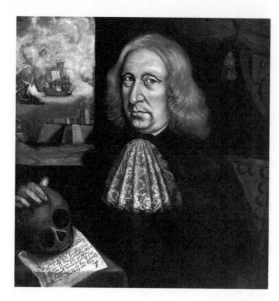

Figure 5.
Captain Thomas
Smith, late seventeenth
century. "Self-Portrait."
Collection of the
Worcester Art Museum,
Worcester,
Massachusetts.

appointed saints swept across Britain in the sixteenth and seventeenth centuries, destroying and defacing tombstones containing any forbidden carvings—including portraitlike representations of the dead.[21] The New World Puritans were, therefore, hardly likely to be any more tolerant.

To be sure, *memento mori* abounded in the death's-heads, urns, scythes, and doused torches that decorated seventeenth-century American tombstones and other objects—from funeral jewelry to children's schoolbooks—but these were abstract typological and secular images, not efforts to render a portrait of the deceased as deceased or other "monuments of superstition" that might be reminiscent of Catholic belief.[22] Also, while colonial portraits of the living sometimes did contain elements suggestive of death, such as the skull being cradled in Captain Thomas Smith's self-portrait of 1690 and the tasseled curtain in the picture's background—open now, but ever ready to ring the close to the good captain's life—these too were the conventional trappings of acceptable *memento mori* and were of an entirely different genre from the postmortem portraits then popular in Europe.

In the mid- and latter-eighteenth century, once the influence of Puritanism had gone into decline, lifelike images of the dead at last did begin appearing on American tombstones, representations quite clearly modeled on the actual appearance of the deceased while alive. This fashion, deriving in part from the contemporaneous popularity in England of the portrait bust, first appeared in America in the South, where Charleston's wealthy merchants were quicker to appropriate metropolitan fashion than were their colonial brethren to the north.[23] But in these carvings no

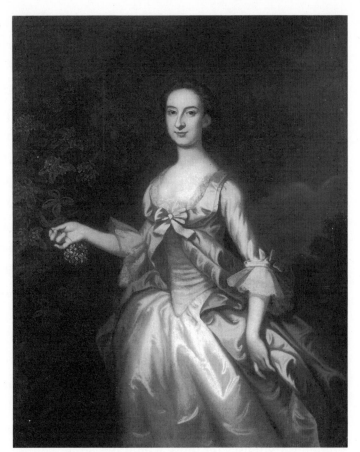

Figure 6.
John Wollaston, circa
1755–1758. "Miss
Elizabeth Wormsley
Spottswood Carter."
Collection of Mr. and
Mrs. Edward Rulon-
Miller.

effort was made to realistically portray the individuals as dead, nor is there evidence to suggest that the images themselves were derived from postmortem portraits. The first such step in this direction—in distinctly romantic form—appears in certain mid-eighteenth-century paintings, such as that of Elizabeth Wormsley Spottswood Carter by John Wollaston, executed in the late 1750s. Although the figure of Elizabeth Carter itself gives no indication of death, the overall tone of the portrait and the symbolic image of the cut branch and flower she is holding indicate that she has died a youthful death, but they also point to the certainty of life's bloom continuing for her in the hereafter. Such images soon became commonplace in the then-emerging genre of American mourning portraiture, just as their parallel symbols on gravestone markers had begun to appear by this time and also would become dominant motifs in nineteenth-century funerary art. It is into this artistic environment that American postmortem portraiture, in painting, sculpture, and daguerreotype, finally emerged.

Just as the macabre portraiture of the Middle Ages took the form that it did in a specific social and religious as well as artistic milieu, while the postmortem paintings produced in European countries from the sixteenth through the nineteenth centuries also derived their particular characteristics from their own particular cultures, so too did the American postmortem portrait grow from its own indigenous environment to develop its own cultural peculiarities.

The early nineteenth century, when postmortem portraiture first became truly popular in America, was a time of extraordinary social, demographic, and cultural upheaval. The population of the country more than tripled between the 1790s and the 1830s and would triple again by the mid-1860s. Even more tellingly, in 1790 only a dozen communities in the United States contained more than 5,000 residents; by 1830 there were 56 such communities; and by 1860 there were 229—a nearly twentyfold increase in the country's level of urbanization within the lifespan of a single individual. Cities emerged seemingly overnight, up and down the Eastern seaboard, as immigrants poured in to inhabit them—three-quarters of a million between 1832 and 1841 alone. As the cities grew, so too did the gap between the richest and poorest of their inhabitants. Formal institutions by the score were created to care for the weak, the dangerous, and the deviant. Almshouses, hospitals, prisons, and asylums—nonexistent during colonial times, because unnecessary—became human warehouses for those whom the larger community rejected.

As the institutionalization of community life increased, so too did the distance of middle- and working-class family units from the communities within which they traditionally had been integrated. Male and female gender roles polarized in this rapidly industrializing society as the workplace, whether factory or office or shop, moved farther and farther from the home—and the home, whenever possible, became in idealized retreat from the workaday world. In short, with the rise of industrial capitalism a new space that in time would become a chasm was forming between the public and private realms. And in the public realm a new version of the ideology of individualism was forming, a version that in practice often became punishingly competitive, avaricious, rapacious—and associated with life in the city. As John Todd, writing in 1841, warned: "Wealth and Fashion are the deities which preside over the great city. . . . [There] you see the young, the ardent, the keen, and the gifted, rushing into these great marts of nations, to court the smiles of Mammon. . . . Your acquaintances come and go,—are here to-day, and off to-morrow, and you have hardly time, or opportunity, to form deep attachments. The unceasing hurry,

and perpetual pressure for time, prevent our forming those deep attachments which we do in country life."[24]

The private realm, in contrast, took on a defensive ideology of refuge—rural refuge. As another mid-nineteenth-century writer put it: "From the corroding cares of business, from the hard toil and frequent disappointments of the day, men retreat to the bosoms of their families, and there, in the midst of that sweet society of wife and children and friends, receive a rich reward for their industry. . . . The feeling that here, in one little spot, his best enjoyments are concentrated . . . gives a wholesome tendency to [a man's] thoughts, and is like the healing oil poured upon the wounds and bruises of the spirit."[25]

This same sort of romantic, rural sentimentalism reached out from the family and affected everything the family touched—from birth to death to the religious sensibility and embraced them both. If the family—especially the rural family—had come to be idealized as a refuge from the world, death was coming to be idealized as a refuge from life. Writing in the 1830s, John Pierpont, a well-known celebrant of life's cessation, described a place not coincidentally similar to the ideology of hearth and home: "Death lays his hand upon the burning brow," he wrote, "and it is cool. He touches the aching heart, and its pain is gone; and upon the whole frame that is wracked with agony, he sprinkles his cold dew, and all is still." Indeed, in a passage not unreminiscent of the suicidal urgings of early Christianity and its rejection of earthly pleasures, Pierpont claimed that humans would be so unrestrainedly desirous of death if they truly understood the wonders of the afterlife that God had been forced to create a natural fear of death to "keep [them] from rushing uncalled into his presence, leaving undone the work which he has given them to do."[26]

That was one side of the new cult of death and dying. In a workaday world of increasing alienation on numerous levels of experience where, as John Todd had put it, "your acquaintances come and go . . . and you have hardly time, or opportunity, to form deep attachments," there was nothing, wrote another commentator of the time, "which wrings the heart of the dying—aye, and the surviving— with sharper agony, than the thought, that they are to sleep their last sleep in the land of strangers."[27] On the other side there were those—"and they are not a few," wrote the famous Harriet Martineau in 1838—"who are entirely doubtful about a life beyond the grave":

Such persons can meet nothing congenial with their emotions in any cemeteries that I know of; and they must feel doubly desolate when, as bereaved mourners, they walk through rows of inscriptions which all breathe more than hope, certainty of renewed life and intercourse, under circumstances which seem to be reckoned on as ascertained. How strange it must be to read of the trumpet and the clouds, of the tribunal and the choirs of saints, as literal realities, expected like the next morning's sunrise, and awaited as undoubtedly as the stroke of death, while they are sending their thoughts abroad meekly, anxiously, imploringly, through the universe, and diving into the deepest abysses of their own spirits to find a resting-place for their timid hopes! For such there is little sympathy anywhere, and something very like mockery in the language of the tombs.[28]

During the preceding half-century many Americans' religious sensibilities had been unsettled by the rise of heretical groups of freethinkers and other anti-Christian militant rationalists as well as by the emergence of liberal Christian thinking such as that espoused by what Emerson had referred to as "corpse-cold Unitarianism." In an intellectual climate, at least among urban elites, that had become fascinated with quantification and that was everywhere displaying what one historian has called the era's "rage for classification," there was nothing that any longer needed to be accepted on faith or consigned to permanent mystery. As Henry Adams later reflected on those days and on "the mental calm of the Unitarian clergy": "For them, difficulties might be ignored; doubts were a waste of thought; nothing exacted solution. Boston had solved the universe."[29]

Not everyone, however, was convinced. Indeed, relatively few were. But they were not unaffected by the threats to traditional piety that could be seen and felt all around them. Sects and cults and revivals exploded across the American landscape during the first half of the nineteenth century as if in response to the dispassionate logic of skepticism that was insinuating itself into the life of the mind. This was America's post-Enlightenment consciousness, pulling in opposite directions and, for one of the first times in human history, trying to cope with what Francisco José Moreno has called the "basic fear" engendered by the rise of modern Western rationalism: the deep disquietude that "results from the inability of our reason to provide us with proper reassurance against the very same problems it raises."[30]

The slow deterioration of unquestioned religious faith, the rise of a new form of intense individualism, and the disintegration of idealized communal values—some

of the same phenomena, albeit in quite different form, that had served as the threshold for the revolution in the Middle Ages' representations of the dead—were at the heart of America's new Victorian vision of mortality. But so too were other concerns that had troubled medieval minds: the frailty of human life, brought powerfully to consciousness by the sudden eruption of epidemic disease, and the place of sensuality—the proper uses and meanings of intimacy and the body.

Since the middle of the eighteenth century tuberculosis had been dramatically on the increase in Britain, Europe, and America. By the turn of the nineteenth century half the population of England had the disease and nearly a third of London's deaths were caused by it. In England as well as in America the early nineteenth century saw tuberculosis mortality rise to a level never attained before or since. Death rates from TB, certain forms of which are now known to be as contagious as measles, were especially high where conditions were crowded. In just a decade and a half, between 1830 and 1845, 10 to 20 percent of America's prison population died from the disease. Similar conditions existed among the burgeoning masses in the cities, though the terrible damage of what came to be called "the great white plague" was by no means confined to urban areas.[31]

Particularly hard hit by tuberculosis (then tellingly known as consumption) were women and the young. Children under the age of five and young adults in their late teens and early twenties had the highest case mortality rates; worst off of all were infants in the first year of life, more than half of whom found to be infected soon succumbed to the disease.[32] One result of this was the romanticization of tuberculosis. When not identified with the evils of urban life, the disease became associated with the bright, the young, the attractive. The outward symptoms—delicate frailty, paleness, glistening eyes—became synonymous with beauty, so much so in fact that "the ill," wrote one observer, "are studiously copied as models of female attractiveness."[33] With his poem "Consumption," William Cullen Bryant was but one of scores of literary figures to celebrate the physical virtues of the tubercular:

> Ay, thou art for the grave; thy glances shine
> Too bright to shine long; . . .
> And they who love thee wait in anxious grief
> Till the slow plague shall bring the fatal hour.
> Glide softly to thy rest, then; Death should come
> Gently, to one of gentle mood like thee,
> As light winds wandering through groves of bloom

Detach the delicate blossom from the tree.
Close thy sweet eyes, calmly and without pain.

In the summer of 1832 another disease made its presence known. This one, however, would not become the subject for poetry. Neither its symptoms (diarrhea, vomiting, acute cramps, dehydration) nor its progress (death within a day, perhaps hours, of onset) lent themselves to lyricism. Cholera tore through America's Eastern cities in 1832 and 1833 and 1834. In New York alone, writes historian Charles E. Rosenberg:

> Cartloads of coffins rumbled through the streets, and when filled, returned through the streets to the cemeteries. Dead bodies lay unburied in the gutters, and coffin-makers had to work on the Sabbath to supply the demand. Charles G. Finney, the evangelist, recalled having seen five hearses drawn up at the same time at different houses within sight of his door. Harsh smoke from burning clothes and bedding filled the air, mingling with the acrid fumes of burning tar, pitch, and other time-tested preventives. Houses stood empty, prey to dust, burglary, and vandalism.[34]

Panic spread everywhere. Suspected carriers of infection were murdered in Pennsylvania. Roadblocks were set up in Rhode Island. City streets and entire small towns became deserted. In New Orleans alone five thousand people died. "Cholera," notes Rosenberg, "was the classic epidemic disease of the nineteenth century, as plague had been of the fourteenth."[35] In other ways as well the comparison of the fourteenth and nineteenth centuries is apt.

Since at least the second half of the eighteenth century a certain new disquietude had arisen in the Western world over the nature of the body and the proper regard that should be shown to the remains of the dead. The seventeenth century had witnessed a true scientific revolution in the field of biology with the anatomical research of William Harvey, and by the middle of the eighteenth century—following the 1752 passage of an act of Parliament allowing English judges to substitute dissection for gibbeting as a postmortem punishment for executed murderers—there was a great demand for corpses in the rapidly growing hospitals and anatomy schools of the British Empire.[36] There was also, in response, a great popular uproar of resistance. Riots broke out at hangings as mobs struggled to prevent the delivery of the dead to the dissection chambers.[37] Hogarth, in the final panel of his *Cruelty* series, captured the mood perfectly: the man who had been a tormentor in life now

suffers institutional torment in death by being dissected and disemboweled. Many people, of all classes, were horrified at the anatomists' violation of the body, no matter how heinous the subject's crime. Their horror was only heightened when it became widely known that convicted murderers were not the only victims of the anatomist's knife.

"If the horrid traffic in human flesh be not, by some means or other, prevented," warned Britain's leading medical journal, *Lancet*, in 1829, "the churchyards will not be secure against the shovel of the midnight plunderer, nor the public against the dagger of the midnight assassin."[38] So great were the medical and anatomy schools' demands for corpses by the 1820s and 1830s—in America as well as in Britain—that a thriving commerce in bodies had developed. First, as the *Lancet* editorial indicated, there was grave robbing; then there was "Burking"—murder to obtain corpses to be sold for dissection—named for William Burke, the most famous practitioner of the crime, who peddled sixteen of his victims to private anatomy clinics before being caught. Although clearly sources of legitimate concern, grave robbing and murder as methods of supplying anatomists with their needed cadavers caused public fear that was greatly disproportionate to the actual danger. What matters in the present context, however, is less the reality underlying the fear than the fear itself.

Similarly, the reverse of the fear of postmortem butchery—the fear of premature burial—existed well out of proportion to reality. The concern became a panic in some places in the wake of the cholera epidemics, especially when authorities understandably pressed for rapid burial following death from cholera in order to minimize the spread of infection. For cholera commonly did prematurely mimic the symptoms of death—a bluish discoloration and chilling of the flesh, stiffness from muscular spasm, and heartbeat and breathing rates reduced to imperceptibility—to the extent that cases did exist of people who survived medical diagnoses of death.[39] Edgar Allan Poe was no doubt indulging in a good bit of literary license when, in introducing his popular short story "The Premature Burial," he asserted that due to "the well-known occurrence of such cases of suspended animation . . . we have the direct testimony of medical and ordinary experience to prove that a vast number of such interments have actually taken place." ("I might refer at once," he added, "if necessary, to a hundred well-authenticated instances.") But literary license or not, enough people were convinced of the reality of the problem that the federal patent office in the nineteenth century was flooded with designs for coffins that allowed the unfortunate victims of premature burial to signal (usually with flags, bells, or whistles) to those above ground that they had not died and had in fact just now awakened

from a state of suspended animation. Such patents were filed alongside other designs for coffins that used everything from cement to explosives to prevent disinterment by grave robbers.[40]

Pathetic and silly though much of this may seem to us today, it is well to remember that these popular behaviors were genuine reactions to dramatically changing attitudes toward the human body that had first begun to emerge in the middle of the eighteenth century. If Aquinas's thirteenth-century pronouncements on the relationship between the body and the soul were one early signal of what would become a revolution in the medieval world's attitudes toward both sensuality and the corpse, perhaps the equivalent statement for the Victorian upheaval in attitudes was found in the obscure words of surgeon William Hunter in his introductory lecture on anatomy at St. Thomas's Hospital in 1780: "Anatomy is the basis of surgery," he said, "it informs the Head, guides the hand, and familiarizes the heart to a kind of necessary Inhumanity."[41] It was that "necessary Inhumanity" in the name of scientific progress that turned the corpse into both an object and a commodity and that, in other realms, began the modern process of dehumanization in the name of efficiency.

Confusion and apprehension about the proper meaning and usage and treatment of the body were not limited, of course, to the dissection room and the burial ground. It was rife, as well, in the bedroom. Traditionally the Victorian era, in both America and Britain, has been viewed as one of sexual repression and prudery. In recent years, however, that notion has been vigorously criticized and the age has now even been characterized as the seedbed of the first great "sexual revolution" in modern times.[42] Both of these descriptions are caricatures, but not because neither is correct. Rather, they are caricatures only when either of them does not allow room for the other, because both portrayals are accurate: the half-dozen or so decades that spanned the middle of the nineteenth century in America were a time of severe sexual repression *and* robust sexual exploration.

Only when considered out of context, without reference to the tumultuous social changes then in progress in America, does it seem paradoxical that at the same time the English traveler Frederick Marryat was entertaining his readers with a description of the American schoolmarm who covered the legs of the school's piano with "modest little trousers" to conceal their indecency, other Americans were entertaining themselves with smuggled-in copies of the 1828 pornographic novel *The Lustful Turk*.[43] As historians such as Nancy F. Cott, Carl N. Degler, and Peter Gay have shown, sensual life in America during the mid-nineteenth century was struggling through a period of fundamental transformation, one in which some women

were adopting for themselves an ideology of "passionlessness" as part of the quest for freedom from sexual subordination, while other women were recording in their diaries their "sweet communions" of orgasm and recalling "over and over, that 'same beautiful feeling of climax I know so well.'"[44]

As we turn now to look at the funerary portraiture of this time—in particular, to those disturbing postmortem daguerreotypes—we might recall the words used earlier to summarize the social environment within which the bizarre funerary art of the Middle Ages emerged; it was a time of "cultural and psychological crisis over the changing meaning of the most fundamental aspects of their lives: their religious beliefs, their survivability in a social world shattered by epidemic disease, their attitudes toward sensuality and the human body, and their basic sense of themselves as singular persons."

"Telling you of Joshua and Edna—I am obliged to sadden your heart—they have lost their little Camille—she is dead—the sweet beautiful babe is dead." So wrote artist Shepard Alonzo Mount to his son William Shepard Mount in 1868. He went on:

> She died from the effects of teathing. It so happened—Providentelly I
> thought—that I was at Glen Cove—and for two or three days before she died.
> I made several drawings of her, which enabled me, as soon as she was buried
> to commence a portrait of her and in 7 days I succeeded in finishing one of the
> best portraits of a child that I ever painted. All the family seemed surprised,
> and delighted with it. And to me it was real joy, to have been the instrument of
> affording so much comfort to all. Joshua and Edna would sit before it for an
> hour together. And Mr. and Mrs. Searing are in raptures with it. I have
> framed it and hung it up for all to see and love—for next to the dear babe
> herself—it is now the idol of the family.[45]

Mount's initial sketches of Camille may, as the artist says, have been done while the child was still alive. But the preliminary drawings that survive depict Camille with her eyes closed and clearly moribund, if not already dead.[46] The completed portrait that became "the idol of the family," however, depicts a wide-eyed, lifelike child whose postmortem state is signaled only by the symbols surrounding her: clouds, the morning star, and her grandfather's watch which, Mount's letter later states, has its "hands pointing to the hour of her birth."

Mourning portraits of this type were designed to provide families with vivid,

Figure 7.
Shepard Alonzo
Mount, 1868. "A
Portrait of Camille."
Collection of the
Museums at Stony
Brook, Stony Brook,
New York; bequest of
Dorothy DeBevoise
Mount, 1959.

likelike images of the deceased (Mount measured little Camille's head with calipers and made marginal notes on his sketches to remind him of the exact hue of her eyes and the shade of her complexion), but they also were intended to serve as unmistakable *memento mori*. Thus, many families deemed it essential that such paintings contain symbols that signaled to the viewer that the lively subject before them was in fact dead. As Phoebe Lloyd has shown in her pioneering essay on posthumous mourning portraiture in America, Shepard Alonzo Mount and his brother William Sidney Mount were experts in the use of relatively subtle and individualized death symbolism.[47] (Camille "was in the habit of holding her grandfather's watch to her ear," Shepard Alonzo Mount noted in his letter to his son, "and all others who came around her did the same." Thus the watch, with its private meaning to the family and its publicly accessible symbolism, became the portrait's ideal emblem of mortality.) Other painters of the time were likely to be more heavy-handed, using weeping willows, broken-stemmed roses, or even (to quell all doubt) tombs in the backgrounds of their portraits.

But then, the Mounts had plenty of practice. Although William Sidney Mount

was known to protest that he wished to paint no more corpses ("I don't believe in Vaults," he said), they did provide him with his best—and sometimes only—commissions. "At times, it did appear as if my only patron was death," he once wrote to an acquaintance, "therefore, consider death not as an enemy, but as a friend." It was an attitude bolstered by the fact that, like many involved in the craft, he charged twice as much to paint the dead as he did to paint the living.[48]

There was little, in fact, that was inexpensive about this era's outpouring of mourning ritual, including the veils, gowns, bonnets, gloves, handkerchiefs, fans, calling cards, stationery, rings, bracelets, lockets, snuffboxes, spoons, pitchers, urns, platters, sheet music ("Fairest Flower So Palely Drooping" and "Cradle's Empty, Baby's Gone" were typical titles), and other common accouterments of the Victorian funeral in America. As we have seen, death was often celebrated at this time—almost desperately—as a joyous liberation from life's bruising realities and as a return to the heavenly embrace that soon would unite families for an eternity of bliss; on the other hand—as a consequence of precisely the same social conditions—death was recognized as doing such terrible damage to the already tattered cultural, religious, and emotional fabric of the times that images of the deceased and other memorabilia were clung to with what later generations would regard as morbid tenacity, while ostentatious mourning might continue for a lifetime.

It all came together in the graveyard. For years reformers had been agitating against the continued presence of cemeteries within city limits, arguing that they were unsightly, unsanitary, and dangerous.[49] And so, beginning in 1831 with the construction of Mount Auburn Cemetery outside Boston, was born the era of the rural cemetery in America. Mount Auburn was followed by Philadelphia's Laurel Hill in 1836 and Brooklyn's Green-Wood in 1838—and then by Green Mount, Spring Grove, the Woodland, Mount Hope, Worcester Rural, Cave Hill, Harmony Grove, and many more. Philadelphia alone was encircled by about twenty idyllically named and idyllically situated burial grounds by the time mid-century had passed. With rolling lawns and winding avenues carrying such names as Pilgrim Path and Sylvan Lane, the rural cemetery became home to monuments that were stonework versions of mourning paintings. Little Edith, here, is just one example, seated above her grave with a bouquet of flowers in her arms but actually, the epitaph reminds us, "safe in her saviour's arms."[50] Whereas there are few extant examples of postmortem paintings or sculpture of children in the European works of the genre during this time, the great majority of American posthumous portraits seem to be of the

Figure 8.
Anonymous, half plate.
Collection of Greg
French.

Figure 9.
"Edith." Green-Wood
Cemetery, Brooklyn,
New York.

very young—not surprising, perhaps, in light of the era's middle-class romanticization of the child as a dear innocent in an increasingly dangerous and treacherous world.

If posthumous mourning portraits were expensive, however, funerary monuments were even more so. The land alone in Mount Auburn Cemetery increased in price almost eightyfold in just a few years.[51] The rural cemeteries were not for the poor or even for the working classes—any more than were the services of a painter like William Sidney Mount—however much the nonwealthy also were experiencing the dislocations of the times and the emotional longings that underlay the desire for such remembrances of the dead.

But in the spring of 1840 the first daguerreotype portrait studios opened in New York and Philadelphia.[52] Others quickly followed. Within a decade thousands of people had made the new profession of daguerreotypist their career. Massachusetts alone reported in 1855 that its nearly four hundred "Daguerreotype Artists" and assistants had taken over 400,000 daguerreotypes during the preceding year, while New York had at least a thousand people employed at daguerreotyping. And those who did not have studios to work out of took to the road: "There is not a place of one hundred inhabitants in any of the Southern or Western states," noted the *Photographic Art-Journal* in 1855, "that have not been visited by from one to any number of [photographic] itinerants."[53]

Not only did the daguerreotype produce within minutes a finished image of stunning clarity, unlike anything anyone had ever seen before, but a portrait cost only two dollars or less, depending on the size of the plate and the reputation of the artist. (Some mass-production operators sold the smallest plates for as little as 25 cents.) Probably at least 95 percent of all daguerreotypes produced in the United States were only about 3 by 4 inches or less in size, and most were so-called sixth plates of 2¾ by 3¼ inches.[54] There was thus a jewel-like intimacy about them that was unmatched by any other mode of artistic reproduction, an intimacy enhanced by the practice of fitting the tiny buffed and silvered copper plate inside snug and delicate yet weighty layers of brass mat, glass cover, and velvet and wood or leather casing. Upon opening the case, "what a strange effect," observed Sadakichi Hartmann in 1912, "this silvery glimmer and mirror-like sheen! Held toward the light, all substance seems to vanish from the picture: the highlights grow darker than the shadows, and the image of some gentleman in a stock or some lady in a bonnet and puffed sleeves appears like a ghostlike vision. Yet as soon as it is moved away from

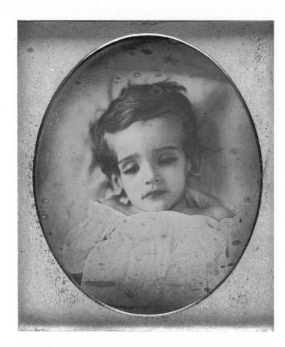

Figure 10.
Anonymous, sixth
plate. Collection of
John Wood.

the light and contemplated from a certain angle, the image reappears, the mere shadow of a countenance comes to life again."[55]

It is little wonder that those who could afford neither a postmortem portraitist like Mount nor a work of funeral statuary to be placed in a Mount Auburn or a Green-Wood or a Spring Grove would turn to a studio or itinerant daguerreotypist to record for posterity the physical image of a loved one who had passed away. What is ironic is that these democratized images for the masses, for all their straightforward lack of guile, turned out to be vastly more powerful as appeals to the soul than did the most expensive paintings or the most elaborate works of sculpture. "I long to have such a memorial of every being dear to me in the world," wrote Elizabeth Barrett of British daguerreotypes in 1843. "It is not merely the likeness which is precious in such cases—but the association and the sense of nearness involved in the thing . . . the fact of the *very shadow of the person* lying there fixed forever! . . . I would rather have such a memorial of one I dearly loved, than the noblest artist's work ever produced."[56] Not surprisingly—though perhaps somewhat pathetically—some wealthy American families with commissioned portraits of their deceased loved ones hanging in their parlors promptly proceeded to have inexpensive daguerreotypes made of the paintings as soon as the new photographic process became available.[57]

To better understand Barrett's artistic preferences, compare Mount's "Portrait of Camille" with the daguerreotype of an anonymous boy about Camille's age taken by an anonymous photographer. Why is it that the painting is memorable today only as a curiosity, because of its genre, while the image of the little boy remains so haunting? Why, when they are placed side by side, is the viewer's eye drawn so irresistibly—though not without distress—to the daguerreotype rather than to the painting? (This is a contrast, incidentally, that would be greatly accentuated were both images not flattened and homogenized by the need to reproduce them photographically for the pages of this book.) Why does it seem probable that, in their own time, the painting of Camille would have been affecting primarily to her family and to those who knew her, while the miniature representation of the boy whose name we do not know would have been both moving and disturbing to anyone who saw it?

The most obvious answer is also both the most naive and the most correct: the central difference between these two works is the difference between fiction and reality, in both the literal and the commonplace uses of those words, at least to the extent that "reality" is a term in any sense applicable to the world beyond the phenomenological "paramount reality" of the immediate present.[58] The portrait of Camille, like all such paintings, is a literal fiction in that it is understood by the viewer that her image was actively fashioned or formed or crafted by human hands; it is also a fiction in the colloquial sense that it is a patent counterfeit—a dead person rendered by the artist as living. The daguerreotype of the boy, on the other hand, is about as close to unfashioned literal reality—that is, to "the thing itself"—as we can expect to encounter in everyday life insofar as it is something that of necessity owes its very existence to an intermediary medium between the flesh and blood of the past and the viewer's gaze of the present. Also, in its intent, it is patently noncounterfeit in that the effort of the daguerreotypist was to render as exact an image of the boy as he looked in that moment of death as was possible. Thus, in choosing between perhaps the two most famous nineteenth-century descriptions of the daguerreotype image—Samuel F. B. Morse's remark that it was "Rembrandt perfected" and Oliver Wendell Holmes's comment that it was "the mirror with a memory"—it is clear that Holmes's phrase was by far the more accurate. And that is the source of the daguerreotype's affective power.

Another irony in the comparison between the painted portrait and the daguerreotype is located in the fact that the daguerreotype continues to create emotional responses among a large viewing public, whereas the portrait lost any such

influence once those who were close to the person portrayed had themselves died—this despite (or, rather, because of) the intimate original intent of the daguerreotype and the private nature of its conventional person-to-person presentation as a tiny image within a delicate enclosed case, as opposed to the open public presentation of the large oil painting hanging on a parlor wall. In a sense this is reminiscent of the difference between nudity and nakedness. But the distinction is not quite that drawn by Kenneth Clark, who regarded nudity as a form of art and nakedness merely as the absence of clothing. Rather it is the differentiation suggested by John Berger. "Nudity is a form of dress," Berger has said, while "to be naked is to be without disguise."[59]

The nude, like the painted portrait of Camille (and untold hundreds of others from that time), is *intended* to be displayed and thus the person represented as a nude almost invariably is portrayed as a self-conscious participant in the spectacle, either gazing back at the viewer or posed in dramatic awareness of his or her public visibility. In contrast, a representation of nakedness, like the postmortem daguerreotype of our unnamed little boy (and, in this case, like untold thousands of others from that time), is by definition *not* intended for public display and the person represented as naked almost invariably is presented as unaware of the spectator.

In the case of nudity versus nakedness, Berger notes that in the European tradition generally a nude woman was portrayed without body hair because "hair is associated with sexual power, with passion" and that passion needs to be minimized so that the spectator (always implicitly male) can maintain his dominance. "Women are there to feed an appetite," he writes, "not to have any of their own."[60] The nude is therefore in a sense tamed or domesticated; in contrast, nakedness is wild—or, at the very least, feral. A naked image does not conceal body hair, because nakedness is private, secret, and someone portrayed as naked is thus, in effect, someone being spied upon. Unlike an inspection of the studied formality of a nude, to observe nakedness is potentially "chilling," says Berger, because of the striking banality of the image. What is created in the observer of nakedness is an uncomfortable because shameful sensation of voyeurism, a sense of looking at something forbidden. It is a sensation not unlike at least one dimension of what we experience as we gaze at the daguerreotype of that dead little boy—and a sensation that is not even suggested by the portrait of Camille.

A truly powerful image of nakedness, however, goes beyond this initial effect. Berger uses the example of Rubens's painting of his young second wife, Helene Fourment, to illustrate the fine distinction between the mundane representation that

gives rise to the gaze of the voyeur and that which suggests the gaze of the lover. In large part that difference, in which the element of banality in the image remains "undisguised but not chilling . . . is to be found in Rubens's compulsive painting of the fat softness of Helene Fourment's flesh which continually breaks every ideal convention of form and (to him) continually offers the promise of her extraordinary particularity."[61]

Similarly, in the case of our postmortem portraits, it is the daguerreotype's astonishingly sharp rendering of detail—something that had even more impact on viewers in the mid-nineteenth century than today (as Elizabeth Barrett's comments indicate) because the daguerreotype was their first encounter with photographic depiction—that retains the banality of the image while simultaneously pushing it beyond the merely chilling. The result of such finely rendered clarity of minutiae is an unambiguous and unblinking representation of the portrayed individual's uniqueness as a singular human being with a singular personality—a singular personality, in the case of the postmortem daguerreotype, that tragically has ceased to exist. Like the daguerreotype itself, which could neither be retouched nor reproduced, the person the daguerreotype depicted in all of her or his "extraordinary particularity," once destroyed, was destroyed forever.

None of this is even hinted at by Mount's portrait of Camille or by most of the other painted mourning portraits of the time, because its emphasis on the sentimental pushes it closer to the safe boundaries of the maudlin than to the dangerous edge of the chilling. However, a few painted portraits did seek out the realistic power of the daguerreotype. Again, a comparison is instructive. Jarvis Hanks's *Death Scene*, painted in 1841 or 1842, is in Phoebe Lloyd's words "a bizarre variant of the posthumous mourning portrait."[62] There was no need for clouds or weeping willows or other conventional symbols of death in this painting, since the three deceased persons—Elizabeth Spencer Stone and her infant twins, Augustus and Elizabeth—are plainly depicted as being dead. (In fact, Elizabeth died half a year before her twins.) Elizabeth's mother, husband, and surviving son look on in varying moods of distress.

Two or three years after Hanks finished his painting, an unidentified photographer took the daguerreotype of an unnamed man cradling his dead child in his arms. Although it is an unspontaneous studio daguerreotype, this image of a man and his son—captured in an instant and recorded on a copper plate 3¼ by 4¼ inches in size—has a haunting power that the laboriously plotted and executed Hanks portrait cannot approach. Apart from the matters discussed above (the intensity of grief is so vividly apparent in the detailed reality of the daguerreotype that it is

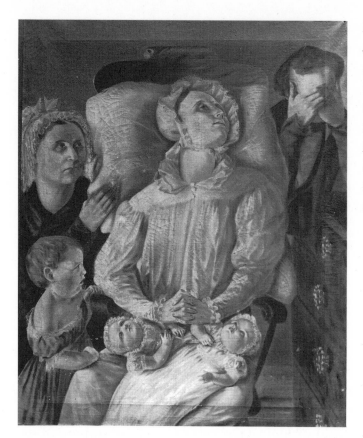

*Figure 11.
Jarvas Hanks, circa
1841–1842. "Death
Scene." Collection of
the Ohio Historical
Society; Campus
Martius, the Museum
of the Northwest
Territory, Marietta,
Ohio.*

lifted above the merely chilling, a transcendence Hanks's stylized and ultimately grotesque painting cannot achieve), the daguerreotype also does not allow us to forget that we are viewing an actual past moment that is frozen in time—a moment that was open on both ends to a history of other lived moments that were shared by this father and son and to a future of innumerable moments that the man will experience as empty without his child. Something that Leo Braudy once said about films is applicable to the photographic image as well, particularly to this comparison between daguerreotyped and painted representations of the dead and the grieving:

> Unlike novels and paintings, where the world is totally and obviously created by the artist, in films, no matter how much control the director and the set decorator have over every object in the scene, we may still feel that the objects are there by chance and may at any moment vanish or extend themselves into the life beyond the frame. Thus, more than novels or paintings, films have the capacity to present an enclosed world of total meaning at the same time that they offer the possibility of another reality outside these momentary limits.[63]

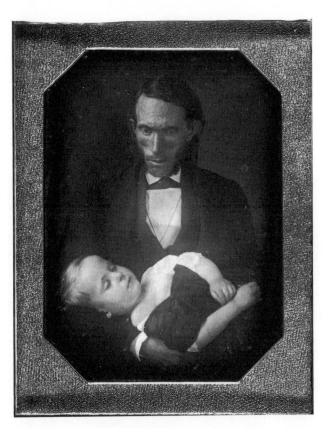

Figure 12.
Anonymous, quarter
plate. Collection of
Matthew R. Isenburg.

This the daguerreotype did better than any other form of representation that humans had until then encountered: it presented a secure and "enclosed world of total meaning" on its miniature polished surface, concealed in a case to contain its secrets—as Alan Trachtenberg has aptly remarked, in size and intimacy the daguerreotype most resembles a pocket mirror[64]—at the same time that its mysteriously evanescent, almost apparition-like images opened up the suggestion of wholly other realities. No other medium, including those that have been developed since then, was so perfectly suited to capturing the elusive temperament of those times when even the most elemental matters of body, self, and soul were being called into doubt.

The postmortem and mourning portraits produced in nineteenth-century America by artists such as Lilly Martin Spencer, Raphaelle Peale, William Stoodley Gookin, Susane Walters, Frederick Spencer, the Mounts, and many others—including even the young Thomas Cole[65]—were one part of a wall of denial erected by the bourgeois culture of the times to resist direct confrontation with the

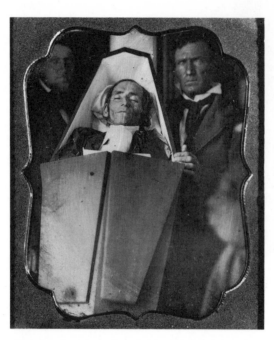

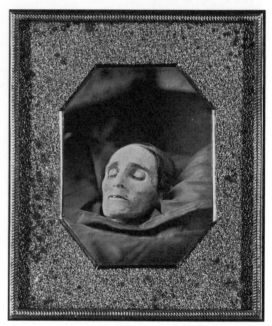

Figure 13.
Anonymous, sixth
plate. Collection of
Gayle and John Felix.

Figure 14.
Anonymous, sixth
plate. Collection of
Harold Gaffin.

steadily rising tide of secularism and the finality and even the reality of death. In a world thoroughly unsure of itself in matters ranging from sex and the self to the body and the soul, those sentimentalized oil-on-canvas images of life continuing in a blissful state somewhere beyond the clouds were assisted by a barrage of complementary imagery in sculpture, song, prose, and verse. One mid-century poetic effort, published in a volume of similar writings to honor the fashionable cemetery of Mount Auburn, must stand as example for legions of others. Entitled "Little Charlie—A Lament," it could have hung nicely (with a change of name) on the parlor wall alongside the portrait of little Camille—or little Rose, or Willie, or Elizabeth, or Susie, or Sarah, or John:

> Within the shrouded room below
> He lies a-cold—and yet we know
>> It is *not Charlie* there!
> It is not Charlie cold and white,
> It is the robe, that, in his flight,
>> He gently cast aside!
> Our darling hath not died![66]

Although verse of this sort was sometimes pinned to the cloth lining of a daguerreotype case containing an image of a dead child, the daguerreotype representations themselves were more at home in a world where less lachrymose sentiments were the rule. In the writings of the people in that world—the world of the urban proletariat and the rural poor—Lewis O. Saum has shown that such "heavenly imagery entered . . . almost not at all. Instead," Saum says, "the imagery regarding death and departure had a more prosaic, more immediate, less contestable and less sublime quality. It centered far more on what was to be escaped than on what was to be realized."[67] Saum cites an unpublished poem by a rural Indiana youth that deserves repetition not for its literary qualities but to serve as illustrative contrast to the ethereal lament for little Charlie:

> My brothers [and] sister kind & dear
> How soon youve passed away
> Your friendly faces now I hear
> Are mowldren in the clay

By the 1870s and 1880s bourgeois fashions in death and dying began taking a new turn. Mark Twain was satirizing sentimental consolation literature with his portrayal, in *The Adventures of Huckleberry Finn*, of provincial poet Emmeline Gran-

gerford—"Every time a man died, or a woman died, or a child died, she would be on hand with her 'tribute' before he was cold"—and portraitist James Beard was parodying mourning portraits to an appreciative audience in the *New York Art Journal*.[68] Soon mortuary ritual, from the funeral to the burial to advice on mourning itself, was being subdued: the funeral was moved out of the home to the professional funeral parlor; the grave was lined with cloth or flowers to conceal the walls of dirt and the family was taken away from the gravesite before the hole was filled; and extended expressions of grief were criticized, in such popular magazines as *Harper's Bazaar* and *Ladies' Home Journal*, as self-pity and "morbid self-indulgence."[69]

American attitudes toward death and dying, at least those of the dominant classes, remained on a path toward radical denial, but by the turn of the twentieth century denial was shedding its trappings of Victorian mawkishness. It was not that the American bourgeoisie had ceased to flee from the ethical and emotional and spiritual dilemmas that had erupted out of their culturally impoverished society of (for some, at least) growing material abundance; they simply had changed their envisioned personal destinations. In place of spiritual deliverance Americans began to lower their sights and yearn instead for earthbound psychic harmony. This new longing, "as an end in itself, rather than as a byproduct of religious faith," writes historian Jackson Lears, "was a new development in the history of Western Christianity." He continues: "By the 1880s and the 1890s, the confluence of weightlessness and persistent introspection had helped to pave the way for the contemporary therapeutic world view recently described by Philip Rieff—an outlook adopted by those for whom all overarching structures of meaning have collapsed, and for whom there is 'nothing at stake beyond a manipulable sense of well-being.'"[70]

Meanwhile, the daguerreotype had fallen out of popular favor around the time of the Civil War when new photographic techniques were discovered that permitted retouching and mass reproduction, even if the replacement methods could never quite match the daguerreotype for sharpness of definition and detail or for the haunting quality of the polished copper plate. Postmortem photography subsequently declined in fashion, as had posthumous portrait painting, though photographs of the dead retained a certain popularity in rural communities and among some urban poor well into the twentieth century, perhaps as a carry-over among European immigrants—particularly those from Mediterranean countries, where postmortem photography began to become popular after the First World War.[71]

As the twentieth century now draws to a close, Americans find their notoriously short attention spans focused almost entirely on life; our strategies of death denial

allow no room for postmortem portraiture of any sort. Not only is it likely that most American families will have numerous photographs of the deceased while they were alive (photographs that contemporary sensibilities, which have no desire for *memento mori*, find far preferable to contemplate), but the very idea of wanting to gaze upon and contemplate a postmortem representation of a loved one is thoroughly anachronistic to a people who happily pay large sums of money so that mortuary cosmeticians will make the deceased look as lifelike as possible.

No doubt, despite our excursion in these pages through the past worlds of *memento mori*, most of us are still likely to find the funerary customs of our ancestors strange and emotionally troubling. To the majority of Americans there can be no denying that the idea of photographing a loved one in death is, to say the least, peculiar. Whether future generations will find such a practice as odd as they may find some of our own popular ceremonials of today, however—such as the recent fashion of photographing or videotaping childbirth—only time will tell.

NOTES

1. Susan Sontag, *On Photography* (New York: Farrar, Straus & Giroux, 1977), p. 15.

2. John Wood, "Silence and Slow Time: An Introduction to the Daguerreotype," in *The Daguerreotype: A Sesquicentennial Celebration* (Iowa City: University of Iowa Press, 1989), p. 25.

3. James Mellaart, *Earliest Civilizations of the Near East* (New York: McGraw-Hill, 1965), pp. 42–43.

4. Philippe Ariès, *The Hour of Our Death* (New York: Knopf, 1981), p. 202.

5. Brent D. Shaw, "Latin Funerary Epigraphy and Family Life in the Later Roman Empire," *Historia* 33 (1984): 482.

6. Peter Brown, *The Body and Society: Men, Women and Sexual Renunciation in Early Christianity* (New York: Columbia University Press, 1988), p. 440.

7. For convenient documentation, see Cyril C. Richardson, ed., *Early Christian Fathers* (Philadelphia: Westminster Press, 1953), pp. 74–120; and Saint Augustine, *The City of God*, trans. Marcus Dods (New York: Modern Library, 1950), pp. 22–32.

8. Jacques le Goff, *L'imaginaire mediéval* (Paris: Gallimard, 1985), p. 123; also cited in Brown, p. 441.

9. Quoted in Philippe Braunstein, "Toward Intimacy: The Fourteenth and Fifteenth Centuries," in *A History of Private Life: Revelations of the Medieval World*, ed. Georges Duby (Cambridge: Harvard University Press, 1988), pp. 622–23. Despite Braunstein's subtitle, the quotation from Bonaventure derives from early thirteenth-century writings.

10. Saint Thomas Aquinas, *Summa Theologica* (New York: Benziger Brothers, 1948), 3: 2894–2931.

11. T. S. R. Boase, *Death in the Middle Ages* (London: Thames & Hudson, 1972), p. 106.

12. This is a matter I have discussed at greater length, though with different emphases, in *The Puritan Way of Death* (New York: Oxford University Press, 1977), pp. 15–22. On the *contemptus*

mundi the best general study is still Donald R. Howard's unpublished doctoral dissertation, "The Contempt of the World: A Study in the Ideology of Latin Christendom with Emphasis on Fourteenth Century English Literature" (University of Florida, 1954).

13. Quoted in Boase, pp. 44–45. The Poggio quotation is in Braunstein, pp. 603–606.

14. See Colin Morris, *The Discovery of the Individual* (New York: Harper & Row, 1972). On other long-range implications, see the classic study by C. B. Macpherson, *The Political Theory of Possessive Individualism* (Oxford: Oxford University Press, 1962).

15. On death masks, see Ariès, pp. 260–66; on portraiture, see the remarkable essay by Anton Pigler, "Portraying the Dead," *Acta Historiae Artium* (Budapest) 4 (1956).

16. Pigler, p. 69.

17. Pigler, p. 69.

18. Both quotations in Pigler, pp. 58, 64.

19. The principal exceptions to this generalization during the Middle Ages were recumbent images of the dead as living individuals, eyes open and usually in a posture of prayer, and—closer to the later fashion of depicting the dead as dead—the so-called *transi*: a usually double-deck tomb depicting the dead in heavenly peace on one level and as horribly decomposed on the other. The classic study of these works is Erwin Panofsky, *Tomb Sculpture: Its Changing Aspects from Ancient Egypt to Bernini* (London: Thames & Hudson, 1964), especially pp. 63–66. However, as Ariès correctly points out: "These works are so powerful that they may create the illusion of being representative. In reality, there are relatively few of them, and they do not in themselves express a main current of the sensibility of the age." Ariès, p. 113.

20. I have discussed this at some length in *The Puritan Way of Death*, chapter 5.

21. See John Phillips, *The Reformation of Images: Destruction of Art in England, 1535–1660* (Berkeley: University of California Press, 1973).

22. There is a good deal of literature on this subject, but see especially Allan I. Ludwig, *Graven Images* (Middletown, Conn.: Wesleyan University Press, 1966); Ann and Dickran Tashjian, *Memorials for Children of Change* (Middletown, Conn.: Wesleyan University Press, 1974); and Peter Benes, *The Masks of Orthodoxy* (Amherst: University of Massachusetts Press, 1977).

23. See Diana Williams Combs, *Early Gravestone Art in Georgia and South Carolina* (Athens: University of Georgia Press, 1986), pp. 131–33.

24. John Todd, *The Moral Influence, Dangers and Duties, Connected with Great Cities* (Northampton, Mass., 1841), pp. 18–20, 119, quoted in Kirk Jeffrey, "The Family as Utopian Retreat from the City," *Soundings* 55 (1972): 26.

25. William G. Eliot, Jr., *Lectures to Young Women* (Boston, 1880 [first published in 1853]), pp. 55–56, quoted in Jeffrey, p. 21.

26. John Pierpont, *The Garden of Graves* (Dedham, Mass.: H. Mann, 1841), pp. 9, 7.

27. Joseph Story, "Judge Story's Address," in *The Picturesque Pocket Companion, and Visitor's Guide, Through Mount Auburn* (Boston: Otis, Broaders & Company, 1839), pp. 67–68.

28. Harriet Martineau, *Retrospect of Western Travel* (New York: Harper & Brothers, 1838), p. 229.

29. Henry Adams, *The Education of Henry Adams* (Boston: Houghton Mifflin, 1961 [first published in 1918]), pp. 33–34. The era's "rage for classification" and related matters are discussed in James H. Cassedy, *American Medicine and Statistical Thinking, 1800–1860* (Cambridge: Harvard University Press, 1984).

30. Francisco José Moreno, *Between Faith and Reason: Basic Fear and the Human Condition* (New York: Harper & Row, 1977), p. 7.

31. René Dubos and Jean Dubos, *The White Plague: Tuberculosis, Man, and Society* (Boston: Little, Brown & Company, 1952), pp. 3–10; Selman A. Waksman, *The Conquest of Tuberculosis*

(Berkeley: University of California Press, 1964), pp. 19, 202.

32. Dubos, pp. 125–26.

33. Abba Gould Woolson, *Woman in American Society* (Boston: Roberts Brothers, 1873), p. 192, quoted in Lois W. Banner, *American Beauty* (Chicago: University of Chicago Press, 1983), p. 51.

34. Charles E. Rosenberg, *The Cholera Years: The United States in 1832, 1849, and 1866* (Chicago: University of Chicago Press, 1962), p. 32.

35. Rosenberg, pp. 37, 1.

36. On the critical importance of Harvey, see I. Bernard Cohen, *Revolution in Science* (Cambridge: Harvard University Press, 1985), pp. 187–94. On the Act of 1752 and subsequent controversies over the use of the corpse as an anatomical object, see Ruth Richardson, *Death, Dissection, and the Destitute* (London: Routledge & Kegan Paul, 1987), pp. 30–51.

37. Peter Linebaugh, "The Tyburn Riot against the Surgeons," in *Albion's Fatal Tree*, ed. Douglas Hay et al. (New York: Pantheon, 1975), pp. 65–117.

38. *Lancet* 2 (1829): 212, quoted in Richardson, p. 52.

39. See Richardson, p. 227.

40. On this and more, see Barbara Jones, *Design for Death* (Indianapolis: Bobbs-Merrill, 1967).

41. Quoted in Richardson, pp. 30–31.

42. See, among many such treatments, Edward Shorter, *The Making of the Modern Family* (New York: Basic Books, 1977), chapter 3; Michel Foucault, *The History of Sexuality: An Introduction* (New York: Pantheon, 1978); and Peter Gay, *The Bourgeois Experience: Education of the Senses* (New York: Oxford University Press, 1984).

43. Frederick Marryat, *A Diary in America, with Remarks on Its Institutions* (London, 1839), 2: 246–47. On *The Lustful Turk*, see Steven Marcus, *The Other Victorians* (New York: Basic Books, 1974), pp. 197–216.

44. Gay, p. 109; Nancy F. Cott, "Passionless-ness: An Interpretation of Victorian Sexual Ideology, 1790–1850," *Signs* 4 (1978): 219–36; Carl N. Degler, *At Odds: Women and the Family in America from the Revolution to the Present* (New York: Oxford University Press, 1980), pp. 249–78.

45. Letter from Shepard Alonzo Mount to William Shepard Mount, 1868, reprinted in part in *A Time to Mourn: Expressions of Grief in Nineteenth Century America*, ed. Martha V. Pike and Janice Gray Armstrong (Stony Brook, N.Y.: The Museums at Stony Brook, 1980), p. 165.

46. See Pike and Armstrong, p. 83.

47. Phoebe Lloyd, "Posthumous Mourning Portraiture," in Pike and Armstrong, pp. 71–89.

48. Lloyd, p. 73.

49. See, for instance, Felix Pascalis, *An Exposition of the Danger of Interment in Cities* (New York: Gilley, 1823).

50. A good collection of these monuments can be seen in Edmund V. Gillon, Jr., *Victorian Cemetery Art* (New York: Dover, 1972).

51. Stannard, p. 181.

52. Beaumont Newhall, *The Daguerreotype in America* (New York: Dover, 1976), p. 25.

53. Newhall, pp. 34, 55.

54. Newhall, p. 63; Matthew R. Isenburg, "The Wonder of the American Daguerreotype," in *American Daguerreotypes from the Matthew R. Isenburg Collection: Exhibition and Catalogue*, prepared by Richard S. Field and Robin Jaffee Frank (New Haven: Yale University Art Gallery, 1990), p. 12.

55. Sadakichi Hartmann, "The Daguerreotype," in *The Valiant Knights of Daguerre*, ed. Harry W. Lawton and George Knox (Berkeley: University of California Press, 1978), p. 142.

56. Quoted in Sontag, p. 183.

57. For example, see Lloyd, p. 85.

58. For the classic phenomenological treatment of "paramount reality" and subuniverses of perception, see Alfred Schutz, "On Multiple Realities," in his *Collected Papers, Volume One: The*

Problem of Social Reality (The Hague: Martinus Nijhoff, 1971), pp. 207–59.

59. John Berger, *Ways of Seeing* (New York: Penguin Books, 1977), p. 54. In the discussion that follows, only phrases that are directly quoted from Berger should be attributed to him. I have layered my own thoughts on these matters with Berger's ideas and he should not be held responsible for the uses I make of his insights or for my extensions of them for the purposes of this essay.

60. Berger, p. 55.

61. Berger, p. 61.

62. Lloyd, p. 85.

63. Leo Braudy, *The World in a Frame: What We See in Films* (New York: Anchor Press, 1976), pp. 76–77.

64. Alan Trachtenberg, "Mirror in the Marketplace: American Responses to the Daguerreotype, 1839–1851," in Wood, p. 70.

65. Lloyd, p. 73.

66. Anonymous, "Little Charlie—A Lament," in *The Mount Auburn Memorial* (Boston: Safford, Brown & Co., 1861), pp. 64–65.

67. Lewis O. Saum, "Death in the Popular Mind of Pre–Civil War America," in *Death in America*, ed. David E. Stannard (Philadelphia: University of Pennsylvania Press, 1975), pp. 46–47.

68. On Beard, see Lloyd, p. 87.

69. See the overview of this in James J. Farrell, *Inventing the American Way of Death, 1830–1920* (Philadelphia: Temple University Press, 1980), pp. 146–83.

70. T. J. Jackson Lears, *No Place of Grace: Antimodernism and the Transformation of American Culture, 1880–1920* (New York: Pantheon, 1981), p. 55. Lears's closing quotation is from Philip Rieff, *The Triumph of the Therapeutic: Uses of Faith after Freud* (New York: Harper & Row, 1966), p. 13.

71. Ariès, p. 538.

BROOKS JOHNSON

The Progress of Civilization

THE AMERICAN OCCUPATIONAL DAGUERREOTYPE

In 1853 the United States government commissioned Thomas Crawford to design a sculptural relief for the pediment above the Senate portico of the Capitol. Titled *Progress of Civilization*, its theme was America's emergence out of the wilderness. The pediment incorporates the allegorical figure of a robed woman, personifying America, flanked by realistic sculptures depicting tradespeople. America stands in the center, holding wreaths of oak and laurel, flanked by an American eagle and the rising sun. She gestures toward the figures on her left, who represent the early days of America. A brawny pioneer felling trees with an axe is followed by a group of Native Americans—a young brave emerging from the woods, a seated chief, a mother and child. Finally, there is a grave. The chief's posture emphasizes his despair for the demise of his people. The grave is open, ready to receive the Native American culture; the antecedent must give way to the new era of the white settlers.

On America's right are figures representing the progress of civilization. First, a Revolutionary War soldier draws his sword. Beside him, a merchant seated on crates stretches his hand over a globe. Next, a schoolmaster instructs a boy, and two youths march toward the center. Lastly, a mechanic, hammer in hand, reclines on a cogwheel.

The figures Crawford chose for the Senate pediment are similar to those frequently found in the daguerreotype images commonly known as occupationals. Occupational daguerreotypes show sitters with the tools of their trade or the accouterments of their hobby or clothed in appropriate dress or uniform. Why was the

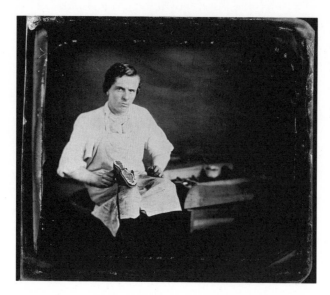

depiction of various trades so prevalent in American daguerreotypes? And why did Crawford choose tradespeople as models for his esteemed pediment? To understand why, we must first look more closely at the inherent symbolism of the pediment figures. We can then more fully appreciate corresponding daguerreotype images.

The pioneer represents the advance of European civilization into the new American Eden. Conquering the wilderness so that America might achieve its manifest destiny required courage, strength, intellect, and tools. Many daguerreotypes show settlers with axes, shovels, and picks—people who were proud of the fact that they used these tools to claim the new land. The surveyor, a common image in this genre (see plate 64), combines physical hardiness with the intellectual sciences of geometry and trigonometry to subdue the wilderness. Personifying human resourcefulness, the surveyor is an icon representing the domination of humankind over the American continent.

Crawford's soldier represents America's fight for liberty. The Revolutionary War, followed by the War of 1812, developed America's patriotism and cohesiveness. The Mexican War, aided by the realistic imagery of the daguerreotype, helped the diverse immigrant populations to unify into an emerging American nationality.

The industriousness of the individual—and thus of the country—is manifest in the persona of the merchant, who symbolizes America's worldwide expansion in trade and manufacturing. Through the export of goods, the merchant and artisan were responsible for much of the wealth entering the country. Images of crafts-

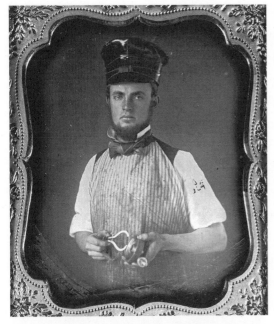

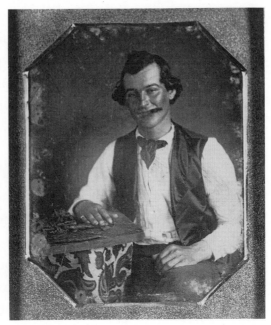

Figure 2.
Anonymous, sixth
plate. Machinist.
Collection of Howard
R. McManus.

Figure 3.
Anonymous, sixth
plate. Cigar Maker.
Collection of Ross J.
Kelbaugh.

Figure 4.
Anonymous, sixth
plate. Bobbin Boys,
one with a lunch pail.
Collection of Ross J.
Kelbaugh.

workers are among the most commonly found daguerreotypes. Two particularly important daguerreotypes of this genre are reproduced here. "Cigar Maker" (fig. 3) illustrates America's first export industry and indigenous product—tobacco. The country's growing textile trade is illustrated by "Bobbin Boys" (fig. 4).

The schoolteacher on the pediment recognizes the importance of knowledge. The youth of the country offered hope and symbolized the untapped genius of this new land. The seed of greatness, already planted, needed only time and nurturing to grow. Daguerreotypes of teachers are quite common (see fig. 5). Additionally, the inclusion of books in many daguerreotypes indicates that the ability to read was a source of pride. With reading skills, even a barefoot boy could learn and improve his lot in life (fig. 6).

Crawford's mechanic commemorates the inventiveness of the young country, personifying the American traits of innovation and technological achievement. In less than one hundred years fledgling America was well on its way to developing one of the leading economies of the industrial age. Correspondingly, the relatively new occupation of mechanic or machinist would flourish. The daguerreotype of a young man with a telegraph device is a prime example of an image bristling with new technology (see fig. 7). The telegraph, permitting instant communications, was as revolutionary then as fax machines are today.

The question arises, was the symbolism of these daguerreotypes intended by the sitter? It is difficult to imagine an individual visiting a daguerreotypist's studio with the intention of creating a symbolic portrait; rather, it seems likely that there was a more immediate purpose. The daguerreotypes were of course taken to be shown. The sitters are posing as they wish to be seen. The daguerreotype depicting one's occupation or interests was, or could be, a conversation piece. Imagine the conversation one might have with William Barnicoat, fire chief of Boston (fig. 8). He could talk about the fires he fought, the improvements in the field, and the difficulties involved in managing fire control for the growing city. He might even have an amusing story about the trumpet he holds in his hand. The occupational daguerreotypes obviously mirror the sitters' pride in their trade or profession.

But, of course, the daguerreotypist cannot be excluded from a consideration of the origins of the occupational portrait. Are we to assume that this kind of portraiture was the invention of the sitter or should we assume that the costuming was largely a convention imposed by the photographer? We know that Southworth and Hawes advertised that they had "ladies" in attendance to aid female sitters in their hairstyles and selection of jewelry.[1] If nineteenth-century photographers could be as intrusive as that into what would strike us as matters of personal taste, it is easy to assume that they would tell carpenters to arrive with saws in hand, butchers to bring their knives, which could be tinted red, and piano tuners their forks. We also know that the photographer's studio of the later nineteenth century was filled to crowding

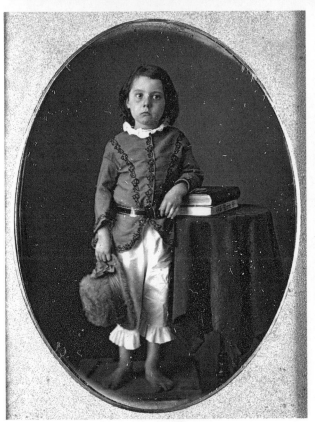

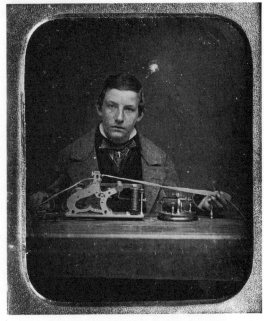

Figure 5.
Anonymous, quarter
plate. A note in the
back of this image
reads: "Mary Rhoads
She taught school
at sixteen near
Philadelphia—rode
horseback to and from
her school." Collection
of Barbara Deutsch.

Figure 7.
Anonymous, sixth
plate. Telegrapher.
Collection of Mark
Koenigsberg.

Figure 6.
Anonymous, quarter plate.
Barefoot boy with books.
Collection of the Chrysler Museum.

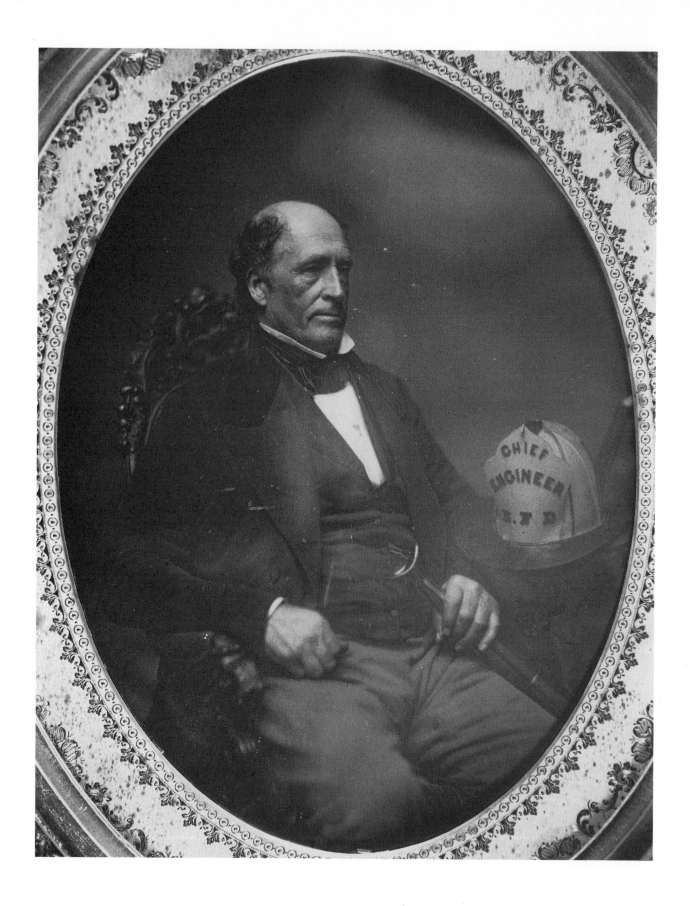

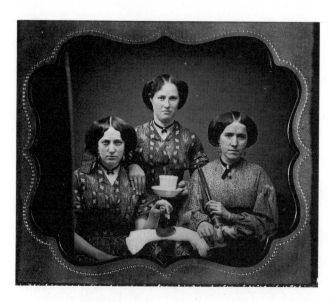

Figure 9.
Anonymous, sixth
plate. Women with
iron, duster, and cup
and saucer. Collection
of Jane Lenharth.

with such props. Napoleon Sarony's studio was described as a "dumping-ground of the dealers in unsalable idols, tattered tapestry, and indigent crocodiles."[2] Of course, the conversational quality of images containing such props would lead other sitters to want to be daguerreotyped in a similar manner, and so the convention would feed off of itself.

To achieve a sense of how occupations were regarded in the nineteenth century, let us look at a contemporary account. In Nathaniel Hawthorne's novel *The House of the Seven Gables*, the protagonist, Holgrave, was currently a daguerreotypist. Hawthorne gives an account of Holgrave's employment history in this excerpt.

> Though now but twenty-two years old (lacking some months, which are years in such a life), he had already been, first, a country schoolmaster; next, a salesman in a country store; and either at the same time or afterwards, the political editor of a country newspaper. He had subsequently traveled New England and the Middle States, as a peddler, in the employment of a Connecticut manufactory of cologne water and other essences. In an episodical way, he had studied and practiced dentistry, and with very flattering success, especially in many of the factory towns along our inland streams. As a supernumerary official, of some kind or other, aboard a packet ship, he had visited Europe, and found means, before his return, to see Italy.

Opposite:
Figure 8.
John A. Whipple,
whole plate. Portrait of
William Barnicoat,
Fire Chief of Boston
from 1839 to 1854.
Collection of Thurman
F. Naylor.

Figure 10.
Anonymous, half plate.
Eyeglass makers.
Collection of Mona
and Marc Klarman.

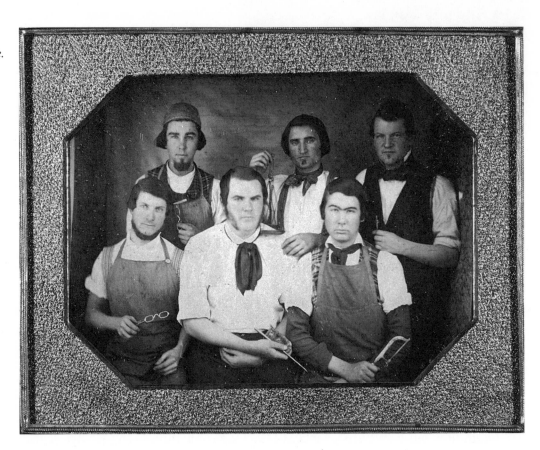

Hawthorne may have taken liberties in explaining the fictional Holgrave's previous trades, but the premise that a man would pursue many different occupations is certainly based in fact. Here was a very young man who had already undertaken no less than a half-dozen different trades. Is it unlikely that he may have wanted a memento of his work in each, or at least some, of those trades? A reminder of his travels around the Middle States, "as a peddler," might make for a fascinating evening of conversation. Or his likeness holding a newspaper might impress the father of the girl he was courting.

Conversational daguerreotypes fulfilled a need in nineteenth-century America. They fostered a sense of identity and provided a nostalgic reminder. They provided a means of entertainment and escapism for people living in a slower-paced and simpler time. Today, long after the sitters' names have been forgotten, these images still serve as conversation pieces, but of a different sort. We wonder who these people were and where they lived and what their life was like. More than one daguerreotype collector has looked at his or her images and thought "if only you could talk." They still stimulate us in more ways than the original sitters could ever have imagined. And finally, as Emerson suggested, these objects do convey to us a sense of the emerging nation as seen through these carefully posed, artistic images of its people. Occupational daguerreotypes, created as conversation pieces, are now, like the Crawford pediment, the symbols of mid-nineteenth-century American society.

NOTES

1. Matthew R. Isenburg, "Southworth and Hawes: The Artists," in John Wood, ed., *The Daguerreotype: A Sesquicentennial Celebration* (Iowa City: University of Iowa Press, 1989), p. 75.

2. Quoted in Robert Taft, *Photography and the American Scene* (New York: Dover Publications, 1964), p. 340.

JOHN F. GRAF

Captured without Resistance

A SOCIAL VIEW OF THE AMERICAN MILITIA

O ne of the most sought-after categories of daguerreotypes is frequently misunderstood. Often classified as occupationals, in the same category as daguerreotypes of blacksmiths, surgeons, or carpenters, images of militiamen are not reflections of a man's choice of employment. Rather, they mirror that person's patriotism in community, state, and nation.

When Louis Jacques Mandé Daguerre announced his invention to the world in 1839, one of the United States' oldest traditions of national defense was on the decline. Only a shadow of the minutemen of Lexington and Concord, the militiamen of the early 1840s were less inclined to pick up their muskets and respond to the nation's call. The daguerreotype has left a record of those, like their forefathers, who were eager to don uniform and musket, if not for defense, for the sake of showmanship.

Prior to the birth of the new nation in 1789, establishment and maintenance of a militia were left to the designs of the individual states. The original thirteen colonies promptly founded militias. The Constitutional Convention, however, divided the authority over state troops between federal and state governments. At a time when the nation's professional soldiery numbered fewer than seven hundred men, the Convention empowered Congress "to provide for organizing, arming and disciplining the Militia, and for governing such parts of them as may be employed in the Service of the United States." It cautioned Congress to do this, however, while "re-

serving to the States respectively, the appointment of Officers, and the authority of training the Militia according to the discipline prescribed by Congress."[1]

The United States Congress implemented the constitutional provisions for the militia by passage of the Militia Act of 1792. In it, Congress set the ages of men to be enrolled between eighteen and forty-five. The act continued the practice of requiring each militiaman to furnish his own arms, insisting that an officer possess "a sword on hanger" and that privates have in working order "a good musket or firelock" in addition to "a sufficient bayonet on belt, two spare flints, and a knapsack, a pouch with a box therein to contain not less than twenty-four cartridges." Most important, the Militia Act of 1792 encouraged the continued growth of volunteer units, stating that "whereas sundry corps of artillery, cavalry and infantry, now exist in several of the said states . . . [they shall] retain their accustomed privileges, subject, nevertheless, to all other duties required by this act."[2]

Under this law, two kinds of citizen-soldier constituted the militia. The two were governed by the same laws, "came from the same communities . . . received the same pay when they received it at all, and were subject to the same command . . . but were, nonetheless, institutionally worlds apart."[3] The first group emphasized the "soldier" part of the compound. Congress sanctioned fraternal paramilitary organizations. These volunteer companies, uniformed at their own expense, were generally incorporated into the enrolled militia regiments as the flank and grenadier companies—the two elite companies in every regiment. Willingly accepting the roles of defenders of the republic, the companies eagerly designed their own uniforms and met regularly to practice the school of the soldier.

The second group focused on the "citizen" side of the compound. Unable to obtain exemptions, ablebodied men between the ages of eighteen and forty-five, willing or not, comprised this group. Rather than pay a fine, these militiamen reported once a year to practice their military skills. More of an inconvenience than an instruction, these yearly musterings became more and more unpopular. By 1840, if individual states had not already done away with the enrolled militia system, they generally looked the other way as musters first retrograded in content and then disappeared altogether. In reminiscing about Muster Day in Lebanon County, Pennsylvania, one former militiaman, George Mays, stated that "general training day was for secular entertainment . . . when the local regiment came out to perfect and reveal its skill in the manual and in the evolution of the line. Side shows and a general good time constituted for the crowd its chief interest."[4]

It is impossible to set an exact date for the beginning of the decline of interest in the militia. The causes for it were many, foremost the lack of military necessity. As the memory of the War of 1812 began to fade from the public mind, the martial spirit also declined. In contrast, as the popularity of the enrolled militia was waning by 1840, membership in the uniformed volunteer companies was growing. As way of explanation, Alexis de Tocqueville asserted in 1840, "Americans of all ages, all conditions, and all dispositions constantly form associations. They have not only commercial and manufacturing companies, in which all take part, but associations of a thousand other kinds, religious, moral, serious, futile, general or restricted."[5]

Evidencing the new upsurge in interest in volunteer militia organizations are the many extant daguerreotypes of militiamen in the studio or in the field. Though both volunteer and enrolled militiamen had the same requirements of armament and attendance at state musterings, a vastly disproportionate number of images of volunteer militiamen exist. This incommensurate representation itself is evidence of the decline of participation in the enrolled militia. In recalling a militia muster during which participants were obviously more interested in fulfilling their obligations than participating in a military display, Senator David Turpie of Indiana commented, "The militiamen were not uniformed, but usually came in their ordinary clothing; their weapons were of no particular pattern—rifles, shotguns, yagers [sic], carbines and muskets—with which they went through the manual of arms."[6]

Indifference often gave way to mockery. Philip Hone, a gentleman of New York, witnessed a parade in New York City aimed at spoofing the local militia. He watched as two or three hundred individuals calling themselves the "Invincible Fantasticals" marched around "in motley dresses of every description—Turks, Indians, Bonapartes, with cabbages for epaulets, band-boxes for helmets and broom-sticks for muskets."[7] Similarly, groups of men and boys in Waterbury, Connecticut, calling themselves the "Fantastics" mocked militia trainings by parading in costumes armed with broomstick muskets and wooden swords.[8]

Despite this obvious movement to disparage the militia, there is little, if any, photographic evidence of such spectacles. Likewise, few images exist which can be conclusively classified as documentation of an enrolled militiaman. Without his weapon and accouterments, there would be nothing to distinguish him from any other citizen as the enrolled militiaman was required to supply only the tools of war, not the uniform (see fig. 1).

Instead, the daguerreian artists apparently focused their attention, not on the caricatures or the less-than-spectacular enrolled members, but rather on the mili-

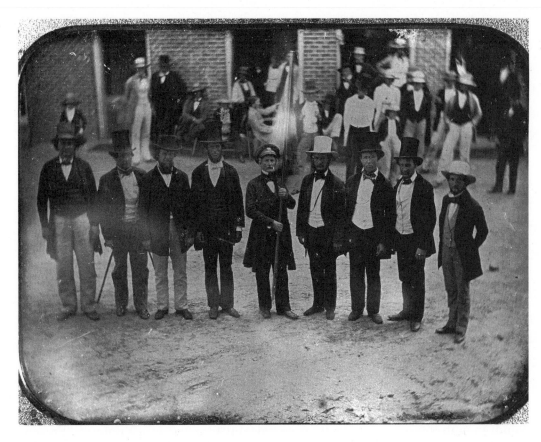

*Figure 1.
Anonymous, half plate.
Mexican War veterans
at Chester, South
Carolina. The man in
the center is Nathaniel
Eaves, color-bearer of
Company B, First
South Carolina Reg-
iment of Volunteers.
Though this image is
actually of a veterans'
gathering, the non-
uniformed gathering is
typical of the scene of
enrolled militia mus-
terings. Collection of
the South Caroliniana
Library, University of
South Carolina.*

tiamen who took pride in their membership in a volunteer company. The dramatic uniforms, the crispness of the accouterments, and the chivalrous air of the posed were all elements that lent themselves to the image in a way that was gratifying both to the artist and to the sitter.

From 1840 until 1846, when war broke out with Mexico, there was a steady increase of interest in volunteer companies. As events in the republic of Texas evolved, a stronger martial spirit began to reemerge. When James Knox Polk was elected to the presidency in 1844, further promotion of a militaristic atmosphere developed, as Polk and his cabinet determined not to back down to England on the issue of Oregon's boundary or to Mexico on the issue of annexation. Though attendance by the enrolled militia continued to decrease (compulsory attendance at musters had been abolished in Massachusetts, Maine, Vermont, Ohio, Connecticut, and New York by 1846),[9] the popularity of the volunteer company climbed.

The image of the Rochester (New York) Home Guard (fig. 2) taken circa 1845 exemplifies this martial spirit prior to the war with Mexico. Not only was one man proud enough to dress in uniform and pay a daguerreotypist to record his image, but an entire squad of eight men, resplendent with Hall's rifles, accouterments, and shakos, visited the studio.

A second image, that of the Easton (Pennsylvania) Fencibles (plate 7) taken in 1845, documents two important aspects of the volunteer militia company during this period. First, the image clearly reflects a strong martial spirit. It was taken atop School Hill near Easton. Either the unit has gathered for the sole purpose of having a daguerreotype made or the commander has allowed the daguerreotypist to interrupt the unit's scheduled military activities of that day. The ground on which the company has posed, though scenic, is certainly not conducive to military evolutions. Second, though the officers have their swords outstretched in a salute of "Present Arms," the company is standing at "Order Arms" (see detail, fig. 3)—the two evolutions do not, by command, exist simultaneously.[10] This fact, coupled with the presence of civilians standing in the background, lends credibility to the possibility that the company was photographed by special request.

Due to the militia's reputation for rowdiness, the government made a number of amendments to the militia law designed to curb the worst abuses. Civilians were ordered to keep clear of militia musterings, and military authorities were empowered to detain offending civilians during the time of the exercises. The fact that there were civilians lingering about when this image was made seems to indicate that the daguerreotypist took the image during a lull in the military exercise, away

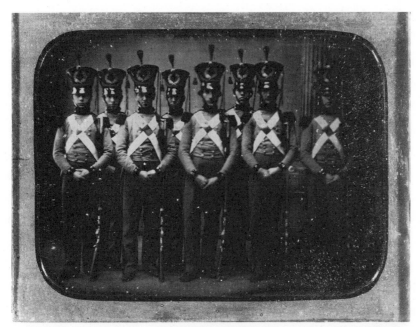

Figure 2.
Anonymous, quarter
plate. Rochester (New
York) Home Guard,
circa 1845. Collection
of the Putnam Muse-
um, Davenport, Iowa.

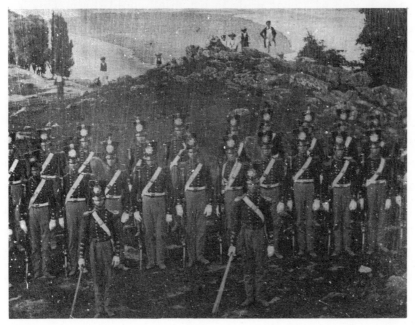

Figure 3.
Anonymous, half plate.
Easton Fencibles,
detail. Collection of
Harvey Zucker.

from the drill field. It was probably made at the special request of the unit or the daguerreotypist—a request, either way, indicating pride in the military unit.

The second important piece of evidence of martial spirit revealed by this photograph is the presence of a band on the extreme left of the image. Though the band members are in uniform, their oilcloth caps identify them as a separate formation from the shako-adorned Fencibles. After a lengthy excursion to New York City in late August 1846, the Fencibles were met by the Easton Brass Band and "over fifty citizens on Horseback, and escorted to the Delaware Bridge." Music was an integral part of almost every militia exercise, but in this instance of returning home after touring in New York and New Jersey, the Easton Band turned out solely for the company's reception. The impromptu parade continued and was met by another volunteer unit, the National Guards. The whole procession made its way through the streets of Easton "amidst firing of cannon, ringing of bells and the waving of handkerchiefs by the beautiful ladies of our lovely town." At the Fencibles' armory, "a beautiful repast was prepared . . . to which both companies, the Band, and many citizens sat down."[11] A band turning out, a parade, and a reception by the townspeople all reflect the prominence the Fencibles enjoyed in Easton social circles.

These two fragments of documentary evidence—a large, ornately framed daguerreotype and a separate newspaper article—serve as testimony to one of the most relevant functions of the militia—that of a social institution. The company of approximately thirty-five men provided the town with a social function when the men arrived home as well as a civic pride in which all could share. This is not wholly unlike a city's attitude toward a professional sports team today.

This is an important fact to remember when viewing images of militiamen. The companies were clubs, in spite of whatever military function they were expected to fill. But in May 1846, when President Polk declared that a state of war with Mexico existed, the time came when many of these "clubs" would have to decide to what degree they were ready to commit their military servitude. Though the militia system on the whole was in feeble condition at the outbreak of the war, it was the volunteer companies that comprised the real backbone of the organizations going to Mexico. The *Alexandria Gazette and Virginia Advertiser* in early December 1846 commented that the "Petersburg Volunteers for the Mexican War have been fully organized and equipped. . . . The ladies of the town are to present them with a Flag and have a Fair for their benefit. A Daguerreotypist is to take a likeness of each member of the company for preservation."[12]

Like Fletcher Archer's company of Petersburg Volunteers of the First Regiment of Virginia Volunteers, the Fannin Avengers, a Georgia company, also took time to record a remembrance before leaving their homes for Mexico (fig. 4). The Avengers were a company of men from Griffin, Pikes County, Georgia, commanded by Captain H. J. Sargent. The militia company volunteered as a whole and was consolidated into the First Regiment of Georgia Volunteers under the colonelcy of Henry R. Jackson.

The image of the Fannin Avengers is a stark contrast to that of the Easton Fencibles taken only one year earlier. The Fencibles, in the security of military pomp, appear crisp, well disciplined, even picturesque posed against the backdrop of the Delaware River. On the other hand, the Fannin Avengers seem aware that their military outing will not be comprised of a series of stops greeted by "beautiful ladies waving their handkerchiefs" culminating in an evening of toasts, food, and speech-making. The unsteady posture of the muskets does not reveal a carefully posed scene like that of the Fencibles but rather one of weary men soon to be soldiers. The area in which the image was made looks as though it is well suited for military evolutions. The buildings, though simple farm structures, lend a barrackslike feel to the image. At about the same time as the Easton Fencibles were returning to their Penn-

sylvania hometown to be greeted by a band, townspeople, and a dinner on their behalf, the Georgia regiment was enduring 112-degree heat at Camargo, Mexico. Of the 910 men who marched across the Chattahoochee River three months earlier, about 600 remained; nearly 70 were buried beneath the chaparral.[13]

For a short period following the signing of the Treaty of Guadalupe Hidalgo ending the war in 1848, the national interest in militia activities enjoyed a resurgence. President Polk's Farewell Address eulogized the performance of the "volunteer army" in Mexico: "Our citizen soldiers are unlike those of any other country. . . . In battle each private man, as well as every officer, fights not only for his country, but for glory and distinction among his fellow-citizens when he shall return to civil life."[14]

Emory Upton remarked that "the Mexican War marked a great change if not a revolution in our military policy."[15] Over the next four years, several states including New York, Virginia, and Wisconsin redefined their militia codes. Missouri and New Hampshire abolished compulsory militia service. The aim was not a total unpreparedness in military training, however, since these companies were reorganized as volunteer militias.

This renewed interest is confirmed by the many extant daguerreotypes of militiamen from the period, images ranging in size from gems to mammoth plates (see figs. 5–7). There are far more images of militiamen from the period of about 1849 to 1855 than any other. These six years were dominated by a general disregard for formal militia laws governing the enrolled militia and an outgrowth of volunteer companies. It also was a period that saw a widespread movement in the Western states to form volunteer companies. One historian has gone so far as to call membership in a volunteer company "the first national pastime in the Middle West."[16]

One such organization, the Quincy (Illinois) City Guard, was formed out of the Phoenix of the Quincy Riflemen, a volunteer company that was called to active service in 1843–45 to take part in the Illinois Mormon Wars and then again in 1846. Returning to Illinois in 1847 after engaging in the defense of Saltillo, Mexico, and the Battle of Buena Vista, the original militia company did not re-form. In 1853 many of the original members of the Riflemen, along with other Quincy residents, established the Quincy City Guard under the command of E. W. Godfrey.[17] Three years later, in a letter dated October 6, 1856, Godfrey announced his intent to resign his commission in favor of James D. Morgan, the former captain of the Quincy Riflemen.[18]

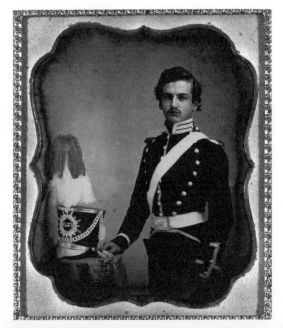

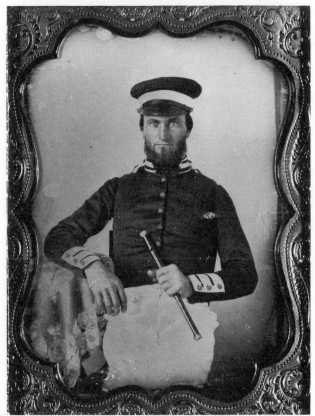

Figure 5.
Anonymous, sixth
plate. Collection of
George S. Whiteley IV.

Figure 6.
Anonymous, quarter
plate. Collection of
John Hightower.

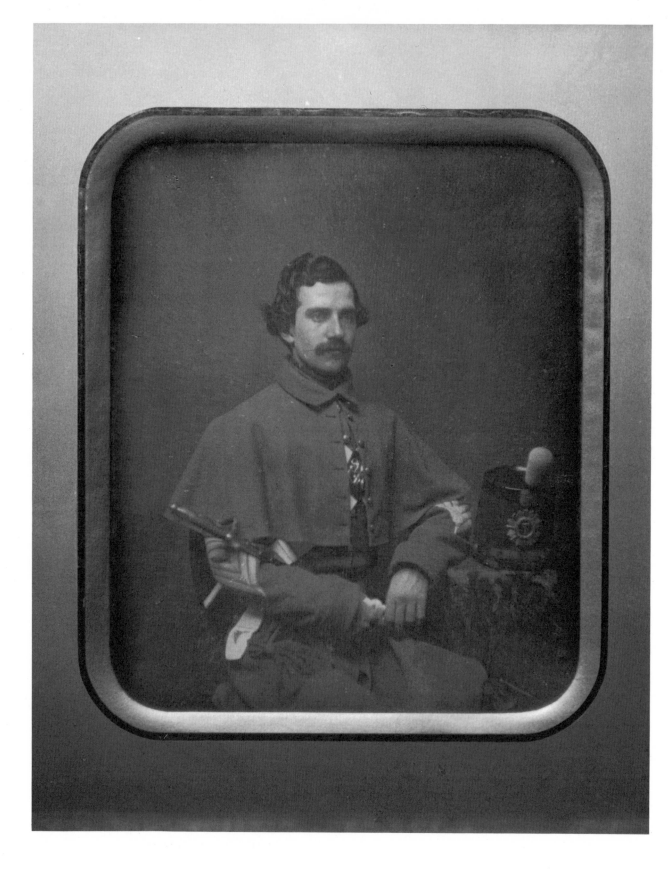

A whole-plate daguerreotype of the Quincy City Guard (see fig. 8) in the collection of the Historical Society of Quincy and Adams County was originally thought to have been made by Warren Reed on July 4, 1855. However, the simple clue of the bare trees in the background seems to indicate that the image was not taken during the middle of an Illinois summer. Also noteworthy is the presence of the two officers. The identity of the officer in the right foreground can be established by a second whole plate (see fig. 9) in the society's collection labeled "Captain E. W. Godfrey and Lieut. U. S. Penfield, Quincy City Guard." More important, Captain James Morgan, resplendent in the uniform of the Quincy Riflemen prior to leaving for Mexico, stands to Godfrey's right in the image of the Guard. Based on Godfrey's letter of resignation, it is probably more accurate to think that this image was taken sometime in October 1856, very close to his turning command over to Morgan.

The background of the Guard image reveals a crowd of onlookers, proof of the continued popularity of militia gatherings during this period. Across the nation, the next few years until about 1858, however, were characterized by a general decline in interest in volunteer companies.[19] This would change as the nation neared the eve of the Civil War.

Through the full history of the American militia, not just the short time limited to the daguerreian era, the main source of popularity in being a member of a volunteer militia organization derived from the militia companies' private character. On parade or dining together amid toasts and cheers, the volunteer companies were as much fraternal clubs as they were official military organizations. Members could feel patriotic and, therefore, democratic. An idealistic romanticizing of chivalry, soldiery, and gallantry was allowed to exist for the militiaman as well as his peers. Through the small window of the daguerreotype, one can gain a fleeting glimpse of the patriotic fervor, militarism, and chivalry once possessed by the nation's citizen-soldier.

Opposite:
Figure 7.
Anonymous,
mammoth plate, circa
1854. A member of the
prestigious Seventh
Regiment of New York.
Investment in such a
large format by this
soldier is a good
example of the pride
involved in member-
ship in a volunteer
militia organization.
Collection of Mark
Koenigsberg.

NOTES

I would like to thank William K. Combs of Hillsboro, Ohio, for his advice, criticism, and willingness to share his vast knowledge of the American militia.

1. U.S. Constitution, Article 1, section 8, clause 16, as quoted in Joseph Holmes, "The Decline of the Pennsylvania Militia, 1815–1870," *Western Pennsylvania Historical Magazine* 57 (April 1974): 203.

2. U.S. *Statutes at Large*, 1:273–74. The Mili-

Figure 8.
Warren Reed, whole plate. Quincy (Illinois) City Guard, circa 1856. Collection of the Historical Society of Quincy and Adams County.

Figure 9.
Warren Reed, whole plate. Captain E. W. Godfrey and Lieut. U. S. Penfield, Quincy City Guard. Collection of the Historical Society of Quincy and Adams County.

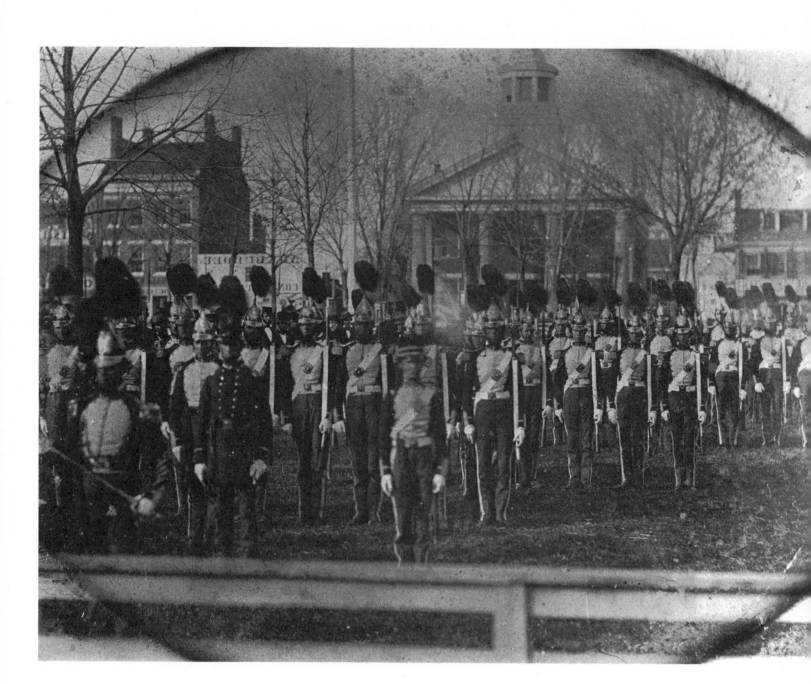

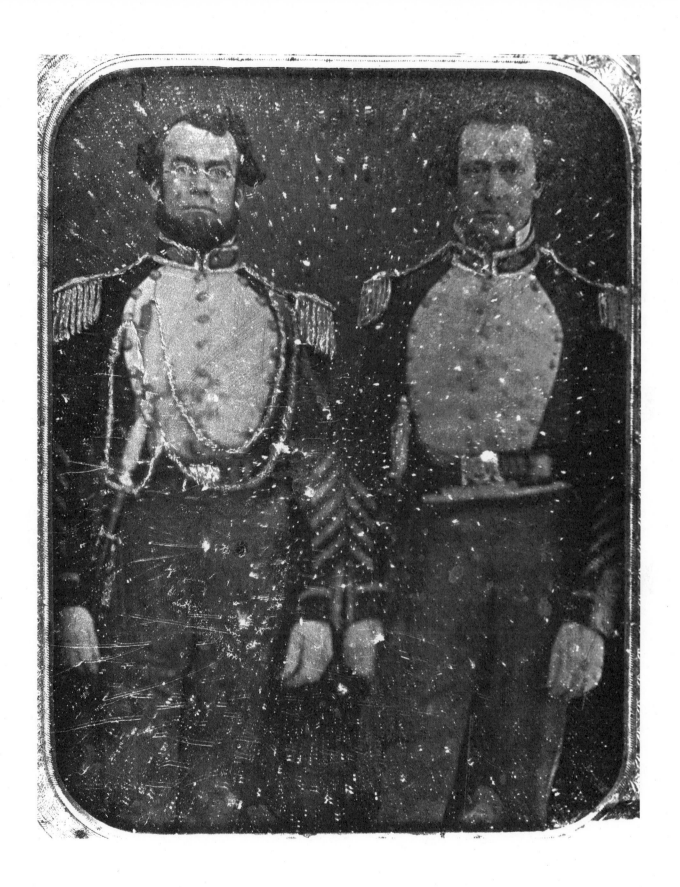

Figure 10.
Anonymous, whole plate. Warren Light Guard Muster. This militia
company from Lawrence, Massachusetts, poses near its armory on Essex
Street, across the Merrimac River from the Atlantic Cotton Mills. The image
was probably made in 1855, the year of its founding. Collection of Matthew
R. Isenburg.

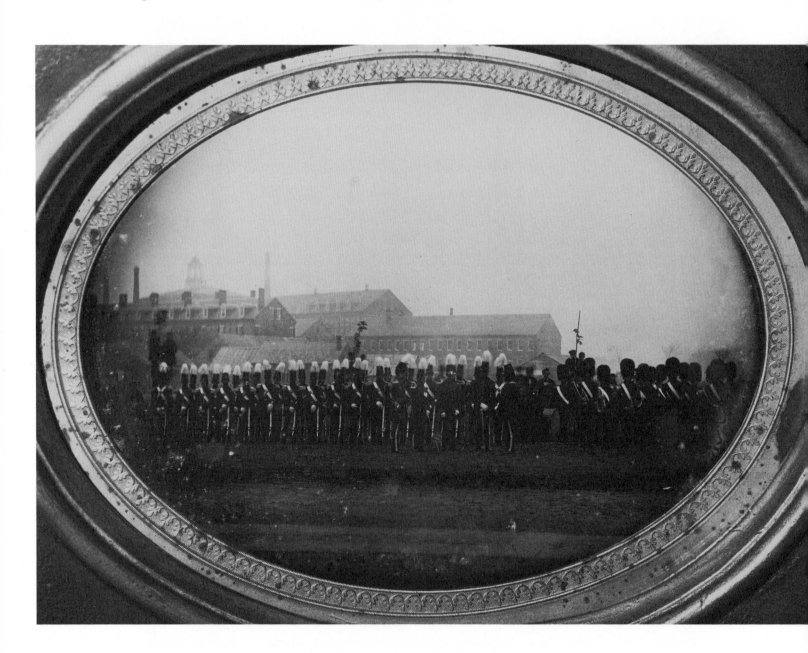

tia Act of 1792 was approved by President George Washington, May 8, 1792.

3. Frederick Todd, "The Militia and Volunteers of the District of Columbia, 1783–1820," *Records of the Columbia Historical Society* 50: 379.

4. George Mays, M.D., "Battalion or Training Day at Schaefferstown in the Olden Time," *Historical Papers of and Addresses of the Lebanon County Historical Society* 1(1899): 150.

5. Alexis de Tocqueville, *Democracy in America* (New York: J. & H. G. Langley, 1840), p. 110.

6. David Turpie, *Sketches of My Own Time,* (Indianapolis: Bobbs-Merrill, 1903), pp. 31–32.

7. Allan Nevins, ed., *Diary of Philip Hone,* quoted in Marcus Cunliffe, *Soldiers and Civilians: The Martial Spirit in America, 1775–1865* (Boston: Little, Brown, 1968), pp. 190–92.

8. Charles W. Burpee, *The Military History of Waterbury, Connecticut* (New Haven: Price, Lee & Adkins, 1891), p. 31.

9. Cunliffe, p. 211.

10. For a full description of the School of the Soldier most used by militia companies between 1830 and 1846, see *Abstract of Infantry Tactics Including Exercises and Manoevers of Light-Infantry and Riflemen; for the Use of the Militia of the United States* (Boston: Hilliard, Gray, Little & Wilkins, 1830).

11. *Easton Democrat and Argus*, September 10, 1846.

12. *Alexandria Gazette and Virginia Advertiser*, December 9, 1846. My thanks go to Lee Wallace, Jr., of Falls Church, Va., for this information.

13. Wilbur G. Kurtz, "The First Regiment of Georgia Volunteers in the Mexican War", *Georgia Historical Quarterly* 27 (December 1943): 311.

14. Charles Sellers, *James K. Polk, Continentalist, 1843–1846* (Princeton, N.J.: Princeton University Press, 1966), p. 204.

15. Emory Upton, *Military Policy of the United States* (Washington, D.C.: Government Printing Office, 1912), p. 221.

16. Theodore G. Gronert, "The First National Pastime in the Middle West," *Indiana Magazine of History* 29 (September 1933): 171–86.

17. *History of Adams County, Illinois* (Chicago: Murray, Williamson & Phelps, 1879), pp. 491–92.

18. E. W. Godfrey to Captain J. D. Morgan, October 6, 1856, James Morgan Papers, Historical Society of Quincy and Adams County, Illinois.

19. Paul T. Smith, "Militia of the United States from 1846 to 1860," *Indiana Magazine of History* 15 (March 1919): 42.

PETER E. PALMQUIST

Silver Plates on a Golden Shore

"THE REAL THING ITSELF"

A daguerreotype of a bearded, pistol-toting '49er with his sluice pan of gold nuggets for all the world to see is an image which has become synonymous with pioneer California. One has to imagine the compelling odyssey and potential impact of these silver daguerreotype plates as they wended their way from the wilds of the frontier West to the sedate homes and families back East. In fact, it might be said that California and the daguerreotype were made for each other. Whereas early reports of California seemed virtually unbelievable, the daguerreotype, then at the peak of its influence, enjoyed a widespread reputation for its ability to document details, no matter how minute. The daguerreotype was capable of recording what California's most famous daguerreian, Robert H. Vance, would describe as "the real thing itself."

Early accounts of the American West, mainly by fur trappers and mariners, had painted a verbal portrait of the Western frontier as a land teeming with game and bristling with fine forests patiently awaiting the settler's axe. Innumerable rivers alive with fat salmon ran through lush meadows—all of which suggested an easy life for immigrants accustomed to the rocky soils and hardscrabble existence of farming in less hospitable climes. Yet the Pacific frontier was also seen as a dangerous wilderness, replete with perils and hauntings.

The discovery of gold at Sutter's Mill on January 19, 1848, placed "California" on everyone's lips. The news of unlimited opportunity was so staggering that public reaction varied from outright disbelief to a wholesale departure by those eager to fill their pockets with gold "for the taking." A number of daguerreotypists flocked to

California along with the hordes of eager goldseekers. There was money to be made initially by capturing the likenesses of the cross-country immigrants for sending to loved ones left behind and later by picturing the "Elephant," a euphemism for gold. An impatient world was mad to *see* California, if not firsthand, then by whatever possible means.

The most successful early representations of Gold Rush California—at least, in terms of reaching a wide audience—took the form of painted panoramas, a popular form of entertainment in the 1840s. The panoramas were generally arranged as travelogues painted on giant canvas rolls, each scene transported from one side of the stage to the other by turning the canvas on vertical rollers. The scenes were usually accompanied by music and/or explanatory narrative.[1] Panoramas of California were rushed into production as quickly as possible:

> One picture of a voyage around Cape Horn was being exhibited in New York in mid-September of the first gold rush year. The spring of 1850 saw at Gothic Hall in Brooklyn a panorama of the Gold Mines of California produced by Emmert (or Eimert) and Penfield. James Wilkins' Moving Mirror of the Overland Trail, painted in Peoria by a St. Louis artist, began its tour in September 1850. Beale and Craven's Voyage to California and Return was showing at Stoppani Hall, New York, in November 1850.[2]

Emmert's panorama, *The Gold Mines of California*, was especially popular and so arranged that the audience could enjoy each of the principal features along the most common route to the California gold fields from the Isthmus of Panama to Acapulco, to "the Entrance to the Bay of San Francisco (called the Golden Gate)," and on to the fields themselves.[3]

These panoramas proved so popular that new ones were constantly being produced; some, painted by artists who had never visited California, were almost entirely fictional. However, as the public became increasingly more sophisticated, the demand for more truthful illustrations led inevitably to the production of panoramas painted "on the spot" in California. From his base in Stockton, W. H. Cressy billed his *Panorama of California* as the "Chef d'oeuvre" of panoramas. "Each view is 20 feet in length and 9 feet in height, and is executed in oil colors."[4] Cressy spent some twelve months completing his panorama, which, despite its early production date (1851), already featured a "historical" context: "The first view is one of the Golden Gate itself . . . the next view, in order, is that of 'San Francisco in 1849.' An excellent picture. The view was taken on the 3rd of July, and the *Philadelphia* is

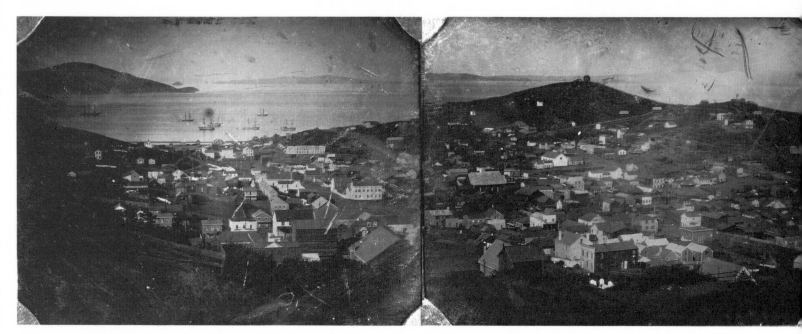

Figure 1.
Anonymous, Pano-
rama of half plates.
This view of San
Francisco is thought
to have been taken
early in 1851 and
has sometimes been
attributed to S. C.
McIntyre. Collection
of the International
Museum of Photogra-
phy at George East-
man House.

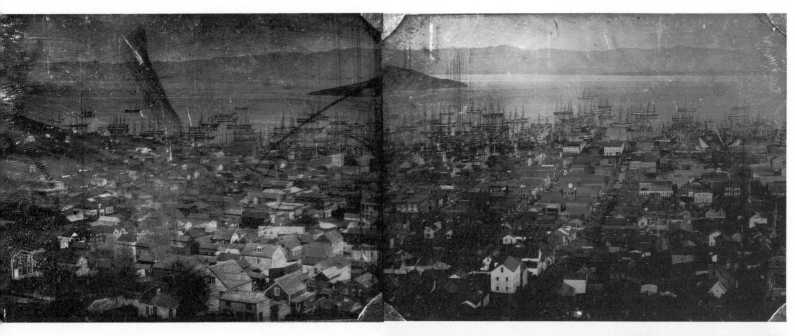

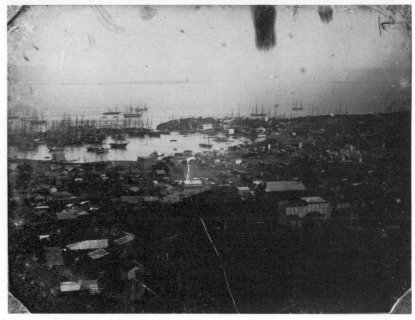

Figure 2.
George Johnson, whole plate. Mining and
assorted activity on the American River near
Sacramento. Collection of Matthew R. Isenburg.

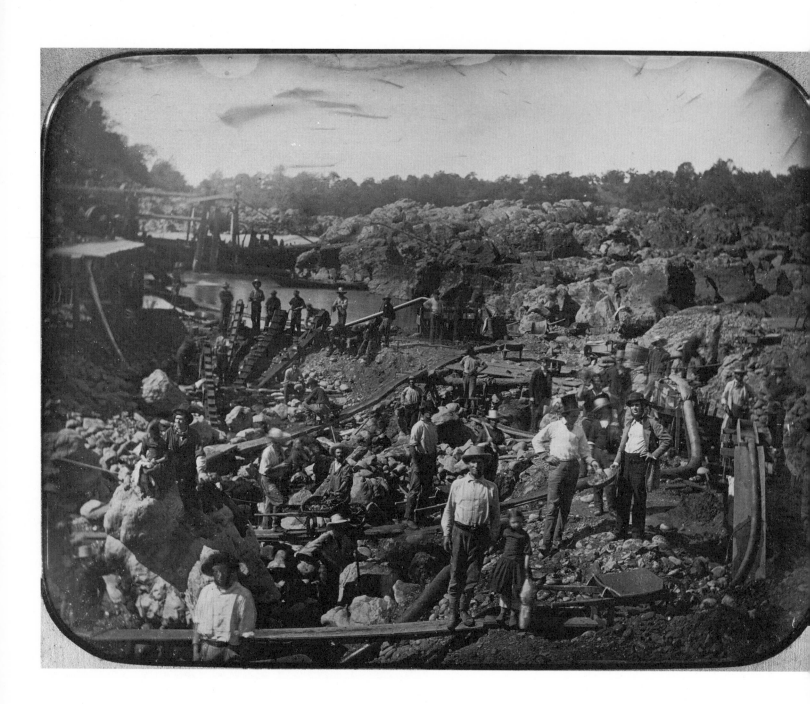

BEALE & CRAVEN'S
PANORAMIC VOYAGE TO
CALIFORNIA!

AND THE
GOLD MINES!
AROUND CAPE HORN,
AND RETURN BY THE ISTHMUS.

Has delighted more than 250,000 visitors in Philadelphia, Charlsteon, and Baltimore, and nightly received unbounded applause

Painted by George Hielge, Esq., on 33,000 Feet of Canvas!
IS NOW OPEN,
AT FRANKLIN HALL.

This Gigantic Panorama accurately depicts the most striking Scenery along the

ATLANTIC & PACIFIC COASTS OF NORTH & SOUTH AMERIGA,
With consecutive Views of the
DELAWARE RIVER, SAN FRANCISCO, AND BOSTON BAYS,
And Graphic Sketches of the WEST INDIA ISLANDS, and of the wild and gorgeous Scenery
along the ISTHMUS OF PANAMA, and numerous interesting localities in the INTE-
RIOR OF CALIFORNIA, with spirited Sketches of the Mining Operations
of the GOLD REGIONS, with a vivid portrature of vessels.
ROUNDING CAPE HORN IN A TERRIFIC STORM! and of numerous prominent American Cities and Towns among
which are Philadelphia, New Castle, Cape May, Charleston, San Juan, Faxardo, Rio de Janeiro, Valparaiso, Mazatlan, San
Francisco, Monterey, Honolulu, Panama, Havana and Boston. [JOHN F. MOORE, PRINTER.]

Figure 3.
Broadside. Collection
of the New Bedford
Whaling Museum.

represented burning in the harbor. . . . At that time Montgomery Street was [still located] on the beach, and the Long Wharf [was] in its infancy; of these historical facts the picture is a record."[5]

By early 1851 almost every Easterner could boast a friend or relative who had "gone West." California also boasted immigrants from every continent on the globe. Moreover, the world's perception of the California frontier was undergoing significant changes as previous rumors and half-truths were replaced by increasingly more accurate and more sober assessments. This reevaluation process also brought painted panoramas into question, in part because the daguerreotype image was considered far more truthful than images formed by an artist's brush.

Seeing the handwriting on the wall, John Wesley Jones decided to have the best of both worlds. In the summer of 1851 he embarked on his ambitious 1,500-view *Pantoscope of California*. Unlike his panoramic predecessors, Jones proposed to daguerreotype every important overland feature along a route that stretched from San Francisco to the Missouri River. Starting from California, he hired the best daguerreotypists available and set out along the overland trail.[6] After the trip these images were converted from daguerreotypes into a painted panorama, ostensibly to better reach a mass audience, a compromise that once again fell far short of "the real thing itself."

Although daguerreotypes suffered from their small size and one-image-at-a-time production restraints, they had special and romantic qualities which helped transcend these faults. Who has not experienced an overwhelming sense of intimacy and awe upon opening a daguerreotype case? Imagine a mother's feelings as she viewed her faraway loved one by candlelight. Likewise, while viewing a surviving daguerreotype panorama taken from San Francisco's lofty Telegraph Hill, one can almost feel the swelling of American pride which had taken place back in 1851:

> Before us was our beautiful bay, on whose bosom the representatives of the
> world's commerce were riding, the tall masts rising thick, like a pine forest.
> The bays of San Pablo and Suison, covered with steamboats and sails lay be-
> yond . . . below us was our city stretching like a panorama over plain and hill;
> the busy streets thronged with men; the bustle and activity of business; the
> crowded wharves, the glaring signs and flying flags. The musical hum of the
> mechanic's hammer rose above the noise and reminded us that what we saw
> was real . . .[7]

Opposite:
Figure 4.
Robert H. Vance,
whole plate.
Sacramento Street,
San Francisco, looking
toward the bay. This
image was probably
made from the upstairs
window or roof of
Vance's gallery on the
corner of Sacramento
and Montgomery
streets. Collection of
the Bancroft Library.

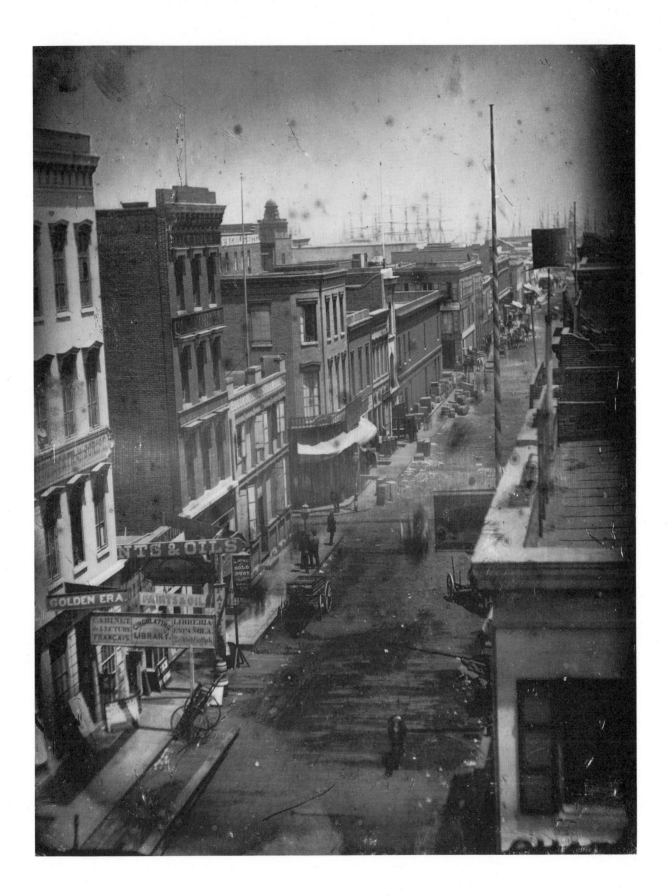

Figure 5.
Woodcut engraving
"from a daguerreotype
by R. H. Vance" as
published in Frank
Leslie's Illustrated
Newspaper, *June*
1856.

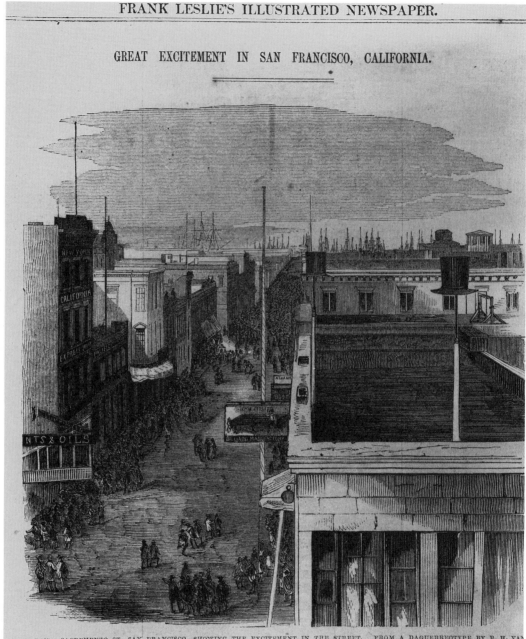

GREAT EXCITEMENT IN SAN FRANCISCO, CALIFORNIA.

VIEW DOWN SACREMENTO ST., SAN FRANCISCO, SHOWING THE EXCITEMENT IN THE STREET. FROM A DAGUERREOTYPE BY R. H. VAN

on the west side of Montgomery │ crossed, and, suddenly throwing off a short cloak which he wore, │ prevailed throughout the stree
lock, as if watching for King's ap- │ presented a revolver at King's person, when he and King were │ beings before the jail preven
he pavement before the Pacific Ex- │ only a few feet apart, and fired. The shot took effect in King's │ There was much feeling manif
d to step into the street as King │ breast, and passed through his body. It is said that Casey called to │ the people was made to take th

*Figure 6.
Carleton Watkins,
paper print of a da-
guerreotype attributed
to Vance, of James
Marshall at Sutter's
Mill, 1851. This is the
nearest image we have
that would have been
like, or possibly part of,
the lost Vance hoard of
three hundred da-
guerreotypes. Courtesy
of Peter E. Palmquist.*

While it is somewhat difficult to regard a daguerreotype as a deliberately se-lected advertising tool, these images clearly helped shape public attitudes toward California and the American West generally.

In the meantime, San Francisco was destined to become one of the most daguerreotyped cities in America. There are at least nine surviving multiple-plate daguerreotype panoramas of the city, compared to none of New York City. The con-temporary enthusiasm afforded these daguerreotype panoramas—both on the part of a San Francisco newspaperman and as regards the panoramas' potential for influencing a world audience—is obvious in the following review. Sterling C. McIntyre, a former Florida dentist turned daguerreotype artist, had produced the five-plate panorama specifically for the Crystal Palace Exhibition in London in 1851:

DAGUERROTYPE OF SAN FRANCISCO—Decidedly the finest thing in the fine arts produced in this city, which we have seen, is a consecutive series of Daguerrean plates, five in number, arranged side by side so as to give a view

of our entire city and harbor, the shipping, bay, coast and mountains opposite, islands, dwellings and hills—all embraced between Rincon Point on the right, to the mouth of our beautiful bay on the left, including between lines proceeding from the hills to the west of the city as the point of vision. This picture, for such it may be termed, although the first attempt, is nearly perfect. It is admirable in execution as well as design. It is intended for the "World's Industrial Convention" in London. We venture the assertion that nothing there will create greater interest than this specimen in the Art among us, exhibiting a perfect idea of the city which of all the world carries with its name abroad more of romance and wonder than any other. It is a picture, too, which cannot be disputed—it carries with it evidence which God himself gives through the unerring light of the world's great luminary. The people of Europe have never yet seen a picture of this, to them, most wonderful city. This will tell its own story, and with the sun to testify to its truth. We would suggest that a subscription be raised to put it into a frame equal to its merits, Californian in style and richness, inlaid with native specimens of gold and auriferous quartz. This would make a perfect gem. The views were taken by Mr. McIntyre of this city. He proposes, if his efforts meet with sufficient encouragement, to finish and furnish duplicates of this excellent and artistical picture to the lovers of art, at one hundred dollars. It may be seen at this office.[8]

Such accounts also illustrate the truly cosmopolitan and entrepreneurial nature of many of California's earliest daguerreians. These men—and women, too, for Julia Shannon was active in San Francisco in 1850–51—were well aware of the daguerreotype's unique ability to *sell* the golden promise of California—and to line their own pockets in the process. The manner in which these pioneer daguerreians exploited the selling qualities of the medium is as diverse as the artists themselves.

The first known daguerreian of California was an Englishman, Richard Carr (1818–1888), who learned of the Gold Rush while in South America. Booking passage on the next available ship, Carr arrived in San Francisco harbor on the very last day of 1848 and shortly thereafter established himself as San Francisco's earliest portrait photographer. Within a few months, however, Carr departed for the gold mines, where he made a modest fortune before becoming a highly successful merchant.[9] Other daguerreotypists, such as Alfred Edwards, a former New Yorker, stuck with their trade: "DAGUERREOTYPING IN THE MINES.—Mr. Alfred Edwards of New York, has been for the last year engaged in taking daguerreotype likenesses of

Figure 7.
Anonymous, half plate,
1849. Flume on the
North Fork of the
American River.
Collection of the J.
Paul Getty Museum.

Figure 8.
Robert H. Vance, half
plate, circa 1851. View
of a California Min-
ing Town with the
Rancherie House Hotel.
Collection of the
J. Paul Getty Museum.

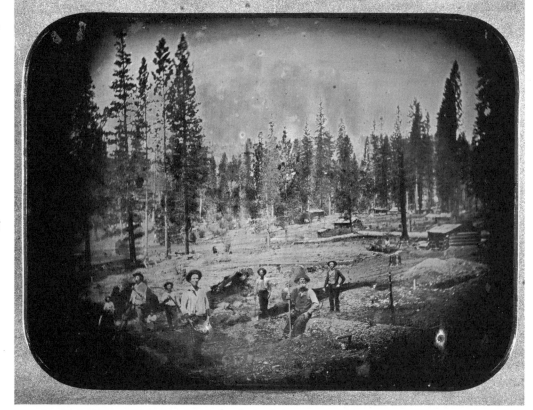

Figure 9.
Anonymous, half plate.
A letter accompanying
this image states, "I
have sent by him a
daguerreotype of a
mining scene in the
mountains. In it you
can see how the honest
miners of Cal. look
when at work. They
have just been cleaning
up their sluices & you
can see the oro in the
pan." Collection of
Matthew R. Isenburg.

diggers, as well as picturesque sketches of various mining localities, etc. Over 1,000 *phizzes* have been taken by Mr. E., and we are gratified to learn that the success met with, has realized his most sanguine anticipations." [10]

Many of the early California daguerreotypists were youthful participants in a more generalized search or longing for adventure, a perfect example of which brought William Herman Rulofson (1826–1878) to California. Rulofson, born and raised along the Maine/Canada border, had learned daguerreotyping in the fall of 1842 at the age of sixteen. His mentor was the operator of a small studio in St. John, New Brunswick. After a few years he moved to Boston, where he worked for L. H. Hale & Company at 109 Washington Street. In 1845 young Rulofson left Boston.

William sought to enlarge his field and focus by travel and observation, and we find him canvassing the Eastern States, the Canadas, thence over the seas to England [he was shipwrecked in September 1846 and landed destitute in Liverpool], Ireland and Wales; from thence to the Azores and Western Islands, and thence through Mexican territory to the Southern States, his mission, in chief, we believe, being the introduction of the Daguerreotype. . . . [A]bout this time, 1848, Rulofson formed a temporary business connection and sought fortune and fame in Newfoundland . . .

From there he traveled through Patagonia and Chile, in the process of which he photographed everything of interest from a "Patagonia Savage to a Brazilian Emperor." He then turned his steps to "the golden shores of the Pacific . . . which was another New-found-land, and also a land of promise." [11]

But of all these early daguerreotypists, none had a greater overall impact on early California photography than Robert H. Vance (1825–1876). Vance surely rates in influence and innovation alongside the great Mathew B. Brady, who was probably the best-known American photographer of the nineteenth century. Not only was Vance the first to systematically explore Gold Rush California with his camera, but he was an astute observer of the growing importance of such work. His "First Premium Gallery" in San Francisco was the most prestigious daguerreian gallery in Western America and his branch galleries eventually extended from the Comstock lodes of Nevada to Hong Kong. Not surprisingly, his photographic establishments served as a training ground for many apprentice operators, a number of whom are among California's finest image makers. [12]

Vance sponsored, and subsequently displayed, the earliest series of large wet-plate landscape views of California—photographs on glass of the American River

Figure 10.
Anonymous, quarter
plate. Miners' shacks
beside a river.
Collection of Matthew
R. Isenburg.

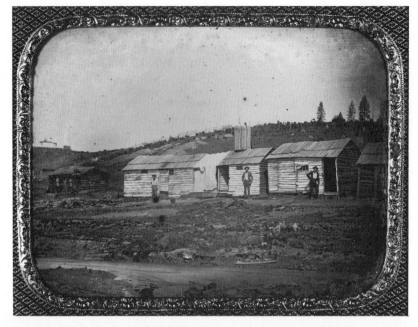

Figure 11.
Anonymous, half plate.
Round Valley ranchers,
including Simmon
Storms, and Indians.
Collection of Peter
Shearer.

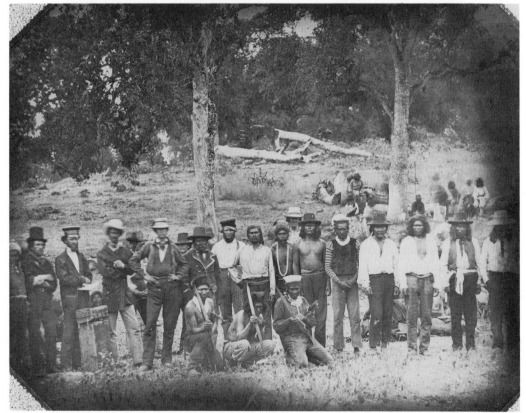

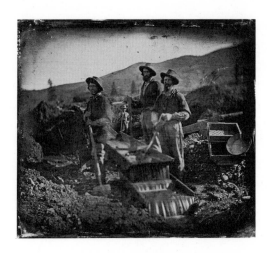

*Figure 12.
Anonymous, ninth
plate, circa 1853.
Thompson's Dry
Diggins, near Yreka,
California. Collection
of the Siskiyou County
Museum, Yreka,
California.*

mining region taken in 1858. The following year he sent his assistant and junior partner, Charles Leander Weed (1824–1903), to the Yosemite Valley where Weed made the first-ever photographs of that geologic marvel. Vance is also credited with the early training and sponsorship of Carleton E. Watkins (1829–1916), who became California's most illustrious nineteenth-century landscape photographer.[13] Because of Vance's own landscape work as a pioneer Western daguerreian and his ongoing support of others who photographed nature, he may well deserve recognition as the father of Western landscape photography.

Vance gained critical acclaim in 1851 when he exhibited three hundred whole-plate daguerreotypes called *Views in California* in New York City. He actually began this series while en route to California. He then turned his camera on San Francisco and the California gold fields. *Views in California* opened at 349 Broadway, New York, and immediately garnered glowing reviews. The *Photographic Art-Journal* exclaimed that "looking upon these pictures, one can almost imagine himself among the hills and mines of California,"[14] and the *Daguerreian Journal* was amazed at the exhibit's comprehensiveness and marveled at the difficulty of Vance's project: "When we consider the disadvantage of operating in a tent or the open air, and in a new country, we are much surprised at such success; as a collection, we have never seen its equal."[15]

The accompanying catalog makes it abundantly clear that Vance's *Views in California* was a premeditated undertaking:

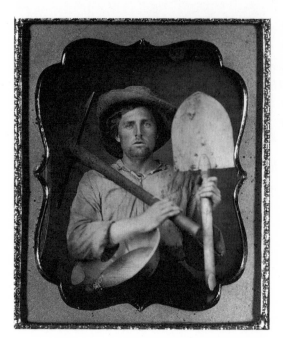

Figure 13.
Anonymous, sixth
plate. Collection of
Matthew R. Isenburg.

To such a pitch has public curiosity been excited [concerning California], that the smallest item of news in regard to this newly discovered El Dorado, is eagerly seized upon. Much valuable information has been given in regard to the country, by several excellent works, but inasmuch as the sight of the place affords so much more pleasure, and gives so much better knowledge than the bare description possibly can, the Artist flatters himself that the accompanying Views will afford the information so much sought after. These Views are no exaggerated and high-colored sketches, got up to produce effect, but are as every daguerreotype must be, the stereotyped impression of the real thing itself.[16]

Originally from Maine, Vance had migrated to Boston as a young man. It was there that he became a daguerreian artist during the mid-1840s.[17] In Boston he was in a perfect setting to view the painted panoramas and to understand the public's need to see "the real thing itself."

Ironically, the best overall review of Vance's *Views in California* compared his productions with the various panoramic paintings currently available to the public. Writing in the *Photographic Art-Journal*, "one of our best landscape painters," un-fortunately unnamed, commented that "form, in color, is perhaps the greatest charm upon which the eye can dwell, therefore a panorama in distemper colors, should be considered of paramount importance to one produced by the Daguerreotype. We

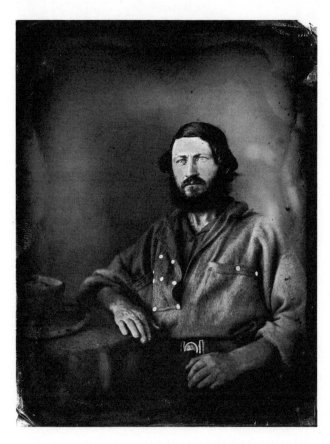

Figure 14. Anonymous, quarter plate. A note in the case reads, "James D. Parker, born Jany. 17th, 1820, in New Bedford, Mass. This daguerreotype was taken for him at Weaverville, Trinity County, about 400 miles north of San Francisco, California, October 30th, 1853, and sent to Jacob Parker, his father by the U. States Mail and rec'd by him Dec'm 13th 1853. Postage paid by James 76 cents." Collection of the Oakland Museum.

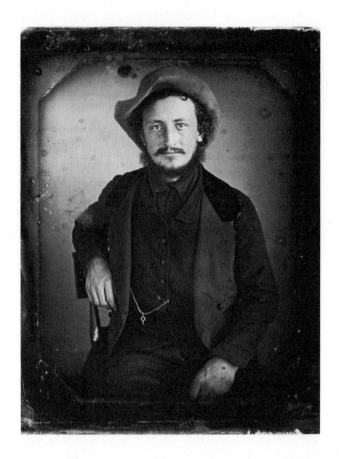

Figure 15.
Anonymous, quarter
plate. Collection of
Peter E. Palmquist.

speak understandingly on this subject, and do not hesitate to say that Mr. Vance's views of California created in us a greater degree of admiration that did Banvard's or Ever's great [painted] productions of the Mississippi and noble Hudson." [18]

The painter then went on to discuss the questions of detail and fidelity of nature found in daguerreotype images. His words form a classic testament to the power and ability of these silver plates to document "the real thing itself":

> Detail . . . should be the principle [*sic*] aim of all artists, and if any desire to see this achieved to the highest state of perfection, let them call and examine the . . . productions of Mr. Vance. Not a blade of grass, nor the most minute pebble—hardly perceptible to the naked eye—nor the fibres of the bark of the tree—nor the myriads of tiny leaves that compose the clustering foliage— nor the silver stretches in the zig-zag ripple of the water as it glides gently on, or meanders among the rocks, washing up in its passage the little spangles of gold that have made California the great attraction of the whole world—

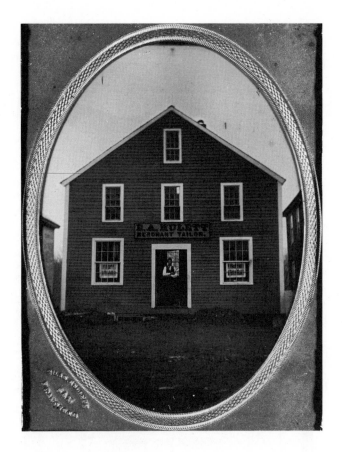

Figure 16.
Silas Selleck, quarter
plate. Hulett's Tailor
Shop, San Francisco.
Collection of Matthew
R. Isenburg.

but are wonderfully portrayed in these pictures in miniature most incomparable. . . . There is one in particular, having in it a fallen tree over three hundred feet in length, sharp, angular rocks, etc., which we have no hesitation in saying, is the finest daguerreotype view ever taken.[19]

Sadly, these images have vanished without a trace. In some ways the loss of Vance's *Views of California* might be regarded as the single greatest loss of the daguerreian era, both artistically and historically.

The daguerreotype, to be sure, marked only the mere beginning of photography's role in California. By 1856 wet-plate negatives were already in use there. This new process led to an explosion of mass-produced and easily affordable paper photographic images carrying California to the farthest corners of the globe. Images of gold miners were supplanted by views of Yosemite. Likewise, stereographs of scenes along the overland railroad became the forerunners of the photo-postcard.

Photographs of the so-called "California vegetables"—giant trees; squash, mel-

Figure 17. Mammoth Tree "from a Daguerreotype taken on the spot." An Adelaide Gallery (London) advertisement described the Mammoth Tree as a "vegetable wonder" and a "vegetable mastodon" and noted that "daguerreotypes were taken on the spot, and certificates obtained from gentlemen of high standing, familiar with the country," so unbelievable were such objects. Courtesy of Peter E. Palmquist.

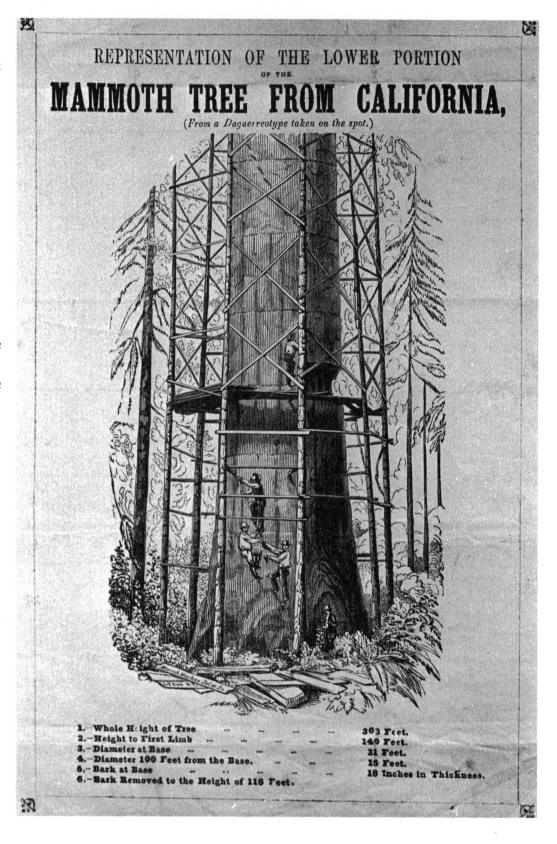

ons, and other vegetables of enormous proportions; fruit trees that doubled in size every year—were mass distributed.[20] The evidence was clear: in California there was good soil, abundant water, and unlimited sunshine. Yet, although photography was clearly capable of producing lasting visual icons, there is not a more compelling phrase to be found in the entire history of photography than that used by Robert H. Vance in 1851: "These Views are no exaggerated and high-colored sketches, got up to produce effect, but are as every daguerreotype must be, the stereotyped impression of the real thing itself."

NOTES

1. For a fine overview of painted panoramas, see Robert Wernick, "Getting a Glimpse of History from a Grandstand Seat," *Smithsonian Magazine* (August 1985): 68–84.

2. John Francis McDermott, "Gold Rush Movies," *California Historical Society Quarterly* 33 (March 1954): 29. There were numerous other painted panoramas, including Skirving's *Panorama of Fremont's Overland Journey to Oregon and California* and the Purrington & Russell panorama, a treasured possession of the New Bedford Whaling Museum.

3. McDermott, p. 30.

4. *San Joaquin Republican*, June 18, 1851.

5. *San Joaquin Republican*, June 25, 1851.

6. Catherine Hoover, "Pantoscope of California," *California Historical Courier* (July 1978): p. 3ff. See also J. W. Jones, "Jones' Pantoscope of California," *California Historical Society Quarterly* 6 (1927): 109–238. Associated with this project were California daguerreians William and Jacob Shew and Seth Louis Shaw.

7. *San Francisco Alta*, January 30, 1851, p. 2.

8. *San Francisco Alta*, January 19, 1851, p. 2. For additional information on McIntyre, see *The Daguerreian Annual, 1990* (Eureka, Ca.: Daguerreian Society, 1990), pp. 190–93.

9. For a discussion of Richard Carr's fascinating career, see Peter E. Palmquist, "An Account of California's First Photographer," in *Photography in the West* (Manhattan, Kans.: Sunflower University Press, 1987), pp. 102–5.

10. *Sacramento Daily Union*, October 20, 1851.

11. Information from *Anthony's Photographic Bulletin* 6 (November 1874): 357–58, and Robert Bartlett Haas, "William Herman Rulofson," *California Historical Society Quarterly* 34 (December 1955): 289–300.

12. For a quick overview of Vance's career, see Peter E. Palmquist, "Robert Vance: Pioneer in Western Landscape Photography," *American West* (September/October 1981): 22–27.

13. For Weed, consult Peter E. Palmquist, "California's Peripatetic Photographer—Charles Leander Weed," *California History* 58 (Fall 1979): 194–219. Likewise, for Watkins see Palmquist, *Carleton E. Watkins: Photographer of the American West* (Albuquerque: Amon Carter Museum & University of New Mexico Press, 1983).

14. *Photographic Art-Journal* 2 (October 1851): 252–53.

15. *Daguerreian Journal* 2 (November 1, 1851): 37.

16. R[obert] H. Vance, *Catalogue of Daguerreotype Panoramic Views in California* (New York: Baker, Godwin & Company, 1851), p. 4.

17. The most complete information concerning Vance's early life is found in Peter E. Palmquist,

Figure 18. Anonymous, whole plate. Grave of Philip A. Potter with obituary and memorials pinned to the case. "Died. In this city, July 22d, of Panama fever, Philip A. Potter aged 21 years, formerly of New Bedford, Mass. Boston and New Bedford papers please copy." The notice of another death listed after Potter's suggests the city was San Diego. With such memorial images as this, the daguerreotype served to keep a record of the Gold Rush dead as well as the Gold Rush living. Collection of Matthew R. Isenburg.

"Robert H. Vance: The Maine and Boston Years" (unpublished manuscript held by the author, 1990).

18. *Photographic Art-Journal* 2 (October 1851): 253.

19. *Photographic Art-Journal* 2 (October 1851): 253.

20. See Gail Buckland, *First Photographs* (New York: Macmillan, 1980), p. 179, for a daguerreotype of a California potato weighing more than seven pounds.

JEANNE VERHULST

The Contemporary Daguerreotype

The daguerreotype is so firmly rooted in the nineteenth century that many people are surprised to learn that daguerreotypy is being practiced today. Yet in 1989, the year that marked the 150th anniversary of the daguerreotype and the beginning of photography, at least seven Americans as well as a Frenchman, a Belgian, and a Japanese were actively making daguerreotypes. Furthermore, the many symposia and exhibitions which surrounded the anniversary inspired a number of people to begin working in the process or to renew former interests, so that at this writing at least three more Americans and several others can be added to the total. In fact, in the past two decades there has been more activity in the practice of daguerreotypy and in research on the process than in the previous seven decades of the century.

The most important consequence of the persistent fascination with daguerreotypy is that an art form is preserved and perpetuated. A daguerreotype is a unique object whose image possesses a beauty all its own; there is no other photographic process which produces such depth and clarity in its image, and the resolution and tonality of the daguerreotype are legendary. The fact that people still work in this elegant medium helps to ensure that it will not simply be consigned to history, but that it will remain vital and perhaps be brought to new levels of expression. All who are willing to attempt daguerreotypy today should be applauded, their successes celebrated, for it will be through their endeavors, and the efforts of those who support them, that the medium will survive to delight and intrigue people with its beauty.

Another valuable aspect of the continued interest in daguerreotypy is that it has led to recent scientific investigations that have increased understanding of the process and of the nature of the daguerreotype itself. This research has not only produced findings of great intrinsic value; it also benefits contemporary workers, at least indirectly, by providing a clear scientific basis for understanding what is happening as they attempt to produce daguerreotypes. In general, investigative efforts have been carried out in two main areas: the conservation of nineteenth-century work and the procedure for making daguerreotypes.

Investigations into the physical structure and deterioration of nineteenth-century daguerreotypes were conducted in 1979 by Alice Swan, with Dr. Chuck Fioro and Dr. Kurt Heinrich. Their research found that inadequate or deteriorating seals around the cover glass and plate permitted contaminants to reach the surface of the image, and they identified decomposing nineteenth-century glass as the primary cause of physical damage to the image. Their conclusions urged periodic testing for evidence of glass deterioration, replacing old seals, and covering plates with new glass as a means of adding to the longevity of the object.[1] Obviously, these recommendations are applicable to new daguerreotypes as well, to ensure that the same deterioration does not befall the treasures of tomorrow.

Since 1979, Dr. M. Susan Barger has done considerable research on the physical makeup of daguerreotypes. Among her noteworthy efforts was a study done in 1982, in association with others, which led to a breakthrough in cleaning methods. A standard practice for cleaning daguerreotypes had included using corrosive chemicals which, while removing tarnish, also caused minute etching of the plate and left a chemical residue that contributed to additional damage over time. Barger found that the new method, known as electrocleaning, "not only successfully removes tarnish and preserves the image microstructure, it also appears to heal slightly the etched surface of previously cleaned daguerreotypes. Further, no new corrosion products are left on the surface of daguerreotypes cleaned using this method."[2] This discovery was an important contribution to the conservation of daguerreotypes, old and new. Barger's full analysis of the daguerreotype is presented in her book *The Daguerreotype: 19th-Century Technology and Modern Science.*[3]

Irving Pobboravsky, who has been making daguerreotypes for over twenty years, began formal research on the process in 1969 for the purpose of advancing understanding of certain chemical actions which take place during the process of sensitizing the daguerreotype plate. Continuing the work begun by John William Draper in 1841, Pobboravsky's studies centered on the causes of color changes on

the daguerreotype plate as it is being iodized, the thickness of the iodide layer relative to the different colors which the plate assumes during sensitizing, and the sensitometry of the iodized plates developed by both mercury and the Becquerel phenomenon.[4] His investigation into this aspect of the process has, among other things, deciphered what actually happens during sensitizing. It has also provided a color standard using established color specification systems to serve as a guide in sensitizing, established a standard for the point of maximum sensitivity in a plate, and indicated the importance of a stable light source in viewing the plate during sensitizing.

While the scientific studies of Swan, Barger, and Pobboravsky have shed light on some of the complex mysteries of the daguerreotype, others have also made contributions to the field which are specifically aimed at the contemporary worker. For example, Thomas Young, from Boulder, Colorado, addressed special problems which frustrate daguerreotypists today. His research on the topics of the black spots which sometimes appear on plates after development and on the advantages and disadvantages of two daguerreotype plates resulted in two papers, "Spots on Daguerreotypes, Their Causes and Remedies" and "A Comparison of Two Types of Daguerreotype Plates: The Theiss Plates and the Engraver's Plates," which were written in 1976 and 1977 respectively. While these papers were not published, they have been widely circulated among modern daguerreotypists, who have found them invaluable.

In 1977 direct assistance to practicing and aspiring daguerreians became available. The difficulties Kenneth Nelson faced in learning how to make daguerreotypes resulted in the production of a handbook, *A Practical Introduction to the Art of Daguerreotypy in the 20th Century.*[5] In it he warns of the dangers of the toxic chemicals, illustrates designs for equipment, discusses pitfalls to avoid in processing, and indicates the necessary steps to be taken to preserve the finished plate. Nelson's instructions adhere to early formulas, and the manual is presented in clear, understandable language. While instructions for making daguerreotypes have been published in various magazines and journals over the years, Nelson's is the only comprehensive twentieth-century manual on making daguerreotypes published to date.

Joseph Boudreau has also made a significant contribution to the understanding of one variation of the daguerreotype process, and he has clarified a bit of daguerreian history as well. Boudreau is a teacher of photography who has made daguerreotypes for a number of years. In 1980 he succeeded in making Hillotypes (plate 26), following the complicated process that Levi L. Hill first described in 1850.[6] In doing so, Boudreau proved the validity of Hill's claims to have invented a color photo-

graphic process, claims which have been debated by photohistorians for decades.[7] Boudreau presented his findings at a meeting of the Society for Photographic Science and Engineering in 1986.[8] It is unlikely that modern practitioners will ever prefer Hillotypes to conventional daguerreotypes, however, since the process is so much more laborious, requires the use of additional toxic chemicals, and produces an image which is not stable in bright light.[9]

In addition to producing both scientific advances in the field and practical assistance to daguerreotypists, modern interest in daguerreotypy has also resulted in research that has helped expand and clarify the history of the daguerreotype. Not only does this work contribute to the accuracy of daguerreian history, it also serves as a form of encouragement to modern artists, who frequently work in isolation, not realizing that there have been others who have gone or are going through the same joys and struggles with the process.

The very early history of the daguerreotype is well documented by historians and well known by students of photography. Indeed, the fervor of the period, which can almost be felt when reading old journal articles, frequently entices today's photographers to try daguerreotypy. Nonetheless, historians make little mention of daguerreotypy following the introduction of other processes, as though, having served its purpose of launching photography, the daguerreotype became extinct. In 1977, Grant Romer, who has built his career around the study of the daguerreotype and who is a daguerreotypist himself, corrected this false impression when he published "The Daguerreotype in America and England after 1860."[10] This well-researched and important article fills a void in the history of the daguerreotype following its supposed demise in the late 1850s. In the article Romer discusses the many individuals who remained active through the end of the nineteenth century, brings to light several people who worked in the process in the early part of the twentieth century, and introduces those who became active during the 1960s and 1970s.

Only a few individuals kept daguerreotypy alive into the first half of the twentieth century, although there was evidence of interest in the medium in journal articles, some of which carried instructions for making daguerreotypes.[11] In his essay Grant Romer discusses several key figures. The New York City photographer William M. Hollinger offered hand-colored daguerreotype portraits in his photo studios on Fifth Avenue as late as 1929. Charles Herbert Tremear was a tintypist at the Henry Ford Museum at Greenfield Village, Michigan, from 1929 to 1940, and "made daguerreotypes by appointment before the museum opened each day."[12] Romer also corresponded with Ray Phillips, Jr., a Californian who first attempted

daguerreotypes in 1936 and returned to it following the Second World War. Because Phillips's work was among the first made for largely personal rather than for professional reasons, as was the case with Hollinger and Tremear, Romer calls Phillips "the dean of modern daguerreians."

In the three decades following the Second World War, the experimentation taking place in photography included a return to old processes, and some photographers who were looking for greater challenges chose the daguerreotype. Shinkichi Tajiri, an American who now lives in Holland, began making daguerreotypes in 1959 by contact exposing positive transparency images directly onto daguerreotype plates. His retrospective exhibition "101 Daguerreotypes,"[13] which was held at the Stedelijk Museum in Amsterdam in 1976, spanned seventeen years of his daguerreian work. The museum published an illustrated catalog which contained a checklist, a bibliography, and brief instructions for making daguerreotypes and building the necessary apparatus.

A curious reference which indicated the possibility of additional daguerreotype activity at this time appeared on the frontispiece of a small book entitled *The Daguerreotype Story*.[14] The author, Floyd E. Bliven of Erie, Pennsylvania, had evidently consulted an "expert daguerreotypist who had done much technical writing in the field" while preparing this self-published book of family memoirs. Efforts to discover who this "expert" might have been have, unfortunately, not yet been successful.

In the late 1960s and early 1970s, activity in daguerreotypy increased appreciably. An informal survey conducted in 1971 in the *New Daguerreian Journal*[15] by editor and daguerreotypist Walter Johnson reported that eleven people were working with the process. Only five years later, Grant Romer conducted another survey and found an astounding thirty-eight more individuals who had either tried the process or were then working with it.[16] The responses to the two surveys indicated that there were diverse reasons for interest in daguerreotypy and a wide range of successes and failures.

Among those surveyed, James E. Ambrecht of St. Louis, L. Eric Van Cort of Bearsville, New York, and J. Richard Malpass of Sheffield, England, all crafted reproductions of daguerreotype cameras and outfits. Marvin Kreisman, who taught photography and operated the American Museum of Photography in Baraboo, Wisconsin, and Cliff Krainik, then of Arlington Heights, Illinois, a professional dealer in photographica and a frequent contributor to the *New Daguerreian Journal*, each produced numerous plates. Roger Baker, Jr., of Austin, Texas, made conventional

daguerreotypes, but he also experimented with variations such as the development of copper bromo-iodide images using the Becquerel method, and he explored the enhanced light sensitivity of certain copper-silver iodide combinations.[17] Mary Serra, who worked with Scott Hendrickson in the Southwest, was perhaps the only woman in the field at that time.

Walter Johnson's own daguerreotype work was quite extensive. A photo educator and former curator of the Floyd and Marion Rinhart daguerreotype collection at the Columbus Museum of Art, Johnson has exhibited in several galleries. His daguerreotypes include nude studies, double exposure images, and landscapes.

Due in large part to the efforts of Romer and Johnson, a network of daguerreotypists formed to exchange information on problems and sources of supplies. Eventually a "convocation of contemporary daguerreian artists" was organized by Grant Romer and Harvey Zucker, who had been a vocal advocate for daguerreotypy and a daguerreotypist (fig. 1) since 1972. On July 9, 10, and 11, 1976, eighteen people came together at Zucker's home on Staten Island to make daguerreotypes and exchange ideas, many meeting each other for the first time. While no formal organization resulted, the gathering reinforced interest in and enthusiasm for the process and encouraged further efforts. In 1977, Romer encouraged artists further when he organized the first exhibition of contemporary daguerreotypes to be held at an American museum, the International Museum of Photography at George Eastman House in Rochester, New York.

A few individuals currently engaged in daguerreian activity in America began their interest during the revival of the 1970s. Irving Pobboravsky, whose scientific contributions were discussed earlier, first experimented with daguerreotypes on silvered glass in 1962 and came back to the process in 1969 using conventional silver-plated copper.[18] Active for more than twenty years now, he has produced hundreds of daguerreotypes and is known worldwide as a master of the process. The quality of his plates is consistently superb and often compares with the finest work of the nineteenth century. Aspiring daguerreotypists and seasoned veterans alike seek him out with questions and samples of their work for comment. This gentle and generous man willingly obliges, sharing his techniques and knowledge freely. In 1989, he and Grant Romer were commissioned by the Musée Carnavalet of Paris to daguerreotype Paris landmarks for a major exhibition on the history of the daguerreotype which was held in October of that year. Their results (figs. 2–4) are exquisite and historic images of present-day Paris. (It is noteworthy that two Americans were selected for the job and that the museum purchased fifteen of the thirty images dis-

Figure 1.
Harvey Zucker,
3¼ x 4¼ inches.
Alicia. Collection of
the artist.

Figure 2.
Irving Pobboravsky
and Grant B. Romer,
5 x 7 inches. I. M. Pei's
La Pyramid, Paris,
1989. Collection of the
artists.

Figure 3.
Irving Pobboravsky
and Grant B. Romer,
5 x 7 inches. Forum
des Halles, Paris, 1989.
Collection of the
artists.

Figure 4.
Irving Pobboravsky and Grant B. Romer,
5 x 7 inches.
Stone Arch in Square Georges Cain,
Paris, 1989. Collection of the artists.

Figure 5.
Irving Pobboravsky,
4 x 5 inches. Finger
Plant, 1978. Collection
of the artist.

played in the exhibition for its permanent collection.) Pobboravsky's personal work reflects his appreciation for nature, particularly for trees, and also includes portraiture, landscapes, and architectural studies (fig. 5).

Grant Romer, in addition to his many other daguerreian activities, is also a daguerreotypist, although he shuns the title because he lacks the time to devote to continuous practice. He has referred to daguerreotypy as a magical art and to those who work in the process as magicians,[19] and he is intimately aware of the attraction the daguerreotype holds for many. He began working in the process in 1976 and frequently uses the Becquerel method of development. In addition to more conventional daguerreotypes, Romer has made what he calls "snapshot" daguerreotypes, such as his portrait of Robert Mapplethorpe made using a Hasselblad camera while teaching a workshop on the daguerreotype in Arles, France.[20]

When Thomas Young made his first daguerreotype in 1974, he had never actually seen an original example. His systematic approach to the process, such as his investigation into the causes of the appearance of black spots, mentioned earlier, has rewarded him with high-quality plates for which he is much admired. After a ten-year hiatus in making daguerreotypes, Young was inspired by the events of the 150th anniversary to begin to make daguerreotypes again (fig. 6).

Kenneth Nelson had not yet heard of the daguerreian activity on the East Coast when he made his first daguerreotype in 1976 at Arizona State University. By 1977 he had had an exhibit of his daguerreotypes at the university's Northlight Gallery and had written the handbook mentioned earlier. He was invited to Hawaii in 1981 to lecture and to make daguerreotypes of the state's governor and of historic sites. In 1985, Nelson, along with M. Susan Barger, Theodore Rafferty, and Jan K. Herman, made a daguerreotype of the moon, using a nine-inch refractor telescope at the United States Naval Observatory in Washington, reproducing the work done by John Adams Whipple and his assistant, William B. Jones, at the Harvard College Observatory in 1851.[21] This effort was later featured on National Public Radio's "All Things Considered." In addition to portraits and landscapes (plates 27–28), Nelson sometimes pays homage to his nineteenth-century predecessors in a humorous and playful manner. For example, he has daguerreotyped Beaumont Newhall and Helmut Gernsheim, the two preeminent historians of photography, sitting face to face in folding chairs with traditional daguerreotype head braces visible, and he has placed a daguerreotype image of a working television under an ornate nineteenth-century gold mat. Nelson's involvement extends beyond making daguerreotypes, as he has written on contemporary daguerreian activity in the newsletter of the Daguerreian Society and for its journal.

Thomas L. Davies of Philadelphia began working with the daguerreotype so that he could teach photo history more completely, and he frequently appears in a nineteenth-century costume to reinforce his point. He makes his daguerreotypes with replicas of cameras and equipment crafted from period designs. He has painstakingly fashioned a number of items, including a complete traveling daguerreotype outfit based on an 1845 French design, a replica of a half-plate daguerreotype camera built by Joaquim Bishop in 1839, and a replica of the experimental Wolcott/Johnson mirror camera of 1839.[22] He modestly claims that he is not an artist but a teacher. Yet his cameras and accessories are beautiful and well crafted, and the daguerreotypes he has made with them are no less successful (fig. 7).

Gerard Meegan of Minneapolis is new to the process. He was drawn to the me-

Figure 6.
Thomas E. S. Young,
4 x 5 inches. Doll.
Collection of the artist.

dium as a result of his interest in other nineteenth-century processes and his profession of restoring cameras and photographs. Meegan has a dry wit and an understated sense of humor which he extends to much of his daguerreotype imagery. His recent series of images (figs. 8 and 9) are puns on daguerreian nomenclature. In his image of old cameras and photographs, Meegan has carefully posed the objects of his trade, much as Daguerre did in one of his first efforts in 1837.[23] However, in this composition, the Coca-Cola carton poking out from behind an old lens and a newspaper advertisement for the film *Batman* draped casually under two early cameras leave no doubt as to when this daguerreotype was made (fig. 10).

A relative newcomer to the field, Dr. Robert Shlaer began experimentation with the process in 1972, but it was not until 1986 that he decided to make daguerreotypy

Figure 7.
Thomas L. Davies,
2 x 2½ inches. Gar-
goyle, 1985. Collection
of the artist.

Figure 8.
Gerard M. Meegan,
3 x 2 inches. Quarter
plate, 1990. Collection
of the artist.

Figure 9.
Gerard M. Meegan,
4 x 5 inches. Pho-
tographer Unknown,
1990. Collection of
the artist.

Figure 10.
Gerard M. Meegan,
4 x 5 inches. Untitled,
1989. Collection of the
artist.

his vocation. He is the only person in the United States (and probably the world) who can be considered a full-time professional daguerreotypist. Working from his studio in Santa Fe, he has been commissioned to daguerreotype diverse subjects—kings, ancestral homes, portraits of Wall Street—as well as traditional portraits of people. Shlaer's work is of exceptional quality. He works in a variety of formats, including stereoscopic daguerreotypes, and he is one of the few modern artists to successfully work with plates as large as 8 by 10 inches. Shlaer's equipment, although based on nineteenth-century designs, is of modern materials such as lucite and molded plastic, and his innovative car-top traveling laboratory affords him much flexibility.[24] Landscapes, architecture, and nude studies are his personal interests (plates 99–100 and figs. 11–12).

While this essay has focused on American daguerreotypists, no account of current daguerreian activities would be complete without mention of workers from other countries. Probably the most successful of these is Patrick Bailly-Maitre-Grand, an accomplished painter and photographer from Strasbourg, France, who became interested in the daguerreotype process in 1982 as an alternate medium for his art. Bailly-Maitre-Grand works from enlarged transparencies to create a contact image on large daguerreotype plates (often as large as 8 by 11 inches). He is also known for his exceptionally large-scale assemblages of multiple daguerreotype plates, such as his 1-by-5-foot image of a locomotive, and for his panoramic daguerreotypes. His elegantly crafted and totally unique treatment of a lunar image (a kind of homage to the daguerreotype, which he feels is born "of the moon, not the sun")[25] is a free-standing piece made of six plates, stacked three to a side, and set at a right angle, so that the image of one side reflects into the other, causing the image to appear three-dimensional. His work has been exhibited both in this country and abroad, and it is represented in many public and private collections.

Michael Breton, a Belgian, also uses the contact "printing" method in making daguerreotypes. A commercial photographer by trade, he created a spoof on the work of Norman Rockwell in a series of daguerreotype images in 1989.

In Japan, the daguerreotype process has been taught by Professor Sadahiro Koizumi as part of a photohistory course at Nihon University in Tokyo for many years. Koizumi has been making daguerreotypes since 1974 and has published a book of his work, one of the few photo books on contemporary daguerreotypy available.[26] According to Professor Koizumi, daguerreotypy has not developed the following in Japan that it has in the United States and in Europe. He knows of no other daguerreotypists in Japan and is not aware of any photographic society which focuses on the daguerreotype.[27]

Figure 11.
Robert Shlaer, 4 x 5
inches. Antennas.
Collection of Janet
Russek and David
Scheinbaum.

This essay has sought to make a case for the importance of perpetuating the daguerreotype as a viable, vital art form, and it has established that there are a number of people who in one form or other are actively pursuing this goal. But it must be admitted that outside this group of activists, in the wider world of art patrons, museums, and scholars, the general response to modern daguerreotypy is, at best, mixed.

The daguerreotype is usually well received in a historical context, such as a re-creation or a demonstration, but some people, perhaps accustomed to seeing only conventional black and white or color photography, seem to value it only as a historical relic and have great difficulty accepting the contemporary daguerreotype as a valid alternative photographic medium. Paradoxically, others object to modern work because they see it as too closely tied to the past, as merely re-creating the past instead of moving forward to provide new artistic visions, while still others seem confused by some artists' attempts to convey modern imagery via this traditionally nineteenth-century medium.

Interestingly, America, the land whose institutions and individuals embraced the process longer than anywhere else in the world, seems to be home to the contemporary daguerreotype's harshest critics. Europeans have demonstrated a much more open-minded attitude by supporting a number of American and European daguerreotypists with commissions and acquisitions. It is unfortunate, of course, that any efforts in daguerreotypy, a field in which so few are working, are dismissed or belittled. Those who choose to make daguerreotypes for whatever reason are still, at the very least, preserving the art, and if higher levels of artistic expression are desired for the medium, it is encouragment and support that are needed in order to produce an environment conducive to creativity.

Fortunately, some support in the form of organizations and activities which recognize contemporary work has recently developed in the United States. On October 15, 1988, a new Daguerreian Society was formed, "an organization of individuals sharing a common interest in the art, history, and practice of the daguerreotype." Through its journal, newsletter, directory, and annual symposiums, the society, which has an international membership, provides the only organized forum currently available to contemporary daguerreotypists for the exchange of information and ideas.

In the same supportive vein, a recent book by John Wood, *The Daguerreotype: A Sesquicentennial Celebration*, included among its fine collection of essays one on modern daguerreotypy by Grant Romer. The book also includes beautiful reproduc-

tions of contemporary work. And in October 1989 over one hundred works by modern daguerreotypists were displayed at the International Museum of Photography at George Eastman House. This was the first time in twelve years that contemporary work was recognized by a major institution. Events and activities such as these are essential to sustaining interest in daguerreotypy.

Of course, the ultimate reason to pursue contemporary daguerreotypy is to use the medium as a means of artistic expression. The daguerreotype clearly does have inherent qualities that no other medium possesses. But the medium itself cannot be relied upon to create the art. In photography, it is the image that determines the success, the lasting worth of the artist's vision. If daguerreotypy is to survive, it will do so not only because photographers are willing to work in this difficult medium but, in the end, because the images are worth looking at.

NOTES

1. Alice Swan, C. E. Fioro, and K. F. J. Heinrich, "Daguerreotypes: A Study of the Plates and the Process," *Scanning Electron Microscopy* 1 (1979): 411–23.

2. Discussed by M. Susan Barger in her essay "Delicate and Complicated Operations: Scientific Examination of the Daguerreotype," in *The Daguerreotype: A Sesquicentennial Celebration*, ed. John Wood (Iowa City: University of Iowa Press, 1989), p. 107. See also p. 109, citation 17.

3. M. Susan Barger, *The Daguerreotype: 19th-Century Technology and Modern Science* (Washington, D.C.: Smithsonian Institution, 1991).

4. Irving Pobboravsky, *Study of Iodized Daguerreotype Plates* (Rochester, N.Y.: Rochester Institute of Technology Graphic Arts Research Center, 1971). This readable study is essential for any student of the daguerreotype.

5. Kenneth E. Nelson, *A Practical Introduction to the Art of Daguerreotypy in the 20th Century* (Tempe: Arizona State University Press, 1977). Unfortunately, this publication is now out of print.

6. Floyd Rinhart and Marion Rinhart, *The American Daguerreotype* (Athens: University of Georgia Press, 1981), pp. 213–15.

7. Beaumont Newhall, *The Daguerreotype in America* (New York: Duell, Sloan & Pearce, 1961), pp. 97–104. Newhall gives an account of Hill's claims. However, Joseph Maria Eder, *The History of Photography*, 3d ed., trans. Edward Epstean (New York: Columbia University Press, 1945), p. 316, dismisses Hill's work as "nothing but painting over daguerreotypes."

8. Joseph Boudreau, "Color Daguerreotypes: Hillotypes Recreated," in *Pioneers of Photography: Their Achievements in Science and Technology* (Springfield, Va.: Society for Photographic Scientists and Engineers, 1987), pp. 189–99. Hillotypes share some common characteristics with daguerreotypes, but their muted colors and their velvety surface, which can be rubbed to a gloss, make them quite different in appearance.

9. Interestingly, Samuel F. B. Morse, in a letter to the *National Intelligencer* which was reported in *Scientific American*, April 2, 1853, said of the Hillotype: "No exposure to light has as yet been found to impair their brightness." Newhall, p. 102.

Boudreau has found fading in his Hillotypes.

10. Grant B. Romer, "The Daguerreotype in America and England After 1860," *History of Photography* 1 (July 1977): 201. Romer's excellent article is packed with information on the daguerreian activity up to 1976.

11. Romer, p. 208.

12. Romer, p. 209.

13. Shinkichi Tajiri, *101 Daguerreotypes* (Amsterdam: Stedelijk Museum, 1976). In Dutch.

14. Floyd Edward Bliven, *The Daguerreotype Story* (New York: Vantage Press, 1957). The complete note reads: "Since there is much new interest in these older photo processes, the inexperienced should know that while this is an amusing 'family memoir' published privately (a vanity press), 'this book is historically and technically incorrect to a point where it boggles the mind' in the words of an expert who has done much modern daguerreotype work and has published technical work in the field."

15. Walter Johnson, "The 20th Century Daguerreotype," *New Daguerreian Journal* 3 (April 1972): 8–11.

16. I am indebted to Romer for sharing his survey with me. It has been invaluable to me in my preliminary research on the current state of modern daguerreotypy.

17. Roger Baker's response to Grant Romer's survey of 1976.

18. Pobboravsky's response to Grant Romer's survey of 1976.

19. Grant B. Romer, "Heavy Lightness, Serious Vanity," in *The Daguerreotype: A Sesquicentennial Celebration*, p. 114.

20. See Grant B. Romer, "Daguerreotype," *Hasselblad* 20 (November 1984): 10.

21. Newhall, p. 94.

22. Tom Davies, "The Earliest Cameras," *Photographer's Forum* 3 (May 1980): 19–24.

23. Naomi Rosenblum, *A World History of Photography* (New York: Abbeville Press, 1984), p. 36.

24. W. R. Young III, "A Modern Daguerrian Artist on the Old Santa Fe Trail," *Journal of the West* 28 (January 1989): 6. Young gives an excellent account of Shlaer's work.

25. Romer, "Heavy Lightness, Serious Vanity," p. 114. Bailly-Maitre-Grand makes reference to the early descriptions of the daguerreotype as having been created by the sun writing on the plate.

26. Sadahiro Koizumi, *Daguerreotypes 1975* (Tokyo: Sadahiro Koizumi, 1986).

27. Letter from Sadahiro Koizumi to Jeanne Verhulst, September 1989.

The Plates

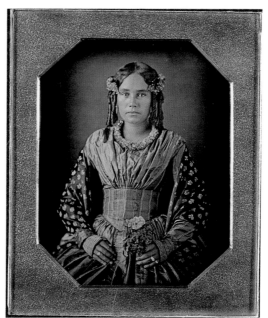

1.
Anonymous,
sixth plate.

2.
Jeremiah Gurney,
quarter plate.

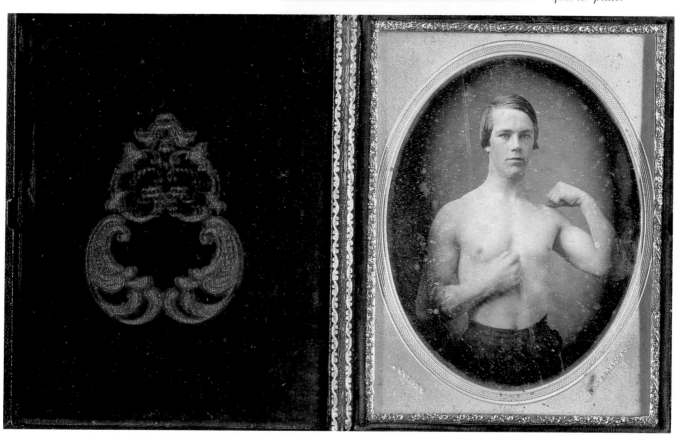

THE PLATES 181

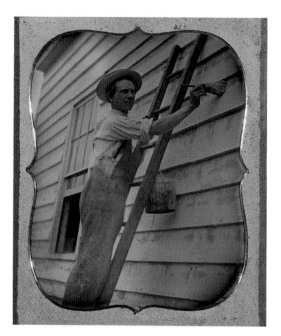

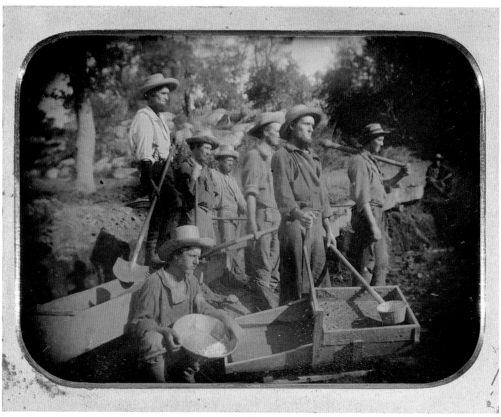

4.
Anonymous, half plate.

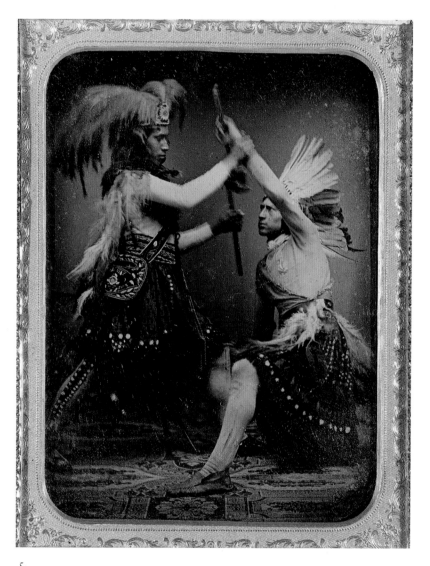

5.
Anonymous, half plate.

6.
Anonymous,
sixth plate.

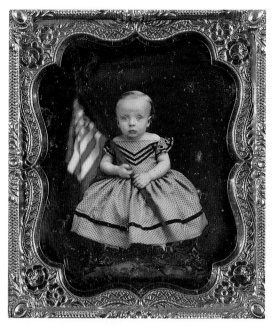

7.
Anonymous, half plate.
The Easton Fencibles.

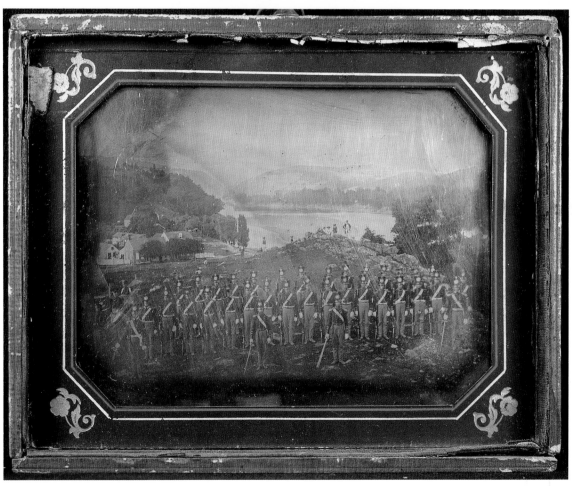

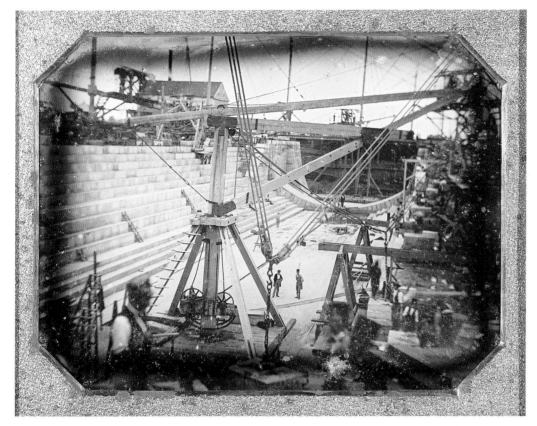

8.
Anonymous, half plate.
Brooklyn Naval Yard.

9.
Anonymous,
half plate.
Seneca Falls,
New York.

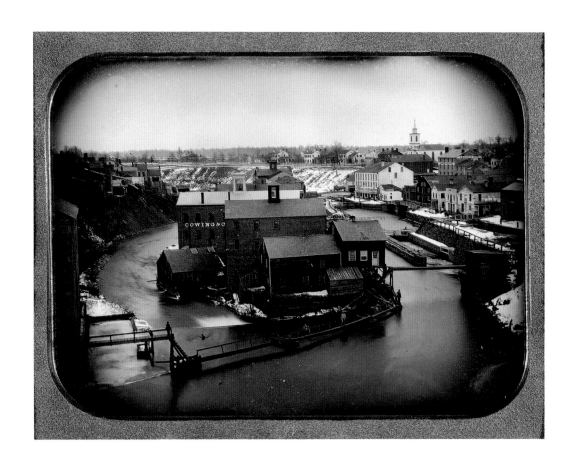

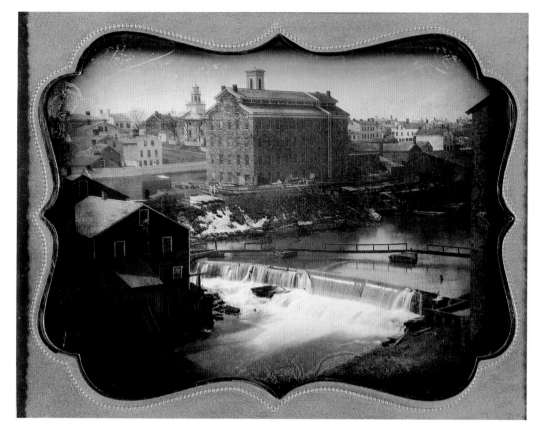

10.
Anonymous,
half plate.
Seneca Falls,
New York.

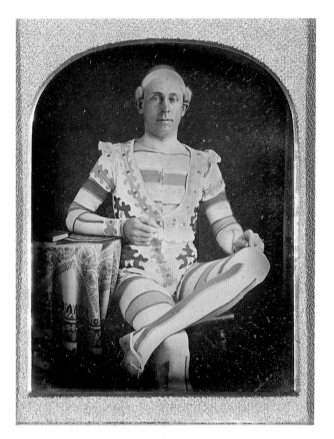

11.

Anonymous,

quarter plate.

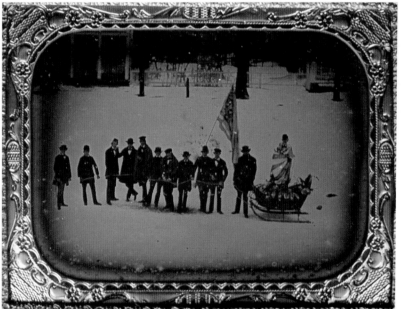

12.

Anonymous, quarter plate.

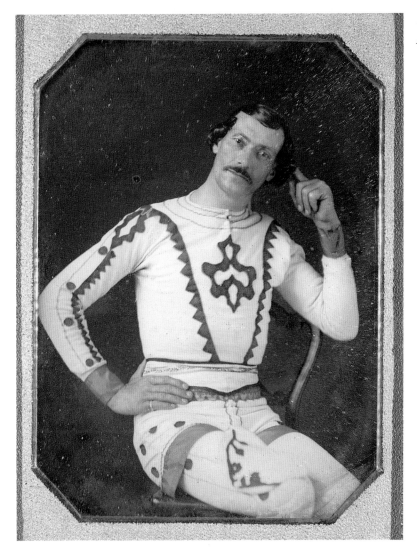

13.
Anonymous, half plate.
William Worrell,
Clown.

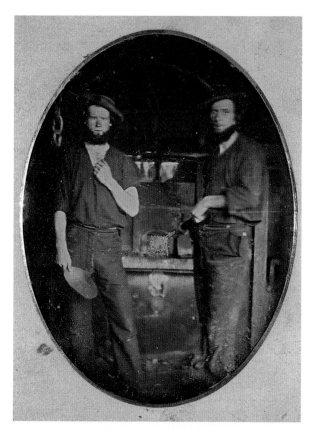

14.
*Anonymous, quarter
plate. Smelting Gold.*

15.
*Anonymous, half plate.
Gold Dust Wanted.*

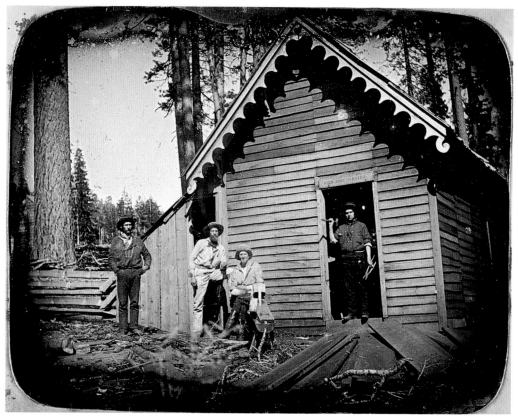

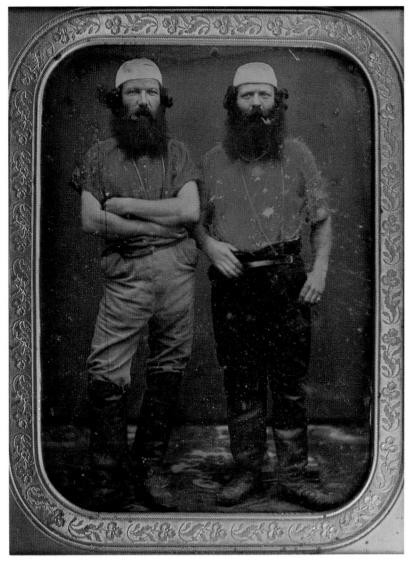

16.
Anonymous, half plate.

17.
*Anonymous, sixth
plate.*

18.
*Rufus Anson, sixth
plate.*

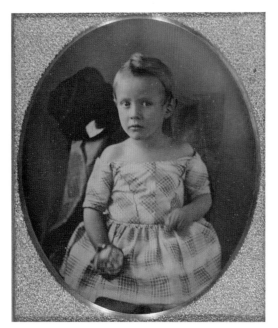
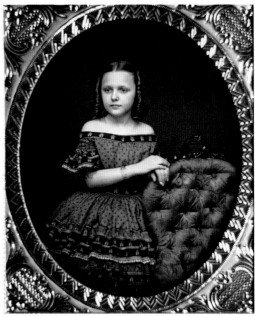

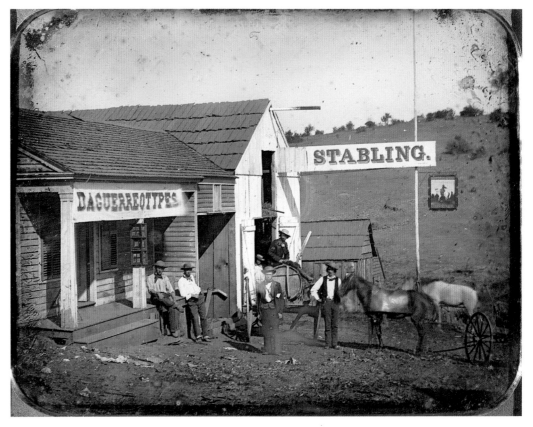

19.
Anonymous, half plate.

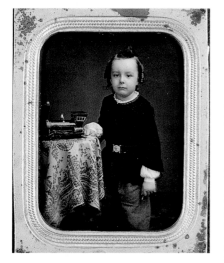

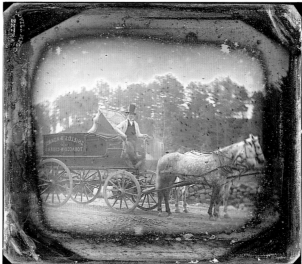

21.

Anonymous, sixth plate. J. H. Ferguson's Tobacco Wagon.

20.

Anonymous, ninth plate.

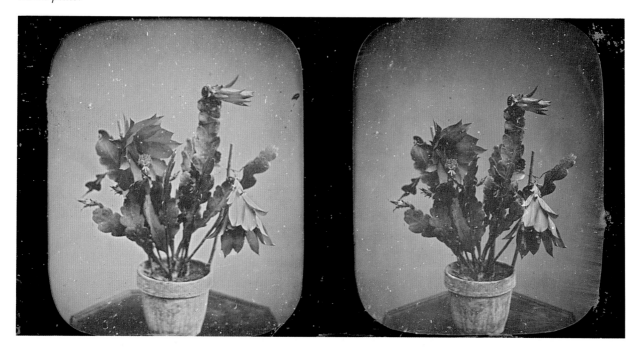

22.

Anonymous, stereoscopic daguerreotype. Flowering Cactus.

23.
Anonymous, sixth plate.

24.
Anonymous, sixth plate.

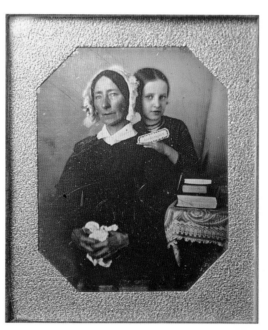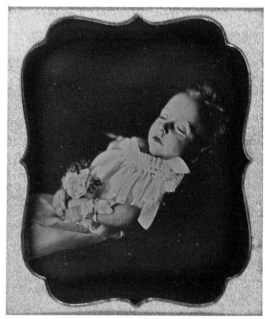

25.
Anonymous, sixth plate.

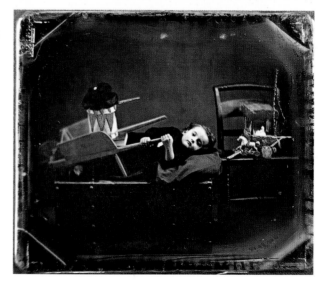

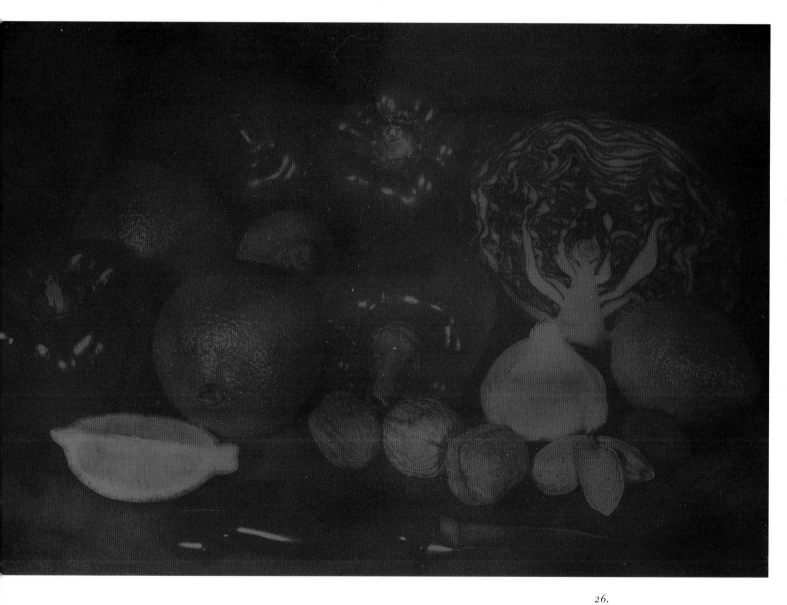

26.
Joseph W. Boudreau,
whole plate. Hillotype.

27.
Kenneth Nelson, half plate. Church, Las Trampas, New Mexico, August 19, 1989.

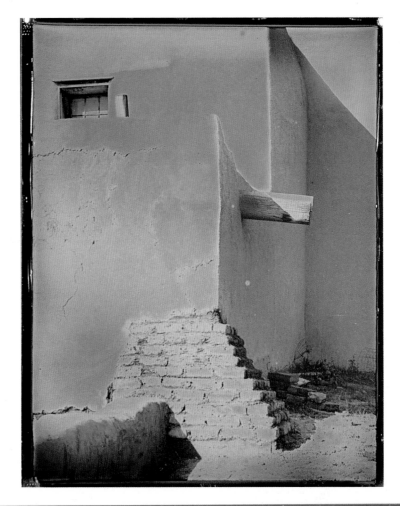

28.
Kenneth Nelson, half plate. Aspen Forest, New Mexico.

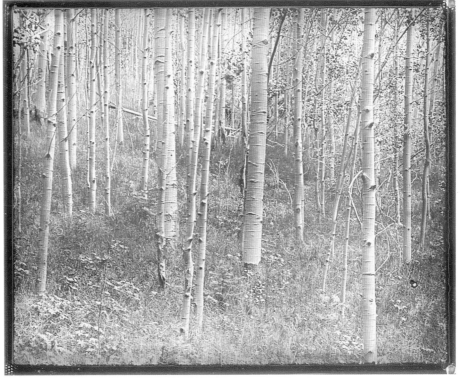

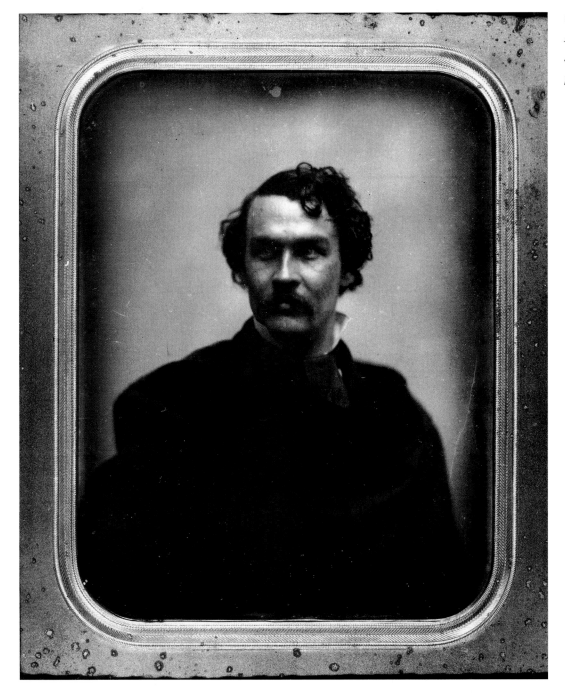

29.
*Albert Southworth and
Josiah Hawes, half
plate.*

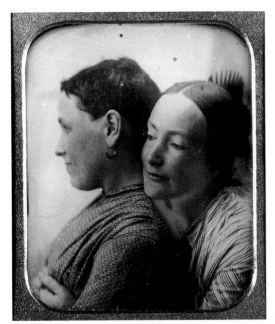

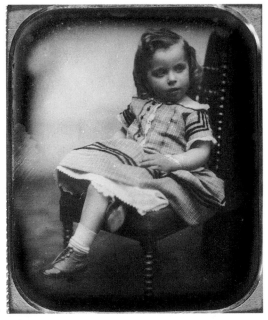

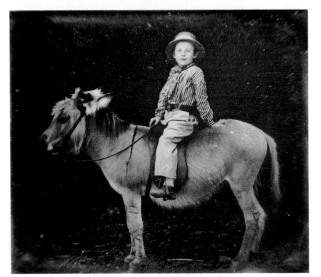

32.

Anonymous, sixth plate. Steve Merritt's Donkey.

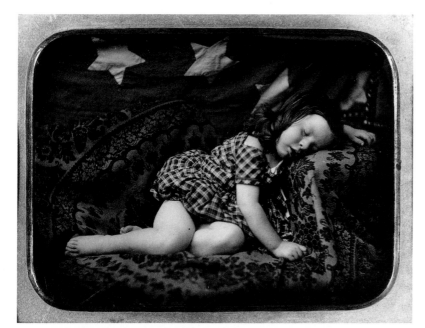

33.
Marcus Aurelius Root,
quarter plate. Portrait
of Anthony Pritchard
Root Asleep by the
Flag.

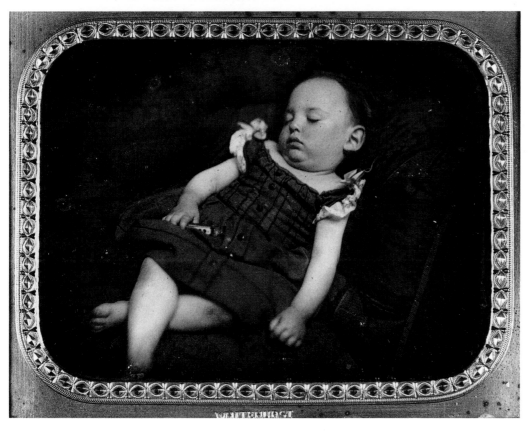

34.
Jesse Whitehurst,
half plate.

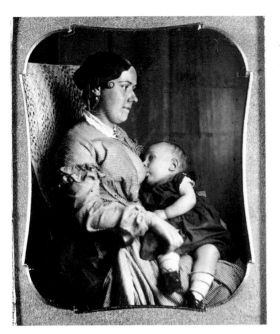

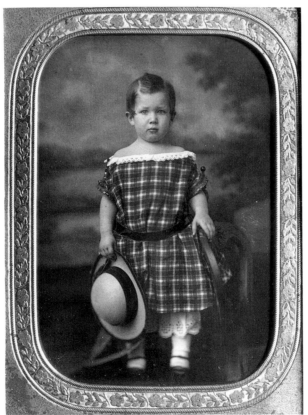

37.
Anonymous,
Daguerreian Brooch.

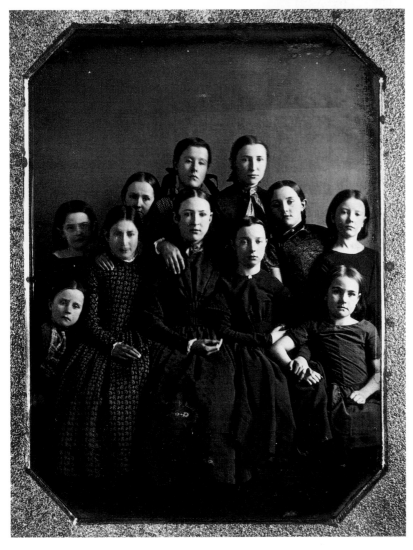

38.
Anonymous, half plate.

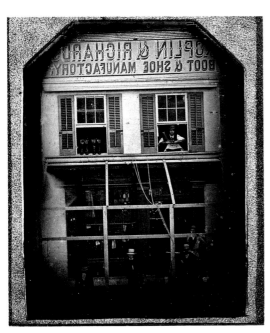

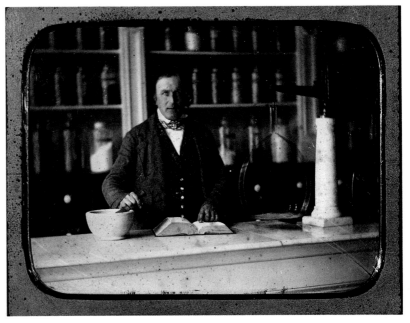

39.
*Anonymous, sixth
plate. Koplin &
Richards Boot & Shoe
Manufactory.*

40.
*Anonymous, quarter
plate. Apothecary.*

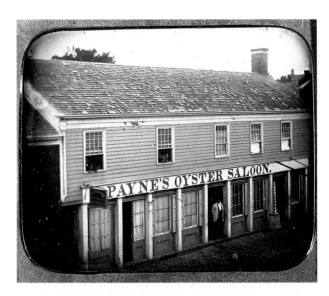

41.
*Anonymous, sixth
plate. Payne's Oyster
Saloon.*

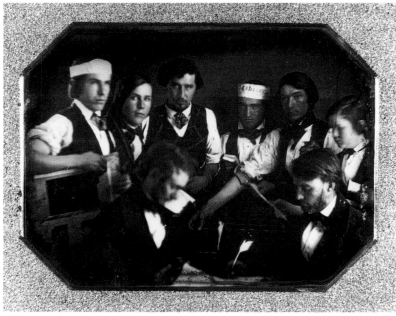

42.
*Anonymous, quarter
plate. The Staff of the
Express.*

PANORA
OF THE
FALLS OF NI

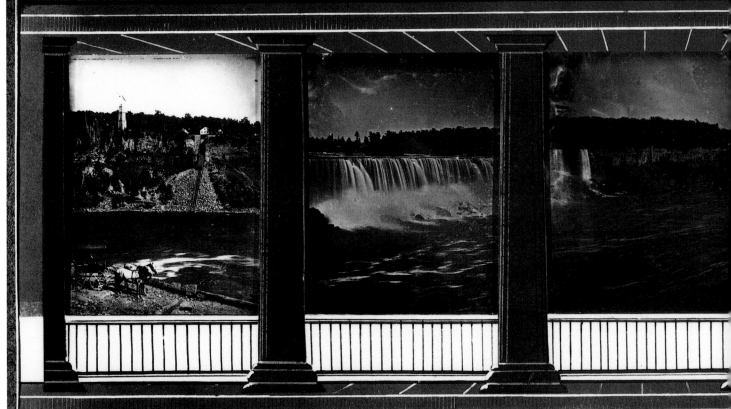

DAGUERREOT
TAKEN FROM NEAR THE CLIFTON HOU
BY
W. & F. LANGE

PROPRIETORS OF THE PHILADELPHIA DAGUERREOTYPE ESTA

43.
William and Frederick Langenheim, panorama of sixth plates. The Falls of Niagara.

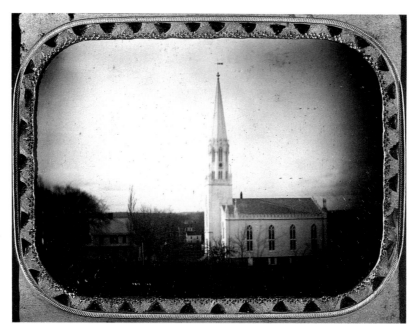

44.
Anonymous, quarter plate.

45.
Anonymous, half plate.

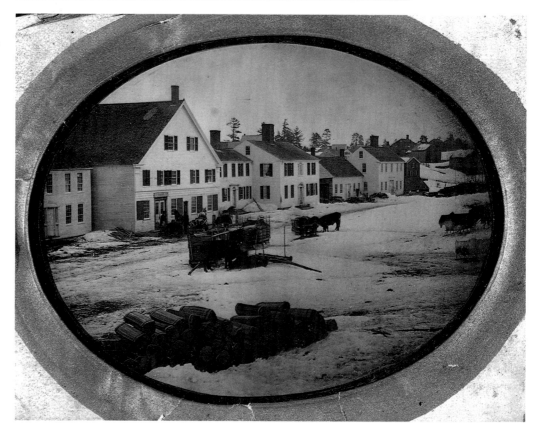

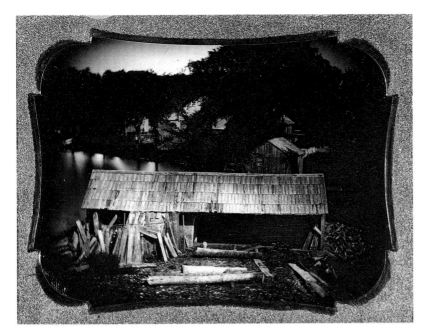

46.
*Anonymous, quarter
plate.*

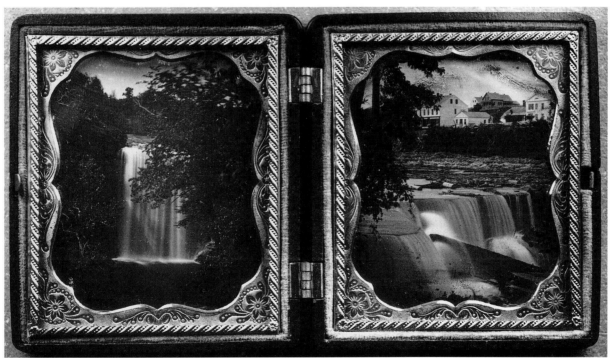

*47 and 48.
Anonymous, sixth
plates. The Minne-
haha and St. Anthony
Falls.*

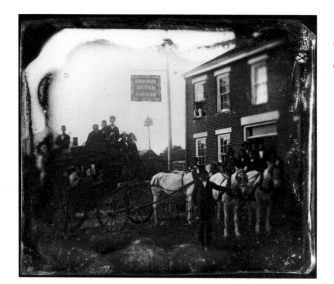

49.
*Anonymous, sixth
plate. S. B. Holt's
Central House.*

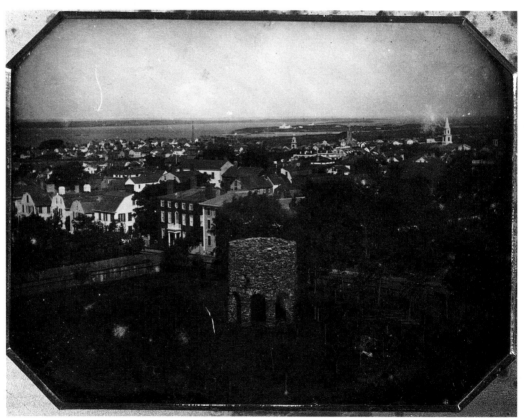

50.
*Anonymous, half plate.
Newport, Rhode Island.*

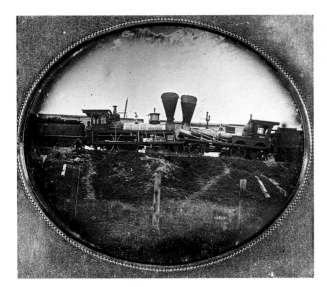

51.
Anonymous,
sixth plate.

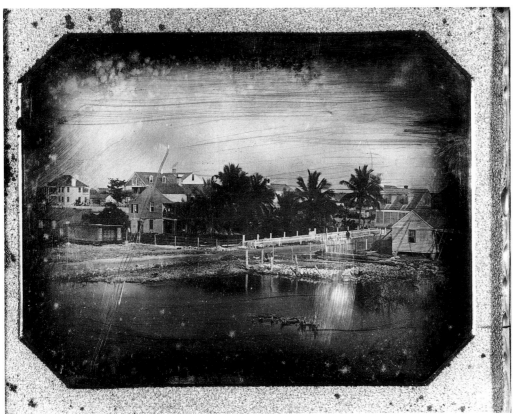

52.
Anonymous, half plate.
View of Key West.

53.
Anonymous, sixth
plate. Ohio Star,
Ravenna, Ohio.

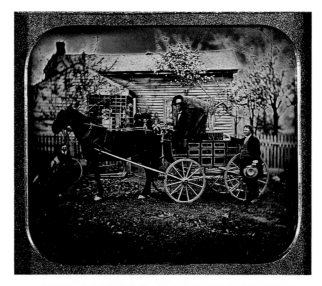

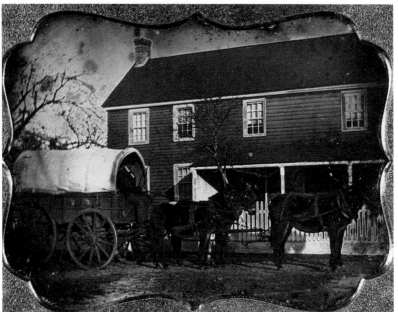

54.
Anonymous, quarter
plate. The Garvas
Tharrow House.

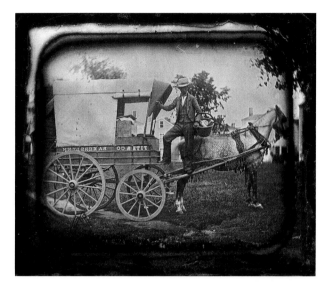

55.
*Anonymous, sixth
plate. Delivery Wagon
of Fitz & Co. Bakers,
Lynn, Massachusetts.*

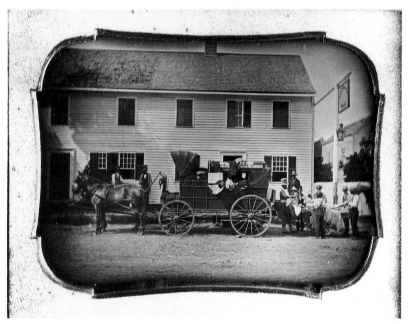

56.
*Anonymous, quarter
plate. The Traveling
Store.*

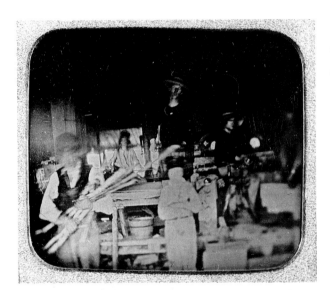

57.
Anonymous, sixth
plate. Saratoga
Mountain Glassworks,
Mt. Pleasant, New
York.

58.
Anonymous, quarter
plate.

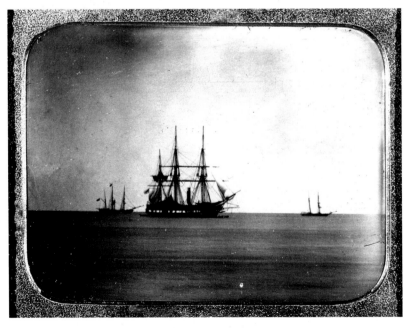

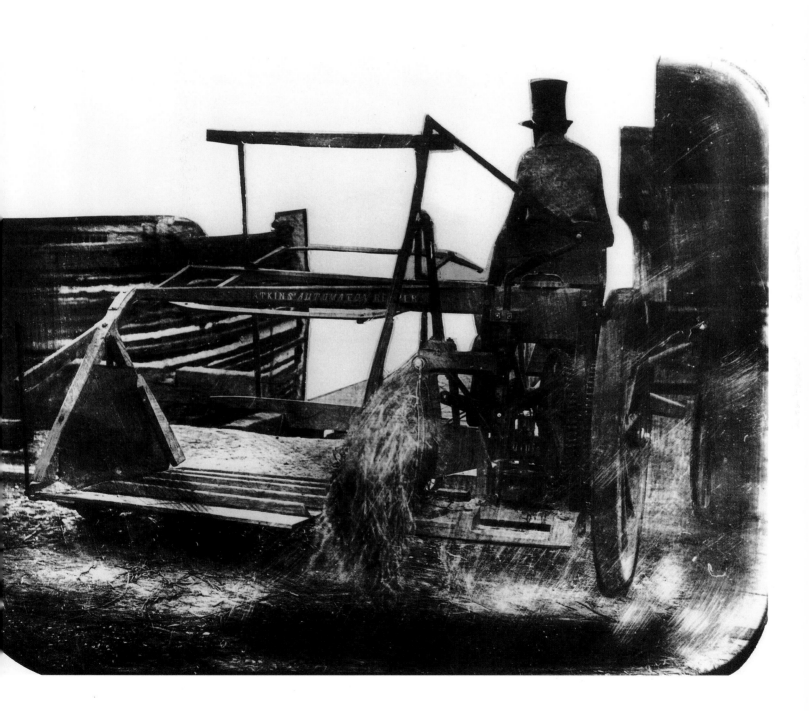

59.
*Anonymous, whole
plate. Atkins' Auto-
maton "Self-Raking"
Reaper.*

60.
*Anonymous, sixth
plate. Main Street,
Minneapolis, circa
1854.*

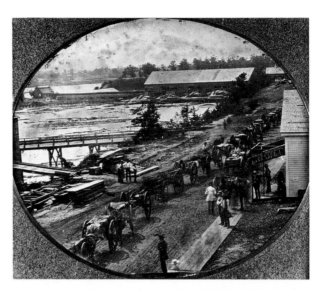

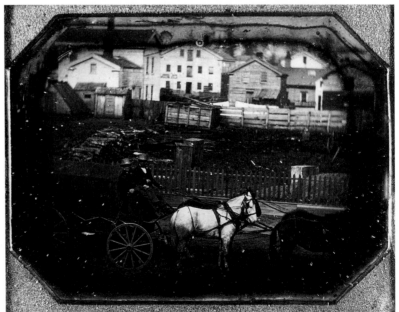

61.
*Anonymous, quarter
plate. Going West,
1849.*

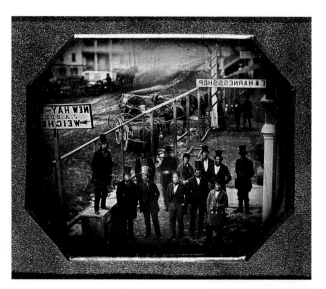

62.
*Anonymous, sixth
plate. The Meeting.*

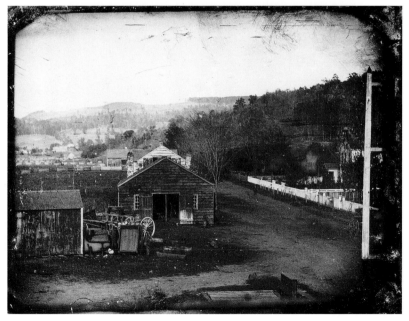

63.
*Anonymous, quarter
plate. Blacksmith's
Shop, Canadaigua,
New York.*

64.
Anonymous,
quarter plate.

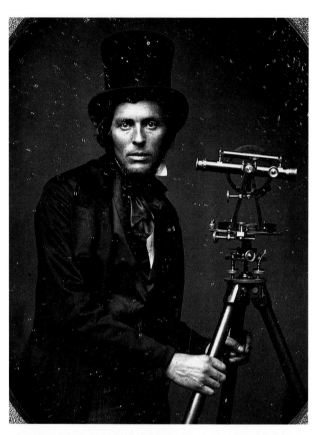

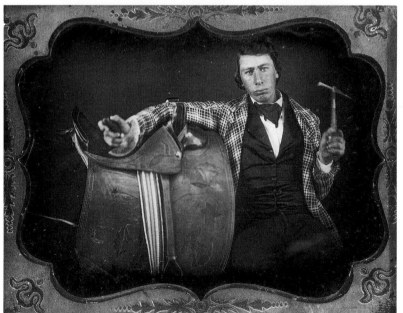

65.
Anonymous,
quarter plate.

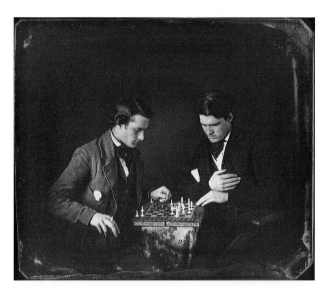

66.
Anonymous,
sixth plate.

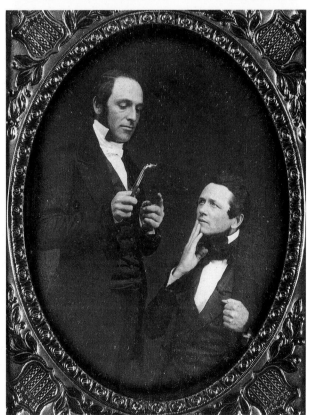

67.
Frank Ford, quarter
plate. The Extraction.

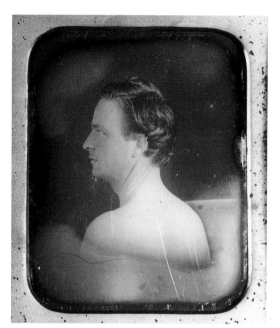

68.
Anonymous,
sixth plate.

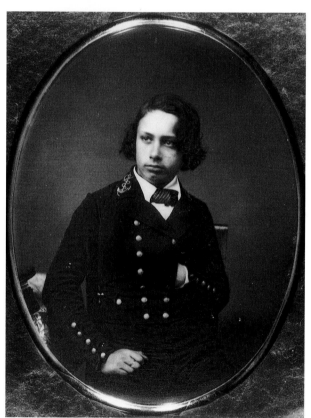

69.
Anonymous,
quarter plate.

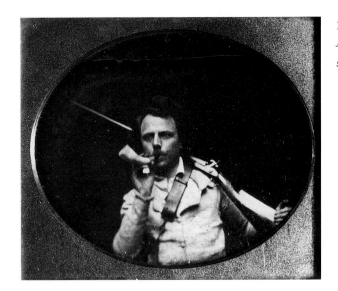

70.
Anonymous,
sixth plate.

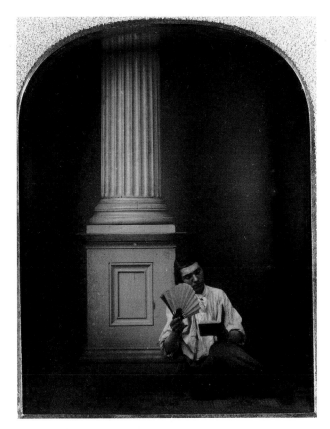

71.
Marcus Aurelius Root,
quarter plate. Portrait
of Anthony Pritchard.

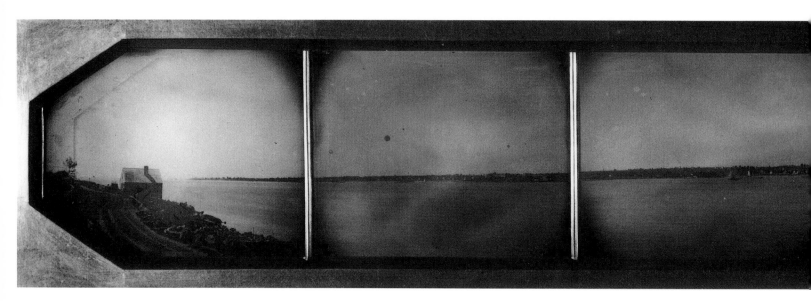

72.
C. H. Gay, panorama of half plates.
New London, Connecticut.

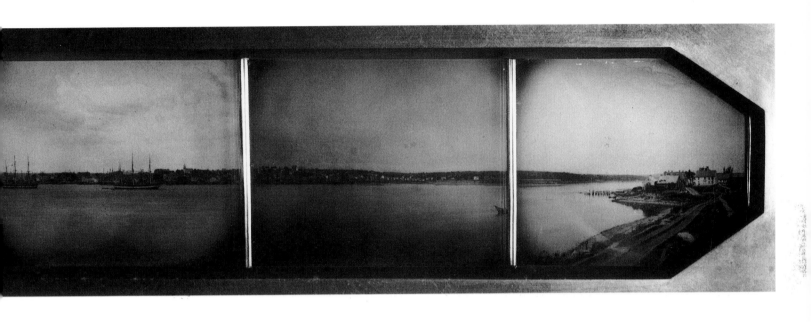

73.
Eliphalet M. Brown,
Jr., sixth plate. Portrait
of Gohachiro Namura.

74.
W. L. Germon,
half plate.

75.
Anonymous, whole plate.

76.
*Joel E. Whitney, sixth
plate. Ojibway Scalp.*

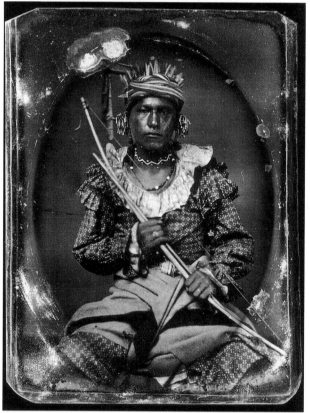

77.
*Anonymous,
quarter plate.*

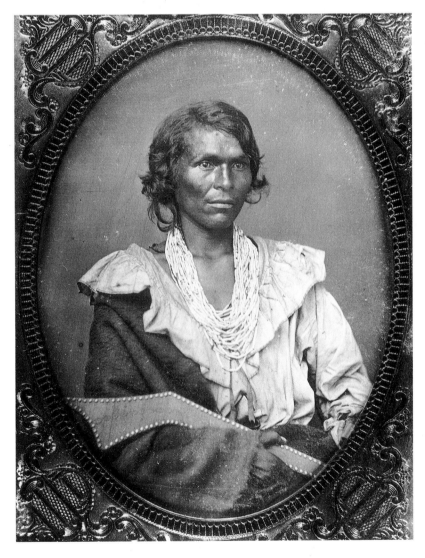

78.
Anonymous, half plate.

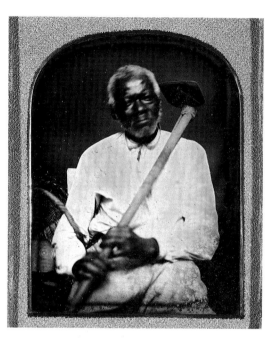

79.
Anonymous,
sixth plate.

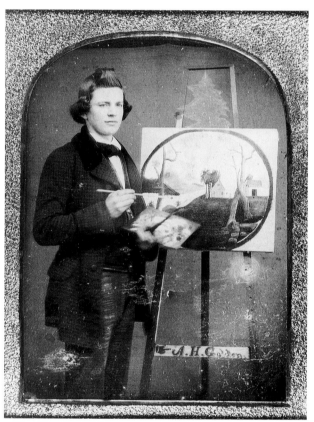

80.
Anonymous, quarter
plate. Portrait of A. H.
Golden, Artist.

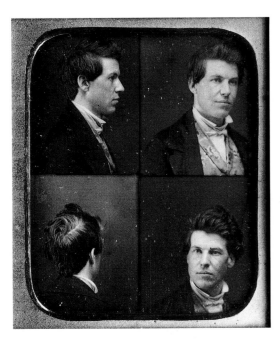

81.
Anonymous,
sixth plate.

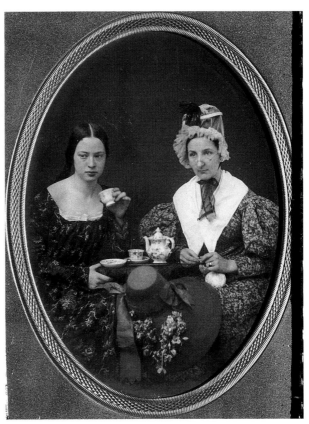

82.
Anonymous,
quarter plate.

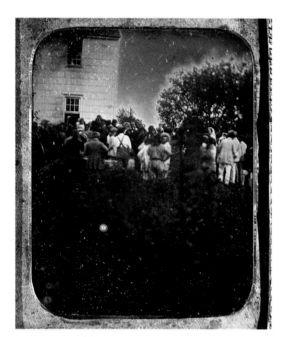

83.
Anonymous,
sixth plate.

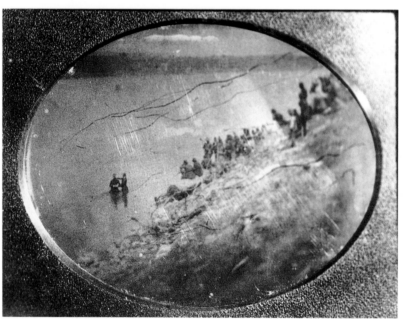

84.
Anonymous, quarter
plate. Baptism in a
River.

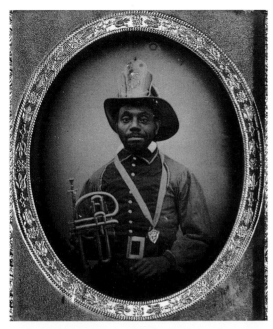

85.
Anonymous,
sixth plate.

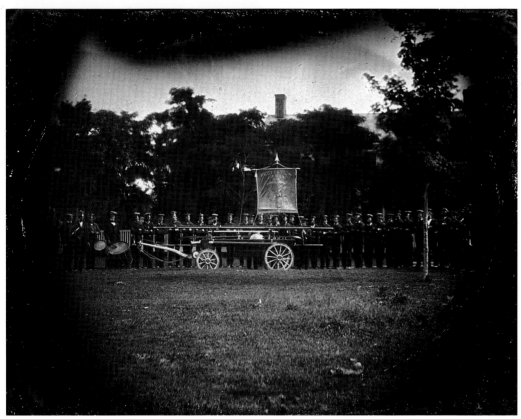

86.
Anonymous, half plate.
Fire Brigade with
Pumper.

87.
*Anonymous,
sixth plate.*

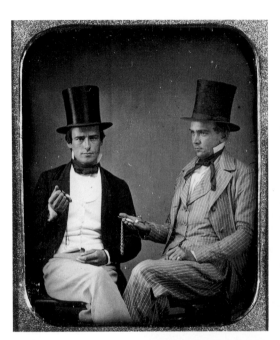

88.
*Anonymous,
sixth plate.*

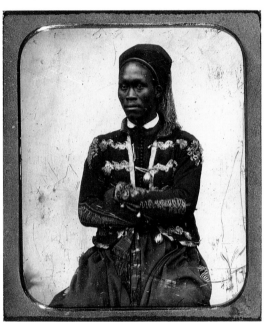

89.
*Anonymous, quarter
plate. Document
Signed by John
Hancock.*

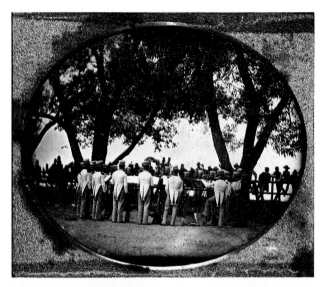

90.
Anonymous, sixth
plate. Band Concert.

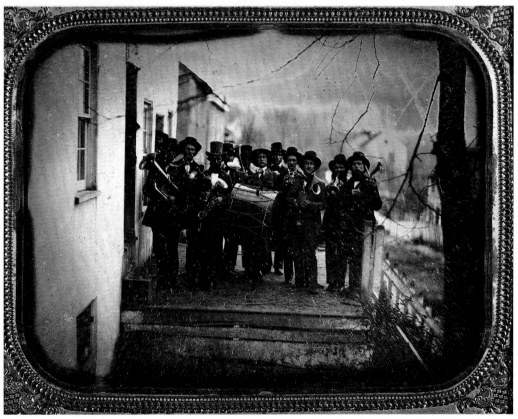

91.
Anonymous, half plate.
Knodles Band.

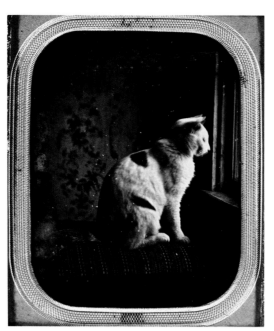

92.
Anonymous,
sixth plate.

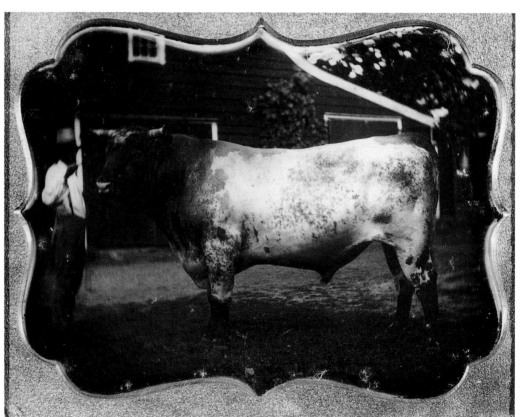

93.
Anonymous, half plate.
Backwoodsman II.

94.
Anonymous,
sixth plate.

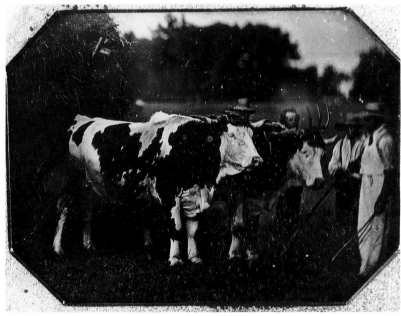

95.
Anonymous,
quarter plate.

98.
*Gilman Josselyn,
whole plate. Faneuil
Hall, Boston, 1839.*

96.
*Anonymous,
sixth plate.*

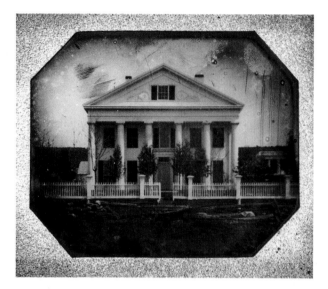

97.
*Anonymous, quarter
plate. Congress Spring
Pavilion, Saratoga,
New York.*

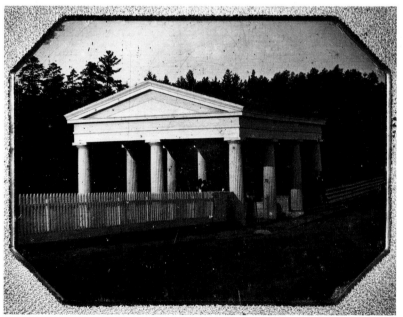

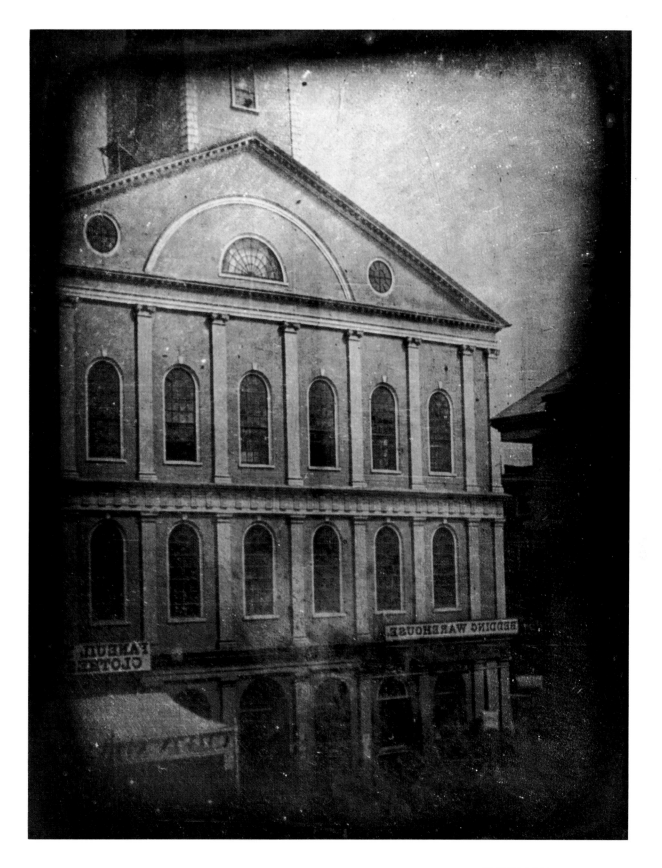

99.
Robert Shlaer,
half plate.

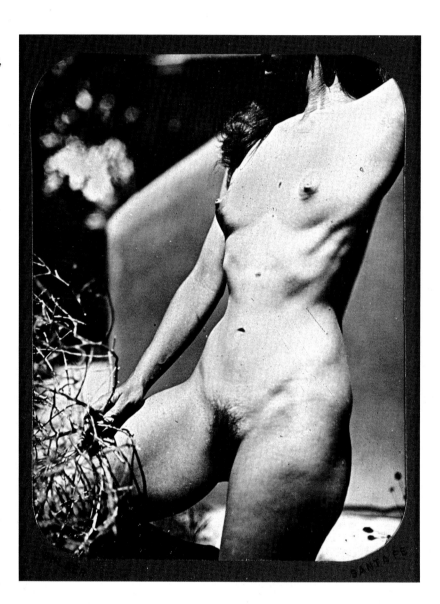

100.
Robert Shlaer,
mammoth plate.

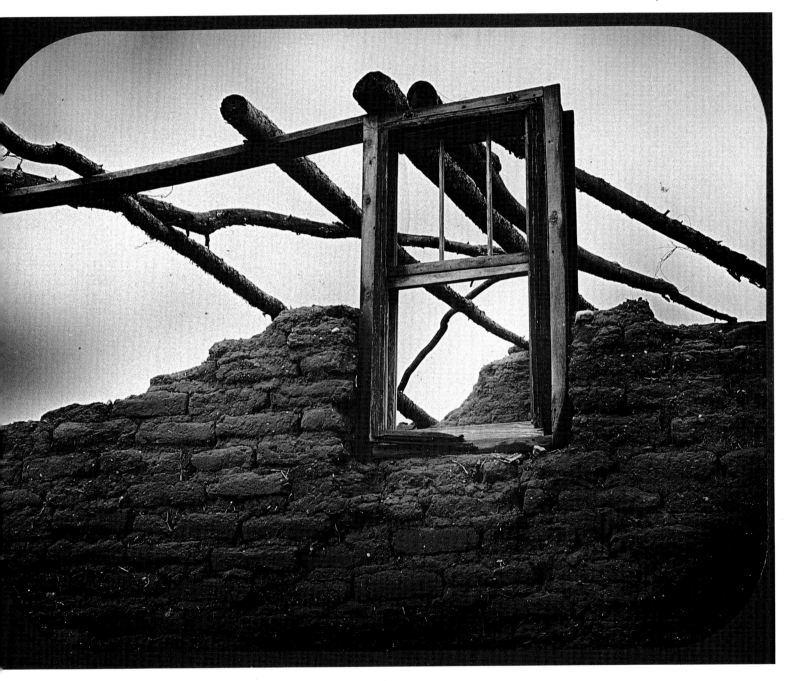

THE PLATES 237

Notes on the Plates

Even the finest reproduction of a daguerreotype cannot capture its three-dimensional, near holographic quality; however, the excellent reproductions in this book come close to suggesting that magic. The individual who has never held a daguerreotype and moved it about to catch its miraculous play of light and shadow needs to do so in order to understand what these paper illustrations attempt to suggest, in order to make that mental leap between inked paper and silver etched by light.

The images I selected for reproduction in *The Daguerreotype: A Sesquicentennial Celebration* represented "a conscious effort to separate art from . . . history, documentation, and social commentary," an effort "to present the daguerreotype solely as an art form." However, in this book it is that exclusively artistic image I have sought to exclude. Though I selected images I found aesthetically pleasing, that was not the criterion for their selection. What is here is here by virtue of being history, documentation, or social commentary.

In this book I have sought to present a visual picture of America between 1840 and 1860. There are many fine photographic portraits of America, but they all begin with 1860 and exclude what we looked like on the daguerreotype. And that is unfortunate, because the twenty-year period when photography first came into being caught us before something fundamental about the way we looked changed, caught a look of idealism which the experience of the Civil War transformed. These are our baby photos, this collective picture of America on the daguerreotype, and like all baby photos they are naive images—immature but filled with promise. Baby pictures do often hint at the future and do at times contain meaning, but we primarily look at them and return to them to contemplate the charm of our youth.

Though there is often some slight variation in sizes, the following equivalents will, in general, hold true: whole plate, 6½ x 8½ inches or 165 x 215 millimeters;

half plate, 4 ¼ x 5 ½ inches or 108 x 140 millimeters; quarter plate, 3 ¼ x 4 ¼ inches or 82 x 108 millimeters; sixth plate, 2 ¾ x 3 ¼ inches or 70 x 82 millimeters; ninth plate, 2 x 2 ½ inches or 51 x 65 millimeters.

1. ANON., SIXTH PLATE.

One struggles for adequate words in the presence of this daguerreotype. The background tones, the tinting, the overall composition, the beauty of the sitter all harmonize to make a masterpiece, which raises the intriguing question of what constitutes a photographic masterpiece. What is it that Southworth and Hawes's portrait of Justice Shaw, Timothy O'Sullivan's "Canyon de Chelle," Alfred Stieglitz's "Steerage," Paul Strand's "Wall Street," and Robert Frank's "Political Rally, Chicago," for example, have in common? They are each the work of a photographer we recognize as a master. Each represents a clear act of vision, a deliberate seizing of the photographic moment that could never be mistaken for a lucky accident. The fact that all five are quite different in terms of processes, styles, composition, and the very aesthetic that motivated the photographer makes the question of their commonality particularly murky.

The photograph, unlike the painting, begins and ends for the most part in the moment, and the photographer exercises an act of craft immediately prior to that moment and at some point after it. There is that initial act of prephotographic seeing, the recognition that a particular arrangement of tones will result in a good photograph. And then there is the later activity of the darkroom, which can vary from photographer to photographer or even be nonexistent—as is the case with the daguerreotypist or a photographer like Cartier-Bresson, who left his printing to others.

What the Shaw portrait, "Canyon de Chelle," "Steerage," "Wall Street," and "Political Rally" have in common is really no more—though it is no little thing—than that each has the power to arrest the eye. This is actually quite a rare thing indeed, for we are daily barraged with countless images that do not. We see them in books, magazines, and newspapers, but how many hold our gaze; how many quiet us and bring us to reflection? To recognize a scene or a moment as one that will arrest a viewer's eye is as much an act of craft as the ability to recognize a melody that will captivate a listener's ear. To say that the primary technique of the art of photography is the ability to recognize what will arrest the eye, what is going to make a good photograph, seems nearly circular, but because photography is so transparent an art, that is all that can be said. This is not to say photography or the making of a master-

piece is easy. Hundreds of thousands of people have seen the same political rally Frank saw, but only he "saw" it; however, in the presence of his image, we all say, "Oh yes, yes, I too have seen that, and that is just how it was—sound and fury, a lot of puffing and tuba blowing."

It is at this level that the photographic masterpiece enters into contention with the masterpieces of the other visual arts because they both achieve this effect. There are photographs, but not many, that will simply arrest any eye. Those works which engage us for the rest of our lives are the masterpieces, and if they are photographic they were shaped by the craft of the eye—that single act of vision which recognizes more than what is merely pleasing or strange or interesting but recognizes the presence of the general, the archetypal, and the universal which an anonymous daguerreotypist once recognized in a lovely Hawaiian girl. Collection of Dennis Waters.

2. JEREMIAH GURNEY, QUARTER PLATE.

It is difficult to imagine a better representation of nineteenth-century America than this handsome young fighter. This is Young America, strong and proud, flexing its muscle, and on the way. It is a vision right out of *Leaves of Grass*. This is Whitman's America—virile and beautiful, America of the open road, America before the open road led to the used car lot, as poet Louis Simpson put it. And like Whitman's dream, this vision is a collective one; each of us can read what we each see into this image: youth, drive, work, sweat, love, passion. But finally this portrait presents the potential for all of this, which is exactly what pre–Civil War America presented— the land of the world's best potential, the land before the great fouling began, before Antietam and Gettysburg, the Palmer Raids, Scottsboro, the murder of the Rosenbergs, of Kennedy, of King, Vietnam, and the War on Drugs. Looking at an image like this, the very metaphor for America, one can only be saddened that we could not have come to our wisdom and compassion through less pain and that this face is not still the face of Young America. Collection of the J. Paul Getty Museum.

3. ANON., SIXTH PLATE.

Most daguerreotypes seem clearly fixed to their place in time, dated by pose and dress, objects or architecture. However, occasionally and remarkably, one will slip those limitations and become unglued in time, like this house painter who could as easily be at work in 1950 as in 1850. Southworth and Hawes also at times achieved this effect in their more relaxed portraits of children (see plate 31, a perfect example were it not for the spats; Sobieszek, Appel, and Moore, *The Spirit of Fact*, plates 51

and 52; Wood, *The Daguerreotype*, p. 39). It is an effect we encounter elsewhere as well, one we usually call snapshot-like, which tries to suggest something modern, spontaneous, unlike the equally beautiful but more considered mid-century portrait. Such effects are interesting but have no aesthetic implications; they are accidents of fortuitous omission. But though meaningless in the world of art, they are vehicles of our empathy and are invested with a poignancy that melds time, that turns a man ages dead into my neighbor, a girl so long gone no one still laments her into my son's playmate. When we see this in the daguerreotype, the power of the form itself to persuade, to insist that it is not art but life in the act which we see, can excite us both to joy and to wonder, as it does in this portrait. Collection of Greg French.

4. ANON., HALF PLATE.

California gold-mining scenes are seldom more than historical documents, albeit important historical documents, but few would ever call forth words like *aesthetic* and *beautiful* or by the power of their composition—a negligible element in most mining scenes—convince viewers that they are in the presence of a work of art. But this image does. Collection of Greg French.

5. ANON., HALF PLATE.

These appear to be Canadian Indians, probably Hurons, engaged in mock fight. This is an unusual image, not only because of its sitters but also because few daguerreotypes present such dramatic tableaux. Though daguerreotypes are occasionally narrative and show work being performed (plate 3, for example), actual events transpiring (as in plates 83 and 84), or people engaged in a deliberate fiction before the camera (plates 64, 80, and 82), they seem static compared to an image like this one, which, though staged, catches us up in its drama. Collection of Greg French.

6. ANON., SIXTH PLATE.

Here is a most telling photographic portrayal of certain aspects of nineteenth-century America: mindless flag-waving, naive innocence, and a look of wonder and surprise. Collection of Julian Wolff.

7. ANON., HALF PLATE.

The Easton Fencibles.

The Easton Fencibles were a Pennsylvania volunteer company, most likely a company of the Seventh Division of the Pennsylvania State Militia, which encompassed

Northampton, Pike, and Lehigh counties. Easton is north of Philadelphia on the Delaware River in Northampton County. At the extreme left of the image one can see three musicians in oilcloth caps instead of the bellcrown shakos of the Fencibles. One also notices several civilians in the background. Due to the militia's reputation for rowdiness, civilians were ordered to keep clear of their musterings. The Easton Fencibles were not among the twenty Pennsylvania companies that enlisted to go to Mexico in 1846 and 1847. Collection of Harvey Zucker. Note by John Graf.

8. ANON., HALF PLATE.

Brooklyn Naval Yard.

Some daguerreotypes appear modern because they lack any specifics that can ground them to the nineteenth century (as in plate 3). However, in rare cases a daguerreotype, like certain paintings and other works of art, will possess some peculiar aura of modernity because it actually seems to presage the aesthetic of a later date. This image is a case in point. Though unmistakably nineteenth-century, it looks like no photograph of the nineteenth century, other than possibly Henri Rivière's of the Eiffel Tower construction. This scene obviously could have been daguerreotyped in a far less angular, far more symmetrical, and more typical manner, but the artist had an eye eighty years ahead of his or her time. This was a distinctly 1920s vision, as a Moholy-Nagy or a Sheeler would later see. This daguerreotype shares the vision of Sheeler's "Criss-Crossed Conveyors" of 1927, Moholy's "Berlin Radio Tower" of 1928 and his 1929 "View from the Pont Transbordeur," and other seminal works from this period. Art so often glances backward to repeat the clichés of the past that it is particularly gratifying to encounter a work like this that strides so vigorously into the future. Collection of W. Bruce Lundberg.

9 and 10. ANON., HALF PLATES.

Seneca Falls, New York.

A more dramatic portrait of the industrial landscape of mid-nineteenth-century America probably does not exist. The long-forgotten moment recorded here springs forth, ironically, as something beautiful—hardly the word one associates with mills, factories, and industrialization. The pristine, well-ordered town is being overtaken by the factories, but still somehow at a century's distance and from on the outside looking in, it is beautiful. Cowing & Co., one of America's first manufacturers of fire engines, and a "Sash & Blind Factory" crowd together on the small island, which now no longer exists. Four people stand on the footbridge or steps that lead to

the island and then across the Seneca going past a stack of lumber. On that bank we can see the church in the background and read signs for "Storage—Forwarding," "American [illegible]," and see clothes hanging on a line connected to a second-story window. It's an image as placid and cool as the snow on the ground, but look upstream at the second plate. The falls rush down and the mill rises, and here people and nature both struggle to dominate the scene but are equally matched. Is this daguerreotype a portrait of human work or nature's? Is it about the mill or the falls? Much of its power and thrill come from this tension, and it is a tension still present in the environment of our society a hundred and forty years later. Collection of Charles Isaacs.

11. ANON., QUARTER PLATE.
Collection of W. Bruce Lundberg.

12. ANON., QUARTER PLATE.
A note on the inside of the case signed "Bully Six" reads, "Boys: Remember the Winter of 1858." This interesting piece of patriotic Americana may illustrate the paying off of an election bet by being pulled through the town by the losers. Later nineteenth-century stereoscopic cards exist which depict somewhat similar scenes and carry titles like "Paying an Election Bet." But whatever is being depicted, a more American, more Currier and Ivesian scene would be difficult to imagine. Collection of Mark Koenigsberg.

13. ANON., HALF PLATE.
William Worrell, Clown.
From looking at the costume one would assume that the sitter in this daguerreotype was an acrobat; however, an inscription in the case reads, "Compliments to / Daniel Klink / By / Wm G. Worrell / of / Welch's National / Circus & Theatre. / Philadelphia July 4th 1855. / Mt Vernon House / No. 95 North 2 Street." William Worrell was a clown in Rufus Welch's National Circus of Philadelphia, which was one of the leading circuses in nineteenth-century America. Welch, in fact, was one of America's first circus entrepreneurs. Of a Brooklyn performance in the 1850s a contemporary critic wrote, "Three clowns vied in fun—Worrell, 'the wit,' Whittaker, the 'stump orator,' and Wallis the 'musical'" (George Odell, *Annals of the New York Stage*, 6: 422). Collection of W. Bruce Lundberg.

14. ANON., QUARTER PLATE.

Smelting Gold.

Few occupational daguerreotypes, excepting the not uncommon though still highly prized gold-mining images, actually recorded people at work. Most were studio-made with the sitter merely posed with a saw, a butcher's knife, threads and needles, or some similar symbol of work. Images like this one of people actually engaged in work are exceedingly rare in spite of their prevalence in this book. With this image, the Saratoga Mountain Glassworks (plate 57), and the apothecary (plate 40), one gets a rare look inside the actual workplace of mid-nineteenth-century America, and with the daguerreotypes of the smelters and the glassblowers one can see what are probably the earliest photographs made inside factories anywhere in the world. Other than the lost image of the millers in the Island Mills, St. Anthony, Minnesota (see Rudisill, *Mirror Image*, plate 101), I am unaware of any similar American daguerreotypes. And though Edouard Duseigneur daguerreotyped the workers in front of his silk factory in Lyon, I know of no similar interior views in European daguerreotypy. Collection of Greg French.

15. ANON., HALF PLATE.

Gold Dust Wanted.

This sluice makers' cabin is not merely one of the best images from the gold fields and an excellent American architectural daguerreotype but also a fine example of technical execution with near three-dimensional quality. Collection of Mona and Marc Klarman.

16. ANON., HALF PLATE.

We would find this image compelling regardless of when it was made or the kind of process used to make it. Its wonder and strangeness are the wonder and strangeness of humankind. More than that, it is simply an outstanding portrait. Collection of Mark Koenigsberg.

17. ANON., SIXTH PLATE.

This little girl with her partially eaten apple is certainly "cute" in the sweetest sense of that word; however, there is something jarring in the daguerreotypist's juxtaposition of female innocence and the proffered apple. Collection of John Wood.

18. RUFUS ANSON, SIXTH PLATE.

Collection of Gary Ewer.

19. ANON., HALF PLATE.

This is certainly an interesting juxtaposition of signs and enterprises. One notices a selection of the daguerreotypist's work mounted on one of the porch columns and the fact that the man in the white shirt appears to be wearing blue jeans. Collection of Greg French.

20. ANON., NINTH PLATE.

This is the kind of daguerreotype that has often led to their being compared to jewels. Collection of Byron Bruffee.

21. ANON., SIXTH PLATE.

J. H. Ferguson's Tobacco Wagon.

This daguerreotype, probably of J. H. Ferguson of Albany, whose name we can read on the wagon, a representative for "Shields & Adams Tobaccos & Cigars," offers an excellent example of some of the beautiful tones the daguerreotype is capable of producing from the solarized blues of the sky to the warm browns of the earth. In black and white, though still an important historical image because of the rarity of the subject, the visual magic would be lost in the translation. So much of the daguerreotype's charm lies in these delicate tonalities, tonalities rich enough in themselves to suggest a multiplicity of colors where only a few are present. Collection of Laddy Kite.

22. ANON., STEREOSCOPIC DAGUERREOTYPE.

Flowering Cactus.

This "Flowering Cactus" was "Sold by James W. Queen, Optician, 264 Chesnut [*sic*] St., Philada." Were it not for the subject matter and the label, any similar flowering plant would suggest a French origin. And though there would eventually be similar American paper stereographs, as a daguerreotype this is a particularly rare and pleasingly symbolic piece. Gone are the delicate bouquets of Europe, supplanted by a flower from our own promising West. Collection of Wm. B. Becker.

23. ANON., SIXTH PLATE.

Even if we could not read the card this long-dead girl holds, this would be a poignant image. But the words *Forget Me Not*, coupled with the intimacy of the posing here of mother and daughter, make this image a moving portrait of loss and a monument to the camera's ability not to forget. Collection of Alan Johanson.

24. ANON., SIXTH PLATE.

Here is that terrible dichotomy photography so often presents us with: the reality of this daguerreotype is tragic, the artifice beautiful. A painting of a dead child is always still a painting, and we know the artist created it from looking at a model; though we are moved by its terrible content, we can still take delight in its deliberate craft. But here, in the presence of an actual child, we are overwhelmed by the content and embarrassed even at our response to the craft. Collection of John Wood.

25. ANON., SIXTH PLATE.

This image of a sad little boy with his toys piled up all around him looks like a final photograph, a pre-postmortem. And what a strange image it is; what a curious piece of nineteenth-century necrology. It is like looking into an Egyptian tomb, and one immediately thinks, even though he was a bit older, of the poor boy-king Tut and those toys and treasures his family left piled around him. But this is a far stranger thanatopsis than the Egyptians', for it is nearly impossible to imagine how parents could have stood to look at such a picture were their child gone, and so perhaps I have read something into this daguerreotype that is not there. But it is also difficult to imagine that this was not a very sick child. It is unsettling in every respect. Collection of Grant Dinsmore.

26. JOSEPH W. BOUDREAU, WHOLE PLATE. HILLOTYPE.

The greatest controversy to surround the daguerreotype erupted in 1850 with the announcement by Levi L. Hill that he had discovered a process for making daguerreotypes in color. Hill's claims for over a century now have usually been dismissed, and he has been described as everything from a fraud to a bungling scientist who stumbled onto color but could never figure out how he had done it. His rambling *Treatise on Helichromy*, its hefty price, and all his various fights and battles did not inspire confidence. However, Joseph Boudreau, following Hill's directions, re-created the process, produced Hillotypes, and published his research in a fully detailed essay on

the procedure (see Eugene Ostroff, ed., *Pioneers of Photography*, pp. 189–99). The beautiful muted colors Boudreau achieves are not unlike those on Hill's own plates, sixty-two of which were donated to the Smithsonian Institution by a descendant. Collection of the artist.

27. KENNETH NELSON, HALF PLATE.
Church, Las Trampas, New Mexico, August 19, 1989.
Both this image and "Aspen Forest, New Mexico" are recent works that mark a new style in Kenneth Nelson's art. Nelson has always been the most irreverent of contemporary daguerreotypists, and his mocking, satiric work has even poked fun at the form itself. But in his new work he has created a more traditional, more formal kind of image and has produced pictures of such uncommon elegance that they are comparable to nothing else in contemporary daguerreotypy or photography. The "Las Trampas" plate suggests a melding of the artistic visions of David Hockney and Georgia O'Keeffe, while the equally cool "Aspen Forest" seems derived solely from Nelson's understanding of the capacities of the daguerreotype process to render light at its most elegant angle. Nelson's work has been widely exhibited and reproduced, and he is the author of *A Practical Introduction to the Art of Daguerreotypy in the 20th Century*. Collection of the artist.

28. KENNETH NELSON, HALF PLATE.
Aspen Forest, New Mexico.
Collection of the artist.

29. ALBERT SOUTHWORTH AND JOSIAH HAWES, HALF PLATE.
It is because of portraiture like this, portraits wrought with drama, that Southworth and Hawes dominate American daguerreotypy. Though the sitter is unidentified, he is clearly someone of importance to be so draped and modeled. Hawes's snobbery would not have allowed him to so pose just anyone who walked in from the street. Though we may find his attitude unattractive, it did inform his art and help shape his vision, which worked in this image to create one of his finest male portraits. Collection of Larry Gottheim.

30. ANON., SIXTH PLATE.
This image is a marvel of composition, generations ahead of its time. Such a work

illustrates the frustrations of studying the daguerreotype; here is a masterpiece of nineteenth-century art, a work no older than Ingres's but one whose maker we will never know. The relaxed intimacy seen here is rare in photography; it can be found in Käsebier and Kühn, but then only in their mother (or nurse) and child portraits. Intimacy, especially without lust, is not a subject easily within the capacity of the camera—apart from that seen between children or mothers and children. One seldom sees it even in *The Family of Man*, where it might most be expected. The emotion expressed through the composition of this double portrait is, therefore, rare not just for mid-nineteenth-century photography but for its entire history. One must look to painting to find anything that resembles it—to painting done generations later, to Edmund Tarbell and his world of women, that world of order and beauty, of *luxe, calme et volupté* that Baudelaire described: "... *ma soeur, / Songe à la douceur / D'aller là-bas vivre ensemble! ... Là, tout n'est qu'ordre et beauté, / Luxe, calme et volupté!*" Collection of Mona and Marc Klarman.

31. ALBERT SOUTHWORTH AND JOSIAH HAWES, SIXTH PLATE.

The work of Southworth and Hawes is probably the most schizophrenic in all of photography and certainly within all of daguerreotypy. Most major daguerreotypists did possess clearly recognizable styles. We can see it in Claudet, Stelzner, Sabatier-Blot, Williamson, the Langenheims, and so forth. In Boston, for example, two of the rivals Southworth and Hawes seemed most conscious of were Lorenzo Chase and John Whipple, though there is no similarity in any of their work. Chase's signature is the heaviness of his posing, as if his sitters were all Egyptian statues, and his minimal, often eccentric use of tinting. Chase's work could never be mistaken for anyone else's, nor could Whipple's, even in his vignettes, which on first glance resemble Southworth and Hawes's but are clearly signed by Whipple's camera position (lower than Hawes's) and distance (farther from the sitter).

Though Southworth and Hawes's work is all marked by a high level of artistry and craft, there are four very different and distinct styles. There are the Southworth and Hawes of idealized beauty (see Wood, *The Daguerreotype*, plates 1–3, 35) or noble manhood (Sobieszek, Appel, and Moore, *The Spirit of Fact*, plates 8 and 9) and the Southworth and Hawes who were the image makers to the republic (*The Spirit of Fact*, plates 10, 20, and 29, and *The Daguerreotype*, plate 47). Then there are the commercial Southworth and Hawes who churned out "artistic" and often lovely but equally often ludicrous portraits of Boston's elite—ludicrous because of

the attention lavished on the hopelessly porcine and homely in futile attempts to transmute them into beauties (*The Spirit of Fact*, plates 34 and 37). And finally there is the purely photographic, candid portrait like this one of a little girl. (Also see *The Spirit of Fact*, plates 51 and 52.) These less posed images have a distinctly contemporary flavor and therefore appear to our eyes as some of Southworth and Hawes's most sophisticated work, though the daguerreotypists themselves would probably have thought them merely accomplished because of the facile handling of children and actually among their least sophisticated. The major characteristic that distinguishes Southworth and Hawes's work from their competitors, regardless of which of their styles we are looking at, is that their concept of art was directly linked to their notion of craft and technique, not to subject matter. Collection of John Wood.

32. ANON., SIXTH PLATE.
Steve Merritt's Donkey.
One would presume that it is Steve in this charming image dated "Washington Apr 9 1854" and identified as "Steve Merritt's Donkey." Collection of Robert L. and Elizabeth V. Babich.

33. MARCUS AURELIUS ROOT, QUARTER PLATE.
Portrait of Anthony Pritchard Root Asleep by the Flag.
Unlike the Whitehurst sleeping baby (plate 34), we can be sure this daguerreotype of a patriotic little boy is, if not an exhibition piece, not merely a commercial portrait. Like the Whitehurst, it too is masterfully composed with those three stars lifting themselves like dreams from the sleeping child's head. Courtesy of George Eastman House, on extended loan from the Miller/Plummer Collection.

34. JESSE WHITEHURST, HALF PLATE.
This could be a postmortem, but I seriously doubt it. The subject looks like a big, tired baby worn out from crawling around and getting its knees dirty. The image seems so clearly the archetypal sleeping baby portrait that one wonders if it could be one of Whitehurst's exhibition pieces. It is certainly a masterfully composed image. Far more attention is lavished on this not-altogether-attractive child than one might expect in an ordinary commercial portrait. In any case, its beauty transcends its subject. Collection of Charles Isaacs.

35. ANON., SIXTH PLATE.

Though the imagery here is reminiscent of those Madonna del Latte images of the Quattrocento, this clearly happy madonna would have probably shocked most nineteenth-century American viewers. It is an amazing document and clearly reflects the sitter's desire to keep her memories of motherhood. Collection of Brad William Townsend.

36. ANON., QUARTER PLATE.

Collection of the Boston Athenaeum.

37. ANON., DAGUERREIAN BROOCH.

The popularity of the daguerreotype in America was so great that daguerreian jewelry and even buttons set with daguerreotypes came into fashion. Collection of Patricia Abbott.

38. ANON., HALF PLATE.

Could these all be sisters? Several have similar eyes. Collection of Dennis Waters.

39. ANON., SIXTH PLATE.

Koplin & Richards Boot & Shoe Manufactory.

It is interesting to note the reversed letters on this building. The daguerreotype process reverses an image from right to left, thereby producing a mirror image, unless a camera is equipped with a mirror for correcting the error. But what is most interesting about this image is that there is nothing like it in European daguerreotypy. In fact, French photography would see little of such imagery until Atget, whose work this suggests in several ways, even down to its domelike top. This is one of those examples we often see in early photography where art penetrates through documentation and where beauty becomes a function of our focus on the past. Collection of Greg French.

40. ANON., QUARTER PLATE.

Apothecary.

Collection of Greg French.

41. ANON., SIXTH PLATE.

Payne's Oyster Saloon.

One can also read the sign of J. T. & T. S. Norbert Physicians & Surgeons hanging on the building, and one wonders if it is their feet sticking out of the windows. Collection of Greg French.

42. ANON., QUARTER PLATE.

The Staff of the Express.

One hesitates to use the word *great* too freely in reference to works of art for fear of debasing it; however, no other word comes to mind with respect to this daguerreotype. It is a great American image—proud, vigorous, and dynamic. A child dressed as Columbia could no more aptly symbolize the still-new republic's essence than this portrait of a newspaper office. Here are Liberty's real defenders—not soldiers with their guns—but these seven men and a boy. The daguerreotypist has skillfully arranged the group with the seated editor writing with his quill while either the publisher or an assistant editor looks on and the staff stands behind them with the objects of their trade—the compositor with his tray of type, the printer with his chase, and so forth. A composing stick, reversed in the image, can be seen at the extreme right, possibly under the copyboy's arm. And, of course, there is the man wearing the hat made from a folded newspaper with the word *Express* emblazoned on his forehead. Though it was obviously the name of the paper, that one word makes this the ideal portrait of the young republic and the freedom to express even opinions the majority might find repugnant. Collection of Charles Isaacs.

43. WILLIAM AND FREDERICK LANGENHEIM, PANORAMA OF SIXTH PLATES.

The Falls of Niagara.

In July 1845 Frederick Langenheim made five sixth-plate exposures of the falls to create this panorama, which were probably the first photographs of Niagara. He went back to Philadelphia and with his brother William made copy daguerreotypes to create eight sets of panoramas, each measuring 12 by 18 1/16 inches. Sets were sent to Daguerre, President Polk, Queen Victoria, the Duke of Brunswick, and the Kings of Prussia, Saxony, and Württemberg. The eighth set, this one, which they retained, stayed in the Langenheim family and was exhibited in 1937 at the Museum of Modern Art's exhibition arranged by Beaumont Newhall on the 100th anniversary of Daguerre's first successful plate. Collection of the Gilman Paper Company.

44. ANON., QUARTER PLATE.

Daguerreotypes of churches are relatively uncommon; however, this surprising image is unlike anything that is usually seen. In producing it, the daguerreotypist was clearly trying to make the most beautiful picture possible. The fact that it is not the expected frontal view, that the church does not fill the plate, that the composition is perfectly balanced, and that empty space is utilized to create the most striking effect—all attest to the skillful eye of this maker. Though we can find a similar creativity and compositional sophistication in the work of the *Missions héliographiques* and in other early work on paper, there is little in daguerreotypy that compares with this: Wilhelm Pero's views of the Ratskirche St. Marien von Osten and the cathedral of Lübeck (see Fritz Kempe, *Daguerreotypie in Deutschland*, pp. 160–63), Jean Foucault's L'Eglise des Carmes (see Françoise Reynaud, *Paris et le Daguerréotype*, p. 109), and Jérome-Vasse's views of the cathedral and bell-tower of Amiens (see Wood, *The Daguerreotype*, plate 63, for the only yet published example). In such company this anonymous American daguerreotypist deserves rightful recognition. Collection of Greg French.

45. ANON., HALF PLATE.
Collection of Greg French.

46. ANON., QUARTER PLATE.
Though this appears to be a sawmill at the bend of a river, what is most interesting about the image is its artistic composition and the beautiful effects of light and light's reflection. Collection of Greg French.

47 and 48. ANON., SIXTH PLATES.
The Minnehaha and St. Anthony Falls.
One wonders if this beautiful pair of daguerreotypes might be by Alexander Hessler, who did photograph these falls. One of Hessler's daguerreotypes of the Minnehaha Falls was given to Longfellow and inspired his poem *Hiawatha*. See William Welling, *Photography in America: The Formative Years, 1839–1900*, pp. 82–83, for a detailed recounting of this story and a reproduction of a Hessler salt print from a daguerreotype of the Minnehaha Falls, an image remarkably similar to this daguerreotype. Collection of Mark Koenigsberg.

49. ANON., SIXTH PLATE.

S. B. Holt's Central House.

I know of few daguerreotypes that seem to create the flavor of mid-nineteenth-century America better than this one. The stagecoach has just rolled up to the inn; people have come out; a man hangs out of the window, another out of the coach's window. Of course, that is how we imagine it would look if we could glance back into the past and into such a moment, but that is not what we are seeing here. We are looking not at some grand arrival or departure but at a response to a photographer. A less romantic but probably more accurate reading would describe a frantic and silly scramble to get into the picture. Two women mounted the high coach to crowd the driver; another woman climbed even higher to sit beside a man, probably her husband, who can be seen holding a small child. Beside him is an older boy. People have crushed together at the inn's door. One figure is behind another so only the hat is visible. Two children, obscured but for their heads, can be seen in an enlargement standing behind the horses. It is still as frenetic and exciting a reading as the other one, if not more so, but also one that seems less alien to us and our time, though less romantic and less as we might wish the past had been. Collection of George S. Whiteley IV.

50. ANON., HALF PLATE.

Newport, Rhode Island.

This expansive view of Newport focuses on its so-called Mystery Tower, actually an old stone mill probably built around 1660 by Benedict Arnold, Rhode Island's first governor, and referred to in his will as "my stone built windmill." Legend ascribed it to the Norse, who, of course, never built such structures. A quarter-plate daguerreotype by Gabriel Harrison just of the tower also exists (see Rudisill, *Mirror Image*, plate 26). Collection of Charles Schwartz.

51. ANON., SIXTH PLATE.

This surprising document presents a classic case of a photographer being in the right place at the right time. Collection of Matthew R. Isenburg.

52. ANON., HALF PLATE.

View of Key West.

This is possibly the earliest surviving image made in Florida and certainly the earliest image of Key West. According to Wright Langley of the Historic Florida Keys

Preservation Board, the view was taken from near present-day Dey Street with Simonton Street in the foreground. The tops of the Baptist church and St. Paul's Episcopal at Eaton and Bahama can also be seen. The height of the coconut trees, Langley writes, suggests that the image was made either before the 1846 hurricane or at least three years after it, though the early mat style and the lack of the preserver suggest the pre-1846 dating. Two views of St. Augustine, circa 1847, are at the Beinecke Library (see Sandweiss, Stewart, and Huseman, *Eyewitness to War: Prints and Daguerreotypes of the Mexican War, 1846–1848*, pp. 236–39). An inscription in the case reads: "This picture belongs to Mrs. Geo. B. Selden. Mary Watkins Sayre mar. Capt. Curtis. Residence of her Aunt Mary At Key West, Florida." The large houses in the distance are on Caroline and Duval, according to Langley, which was where the Curtis home was located. George Selden was George Eastman's attorney, and the image did surface in Rochester. Collection of Bill Flaherty.

53. ANON., SIXTH PLATE.
Ohio Star, *Ravenna, Ohio.*
The *Ohio Star* was a newspaper, and so one naturally wonders if this curious vehicle with what appears to be drawers and compartments is a newspaper delivery wagon of some sort. But why is it stopped in front of this house? And why are the six women and girls who are standing in the background beside the porch in this image? Is the *Ohio Star* wagon significant to this scene or is it merely incidental? Could the fat man and his family, if indeed the two women and four children are his family, own the paper? What is being commemorated here? Collection of Charles Isaacs.

54. ANON., QUARTER PLATE.
The Garvas Tharrow House.
Tharrow of Eagleswood, New Jersey, was the inventor of the Garvey, a boat for use in shallow bay waters, but what is more interesting about this image is that here we actually see a covered wagon, a vehicle that, thanks to television and the movies, has entered the American imagination like few others. Collection of Matthew R. Isenburg.

55. ANON., SIXTH PLATE.
Delivery Wagon of Fitz & Co. Bakers, Lynn, Massachusetts.
Though probably posed, this image looks like a candid shot of Mr. Fitz stepping from his wagon to deliver bread. It is interesting to note the fly net on the horse.

Weights, which can be seen at the bottom, held it on and as the horse moved, the netting would shift at a different rate and shoo the flies off the horse. Collection of Frank Molinski.

56. ANON., QUARTER PLATE.
The Traveling Store.
The sign on the wagon reads "Webster & Bailey New Britain." David Webster and Norris Bailey opened the first clothing store in New Britain, Connecticut, in 1845. Though the image was made in front of a typical Connecticut inn, it was very likely not in New Britain but some nearby town that did not yet have a clothier. This daguerreotype is an important social document of nineteenth-century life in New England, a vivid record of the day the traveling store rolled into town. It is also a perfectly composed and aesthetically pleasing image as neat and as ordered as Paul Strand's views of Gaspé, Maine, and Vermont would be three-quarters of a century later. Collection of Harvey Zucker.

57. ANON., SIXTH PLATE.
Saratoga Mountain Glassworks, Mt. Pleasant, New York.
This and the image of gold smelters (plate 14) may be the world's first photographs of the interiors of factories. It is difficult to say which was taken first, but both were made after 1849. Though the historical importance of such daguerreotypes is immense, this one is also a daguerreian *tour de force*. Imagine taking the interior of a dark factory and asking everyone to freeze while they are actually working with molten glass. Six workmen can be seen. One at the left holds a bundle of sticks, another stands in the foreground, one at the right is blurred, and three glassblowers can be seen either standing or sitting around the base of the large conical-shaped furnace, each holding a rod, one still in the furnace but two with ends visible and balls of molten glass attached. The furnace ports can also be seen in the background as white openings. This image was acquired from the great-granddaughter of James Peacock, glassblower at the works, which were founded in 1849. Along with it came a daguerreotype of the village and one of the glass bottles made there. Collection of Julian Wolff.

58. ANON., QUARTER PLATE.
Collection of Greg French.

59. ANON., WHOLE PLATE.

Atkins' Automaton "Self-Raking" Reaper.

This image taken on or beside a canal—note the canal boat—was reproduced as a woodcut in the *Illustrated London News* of July 23, 1853. From the Collections of the Henry Ford Museum and Greenfield Village.

60. ANON., SIXTH PLATE.

Main Street, Minneapolis, circa 1854.

In this view of St. Anthony and the falls one can also see the "General Intelligence Office & Land Agency" as well as a procession of fur carts. Collection of the Minnesota Historical Society.

61. ANON., QUARTER PLATE.

Going West, 1849.

A note in the case with the image signed and dated by C. E. Wilde reads, "This daguerreotype was taken in March of 1849 at Battle Creek. The men are Charles W. Cox (Great Uncle of C. E. Wilde) and Walter Brewster, as they were ready to start overland for the gold diggings in California. They drove these two teams through without serious mishap. One team they purchased from my Grandfather, who lived near Augusta, Kalamazoo County—Andrew D. Cox. Charles W. Cox returned to Kalamazoo County, later and died in Kalamazoo." In many ways this is a more exciting picture of the Gold Rush than one of miners at work at their diggings, for here one can get a sense of the excitement that swept America in 1849. It looks as if Cox and Brewster, like thousands of others, simply picked up and headed West. The family member who had the daguerreotype made probably did not expect ever to see them again. Cox and Brewster look fairly prosperous with their four horses, fresh wagon, and good clothes, so it obviously was not poverty that propelled them. Collection of Matthew R. Isenburg.

62. ANON., SIXTH PLATE.

The Meeting.

This may well be the first photograph of a political meeting. A mixed crowd of men, some dressed more prosperously than others and some appearing to have arrived by wagon, stand beneath a man one can only assume is a speaker perched on a box. The angle of the image is highly unusual, and one wonders if a daguerreotypist in a

studio looked down, saw the meeting, moved a camera to the window, and asked the gentlemen to look up, all of whom but the speaker did. Collection of Greg French.

63. ANON., QUARTER PLATE.
Blacksmith's Shop, Canadaigua, New York.
From the Collections of the Henry Ford Museum and Greenfield Village.

64. ANON., QUARTER PLATE.
Of the various occupational images one encounters in studying the daguerreotype, none seem more symbolic of the idea of America, of the frontier, of hope and the possibility of prosperity, than those of the surveyor. And most books on the daguerreotype in America seem to include a surveyor; however, I have never seen one with a look like this. Most are rather nondescript as portraits and are more interesting for what they symbolize than for what they actually show. But here is as engaging a portrait as one sees in photography. Few examples of artistic portraiture look so deeply back at the observer as this surveyor looks at us. Collection of W. Bruce Lundberg.

65. ANON., QUARTER PLATE.
There is something amusing in the posing of this proud saddler with his hammer held high. Nineteenth-century photographs often have this charming, slightly comic look about them, a kind of camera-shy naiveté, a look from a time before the world knew how to act in front of the camera. Today everyone looks unperturbed in photographs, but today the camera is everywhere. It is difficult to imagine places or people so remote that a *National Geographic* team has not visited for a few weeks and educated them to the camera's charm, that ability to flatter our egos regardless of our looks. Collection of Keith E. Kelley.

66. ANON., SIXTH PLATE.
One occasionally sees daguerreotypes of men at chess or checkers, but I've never seen one so intimate, so truly candid-looking as this one. Usually the sitters are stiffly and unimaginatively posed on either side of the board, looking as if they were having a portrait made. These gentlemen look as if their only interest is the game. Collection of Frank Molinski.

67. FRANK FORD, QUARTER PLATE.

The Extraction.

Frank Ford opened a studio in Ravenna, Ohio, in 1853. A hundred and thirty years later the contents of his studio were auctioned off and this image came from that sale. Though this portrait must be read as a piece of nineteenth-century humor, the look of the patient seems genuine, and the image lacks the exaggerated quality so often seen in "humorous" nineteenth-century prints and photographs. See Beaumont Newhall's 1971 Winter House edition of Daguerre's *An Historical and Descriptive Account*, plate 33, for another, more typical dental portrait. Collection of Matthew R. Isenburg.

68. ANON., SIXTH PLATE.

The bare-shouldered look photographed from the back is not uncommon in daguerreian imagery, and Southworth and Hawes used it often (see Wood, *The Daguerreotype*, p. 32). But I have never seen it used with a male model. There are, of course, the two famous shirtless portraits of Southworth (see Pierre Apraxine, *Photographs from the Collection of the Gilman Paper Company*, plate 82, and Sobieszek, Appel, and Moore, *The Spirit of Fact*, plate 13), Claudet's shirtless study of his son (see Janet E. Buerger, *French Daguerreotypes*, plate 170), the Gurney fighter (plate 2), as well as a few nude studies, but all of those are frontal views. This imitation of a pose usually reserved for women looks to the modern eye coquettish, suggestive even, though it is possible to imagine that to the nineteenth-century eye it would have had the innocence of a classical bust—but more likely a bust of Antinous or Ganymede. Collection of Harvey Zucker.

69. ANON., QUARTER PLATE.

I am not the only person to have looked at this image and immediately thought of Thomas Mann's Tadzio from *Death in Venice*. We are drawn to this boy just as Aschenbach was to Tadzio for reasons that have nothing to do with art. And it is this very fact that lies at the heart of what is most disturbing about the nature of photography. Photographs elicit powerful social reactions from us which are often confused with aesthetic reactions, to which they bear no similarity. This is not something that would happen with a painting unless one were dealing with a piece of obvious kitsch. A great painting's content is probably its least important element. But a photograph like Diane Arbus's "Boy with Toy Hand Grenade" has no meaning apart

from its content; any aesthetic quality it might possess is related nearly exclusively to Arbus's eye, to her having selected a particular subject that was capable of evoking an emotional reaction. Where a great painter like Cézanne or Kirchner or Picasso might give us new ways of seeing that demand that we refocus our vision, the great photographer often does no more than give us new subjects, which usually demand no more than that we enlarge our tolerance for the grotesque and out-of-the-ordinary. This is not to condemn the grotesque or photographers like Joel-Peter Witkin for indulging in it; it is only to consider the nature of our response to photography—a response at times clearly aesthetic in its traditional ways, in ways we might apply to other art, but at times clearly something else—as is the case with this compelling portrait of a mid-nineteenth-century Tadzio. Collection of John Wood.

70. ANON., SIXTH PLATE.
This is a far more stylish-looking hunter than one usually finds in the daguerreotype. He looks more of a sportsman than a woodsman. Collection of Count Geoffroy de Beauffort.

71. MARCUS AURELIUS ROOT, QUARTER PLATE.
Portrait of Anthony Pritchard.
As in the portrait of Anthony Pritchard Root asleep beneath the flag (plate 33), we can again be certain we are not looking at Root's ordinary commercial work. As good as that work is, it pales by comparison to this, which offers an interesting insight into Root's artistic genius. *The Camera and the Pencil,* Root's study of the art of photography, has chapter after chapter on lighting, posing, and the other elements of photography's craft, as well as extensive quotations from eighteenth- and nineteenth-century art critics on the history of European painting. But there is nothing to prepare us for an image such as this. All those elements of craft Root understood are present. He has picked up the fluting on the column in the folds of the fan, which are then restated in the single large fold of the open book. The pose is natural, the lighting on the column dramatic, and so forth. But there is something more, and that is that "grace beyond the reach of art" which Alexander Pope spoke of. This image derives its power not from craft; Root's craft merely gives shape to his artistry—or, perhaps I should say, shapes that "grace" beyond any kind of ordinary invention. Courtesy of George Eastman House, on extended loan from the Miller/Plummer Collection.

72. C. H. GAY, PANORAMA OF HALF PLATES.

New London, Connecticut.

These striking panoramas with their clear separations presage David Hockney's photo collages. I know of no other daguerreian panorama that generates such a sense of stillness and quiet. Usually each panel of a panorama is filled with activity. Gay evidenced a highly modern eye in this composition. The first and last panels could be by Paul Strand, and the second, third, and fifth are images of pure, static beauty. Only the fourth panel looks like other daguerreotypes, but the overall effect is one of silence. Collection of the J. Paul Getty Museum.

73. ELIPHALET M. BROWN, JR., SIXTH PLATE.

Portrait of Gohachiro Namura.

In 1852 President Millard Fillmore sent Commodore Matthew Perry on a military expedition to Japan, with the goal of forcing Japan to abandon a policy that prevented any contact or trade with other countries. With a rapidly developing American presence in the Pacific, the need for trade and supply ports in Japan became a strategic objective for the U.S. government. Perry, not knowing the nature of the reception he would receive, insisted on a military crew with the exception of two civilian artists, Wilhelm Heine, a twenty-five-year-old painter from Dresden, and Eliphalet Brown, Jr., a thirty-six-year-old lithographer/daguerreotypist. The perception of the technological superiority of the West was a critical factor in Perry's strategy and the inclusion of the daguerreotype was an important part of that objective. But who was Eliphalet Brown and why was he chosen for such a mission?

Born in 1816 in Newburyport, Massachusetts, Brown eventually ended up in New York working as an artist. For thirteen years he was part of a circle of engravers and lithographers kept busy producing the thousands of handmade illustrations required by publishers before they had access to halftone reproduction. Brown worked sometimes on his own and occasionally in partnership with others, including a two-year period with his younger brother, James Sydney Brown. James, with Eliphalet's help, had also established himself as an artist with his own portrait studio but gave that up in 1843 to become the first operator at the new Mathew Brady Gallery. He most likely taught the procedures to Eliphalet during their partnership of 1846–48, but when Eliphalet was chosen for the Perry expedition he was once more working as a lithographer for Currier and Ives, a previous employer. Apparently Perry wanted someone adept at both drawing and daguerreotypy, and in fact twenty-five

of the illustrations in the official report of the expedition list E. Brown as co-artist.

The expedition sailed from Annapolis on November 24, 1852, and eventually set up a base of operations at Naha, Okinawa. On July 2, 1853, it sailed for Japan, and after nine days of tense negotiations President Fillmore's letter requesting a treaty was accepted, with Perry promising to return in the spring for the official response. On that return trip, the Japanese agreed to a treaty giving the United States access to the ports of Shimoda in the south and Hakodate in the north. The expedition visited both ports, and Eliphalet Brown was kept busy making daguerreotypes, as he had throughout the journey.

When they returned to New York, a three-volume illustrated report was published, with ninety lithographs and numerous wood engravings based on the drawings and daguerreotypes of Heine and Brown. All of their original work, including the more than four hundred daguerreotypes, has since vanished. A fire in one of the lithographic firms may have destroyed the six daguerreotypes they utilized, and the rest have simply disappeared.

In recent years, five of the daguerreotypes taken and left in Japan have surfaced. One of them, a sitting portrait of Gohachiro Namura, a Samurai interpreter assigned to the expedition, passed to his descendants who eventually emigrated to Hawaii. The daguerreotype, now in the Visual Collections of the Bishop Museum in Honolulu, is the only identified Brown daguerreotype in the U.S. It is a sixth plate, signed and dated on the lower right *E. Brown, Jr., 1854*, and was taken in Yokohama during the treaty negotiations. Four other daguerreotypes exist in Japan, all portraits of Japanese officials and their retainers. The Perry report used lithographic versions of two of these five daguerreotypes, indicating that Brown took multiples of many of his subjects, leading to the hope that more of them may yet turn up in the future. Visual Collections, Bishop Museum. Note by Bruce T. Erickson.

74. W. L. GERMON, HALF PLATE.
Though there are a few irregularities in the dress and the insignia on the epaulet is not discernible, this appears to be a U.S. Navy lieutenant. Washington Germon was a Philadelphia daguerreotypist in partnership with James McClees from 1847 to 1855. Since this image bears only Germon's name, it was obviously made in 1855 or later. Collection of John McWilliams.

75. ANON., WHOLE PLATE.

The scroll this naval officer holds has the words *Gulf of Manar* written on it. The Gulf of Manar is an arm of the Indian Ocean that lies between India and Sri Lanka, but I can only guess at its relevance to this man since I can find no reference in military or political histories of the United States to any American presence there during the period this image would have been made. Collection of Thurman F. Naylor.

76. JOEL E. WHITNEY, SIXTH PLATE.

Ojibway Scalp.

General C. C. Andrews writes in his *History of St. Paul, Minn.*, p. 67: "On the 9th of April [1853] a party of Ojibways killed a Sioux near Shakopee. A war party from Little Crow's village then proceeded up the valley of the St. Croix River and retaliated. On the morning of the 27th a band of Ojibways appeared not far from where the Wilder block on Fourth street is built, searching for some Sioux. Perceiving a canoe with some women, and a man who had lost a leg in battle a few years before, coming up the river, they waited for them to land at the foot of Jackson street, and then as they walked up the hill toward Third street they advanced toward them. The Sioux, alarmed, hastened into a trading establishment which stood at the southeast corner of Third and Jackson streets, and the excited Ojibways fired at them through the windows, mortally wounding a Sioux woman. For a short time the town presented a sight similar to that witnessed in Colony times in Hadley or Deerfield, then the frontier towns of Massachusetts. Messengers were sent to Fort Snelling for the dragoons, and citizens on horseback were quickly in pursuit of the painted, naked savages who had avenged themselves in the streets of St. Paul. The dragoons, under Lieutenant Magruder, were soon on the track of the assailants, and reached them near the Falls of St. Croix. The dragoons fired upon them and an Indian was killed. His scalp was brought to St. Paul and daguerreotyped by Joel E. Whitney."

The scalp was illustrated in a January 1855 article on "Saint Paul and Its Environs" by Edward Neill in *Graham's Magazine*. Neill notes, "The scalp here represented is decorated with feathers, the sign that it was peeled from a man's head. Had it been that of a woman, it would have been ornamented with a comb." General Andrews's report leaves the impression that the scalp was taken by the dragoons, but Neill explains that the dragoons were accompanied by "Sioux guides scenting the track of the Ojibways like bloodhounds." Collection of the Minnesota Historical Society.

77. ANON., QUARTER PLATE.

The headdress and earrings worn by the Indian in this portrait are the same kind as those worn by Kno-Shr, the Kansas chief, in his portrait by John Fitzgibbon (see Wood, *The Daguerreotype*, plate 14). Fitzgibbon is known for having created a major collection of Indian portraits, which but for Kno-Shr appear to be lost. Perhaps this is another. Certainly many of the same strengths present here are found in the Kno-Shr portrait. It it interesting to note the paint on this man's cheeks as well as the bow and arrow, because this is probably the first photograph of these characteristics. Indians are often seen in attire that combines both European and native elements, and one cannot keep from wondering if this brave has not adapted a white woman's dress to his own uses. Collection of Frank Molinski.

78. ANON., HALF PLATE.

The object held by this handsome Indian is a gun-stock war club made of wood and decorated with brass tacks. Collection of the Minnesota Historical Society.

79. ANON., SIXTH PLATE.

This portrait of strength and endurance is a tribute to the human spirit. Daguerreotypes of black Americans in this pre–Civil War period are usually either images of total exploitation and defeat, running the gamut from the painful Zealy-Agassiz portraits (see Gail Buckland, *First Photographs*, pp. 202–3) to those of blacks as mere pendants to a white family (see William Welling, *Collector's Guide to Nineteenth-Century Photographs*, p. 14), or they are images of blacks who escaped the indignity of slavery (see Harold Pfister, *Facing the Light: Historic American Portrait Daguerreotypes*, p. 274), never suffered it (see Thomas Fels, *O Say Can You See: American Photography, 1839–1939: One Hundred Years of American Photography from the George R. Rinhart Collection*, p. 23, and Richard Field, *American Daguerreotypes from the Matthew R. Isenburg Collection*, p. 66), or had clearly made it in the white world (see Wood, *The Daguerreotype*, plates 55 and 85). The kind of promethean nobility of spirit present here is seldom seen. Other than in John Plumbe's portrait of Isaac Jefferson (see Gilbert, *Photography: The Early Years*, p. 17) and in this moving portrait, I can recall it nowhere else. Collection of Greg French.

80. ANON., QUARTER PLATE.

Portrait of A. H. Golden, Artist.

He may not have been a very good artist, but he certainly had all the ego of one and an admirable pride in his work. Ross J. Kelbaugh Collection.

81. ANON., SIXTH PLATE.

This daguerreotype contains four separate exposures on a single plate. Albert Southworth claimed to have invented the sliding plateholder necessary to produce an image such as this, and he held an 1855 patent on it. But in 1865, when with the assistance of Simon Wing he began to prosecute other photographers for patent violations, the resulting case, which Southworth lost, produced testimony from several famous daguerreotypists stating they had used or knew of the use of such a plateholder prior to 1855. Collection of Mark Koenigsberg.

82. ANON., QUARTER PLATE.

This looks like a charming genre scene of a tea party, and indeed it is; however, there is a curious note on the inside of the case that, unfortunately, is only partially legible. It reads: ". . . taken Monday Sept 7th 1857, at the winding up of a frolic . . ." In the nineteenth century, "frolic" also meant a party. Something about the bespectacled "older lady"—the glasses pushed down on her nose, the knitting—makes one wonder if the frolic that was winding up was a dress-up party. Regardless of what had just wound up, this kind of imagery is unique in the American daguerreotype. We see it in Claudet's work, but there it is far more contrived and overpainted as well. Claudet, so driven to have his work look like "high art," could have taken lessons from this anonymous American. Collection of Roberta DeGolyer.

83. ANON., SIXTH PLATE.

This may be the world's first wedding photograph. Southworth and Hawes were quick to recognize the potential for lavish and expensive whole-plate daguerreotypes of splendidly attired brides, but this simple crowded sixth plate made at an actual wedding is, as far as I know, unique and constitutes a document of the greatest social importance. Wedding photography may have begun with this shy daguerreotypist in the distant background, but in less than a century and a half photography would become so important to our lives that the wedding photographer, instead of being relegated to the background, would actually be the impresario of the entire affair

whose word would be weightier than bride's, groom's, or preacher's. Collection of Greg French.

84. ANON., QUARTER PLATE.

Baptism in a River.

This baptism in a river is one of the camera's greatest social documents. It is not only "Shall We Gather at the River," camp meetings, brush arbor, and nineteenth-century, primitive Protestantism but also one of the earliest photographs of a religious ceremony, the most important of such Christian ceremonies. Collection of James E. Sanders.

85. ANON., SIXTH PLATE.

This fireman is probably a member of a firemen's band since the horn he holds is an actual musical instrument and not the usual fireman's horn. Collection of the J. Paul Getty Museum.

86. ANON., HALF PLATE.

Fire Brigade with Pumper.

This was certainly a fancy fire company with their fine pumper, musicians, and big banner. Collection of Mona and Marc Klarman.

87. ANON., SIXTH PLATE.

Daguerreotypes are often misunderstood, but in addition they are perplexing because we cannot be sure if we are unable to understand them because of some indecipherable bit of personal imagery or because they contain an allusion we simply can no longer read. Both of these handsome young men hold watches, but one also holds a ring and a pair of scissors. Anyone can conjecture about this imagery, but unless an individual actually possesses that specific bit of social history to explain such symbolism, if indeed it is social and not personal, such conjecture is of little value. An image such as this makes clear the importance of social history in understanding part of photography's art. This is not, however, an image in which meaning is resident exclusively in content. Our response to these two men is an immediate aesthetic response; this is an intriguing portrait which draws us into its composition, the odd positioning of sitters for a double portrait, even before we notice the mysterious objects. Collection of Byron Bruffee.

88. ANON., SIXTH PLATE.

Here is another image as perplexing as the last, though for different reasons. Who could we be looking at? The fancy dress might make one think of a Zouave, but a black Zouave is unlikely. And were he a black Zouave, and thus a Civil War soldier, it is unlikely the image would be a daguerreotype. Had a daguerreotypist even been available to have made such an image in the early 1860s, it is unlikely a black soldier could have afforded it. Are we looking at a real, i.e., French-Algerian, Zouave, who happened to be black? If so, we wonder what he was doing in the United States, because the image is clearly American. Or are we looking at a visiting prince from Senegal, perhaps? That is what we might most hope because it appeals to our romantic yearnings, but that too is unlikely. Little is certain of this sitter but his clear nobility; that registers through all the anonymity and mystery. Collection of Greg French.

89. ANON., QUARTER PLATE.
Document Signed by John Hancock.
Though Fox Talbot reproduced a page from a Norman French book in the *The Pencil of Nature* and went on to say, "To the Antiquarian this application of the photographic art seems destined to be of great advantage," this daguerreotype of a document signed by John Hancock allowing Mary McCarthy admittance to the almshouse, "she being a poor Person," may very well be the first photocopy of a document. It was obviously made to preserve an already worn and fragile piece of paper, but so early an application of photography to one of its most common uses today is indeed surprising. Collection of Julian Wolff.

90. ANON., SIXTH PLATE.
Band Concert.
This is one of the earliest photographs of a concert. Collection of Greg French.

91. ANON., HALF PLATE.
Knodles Band.
Written in the back of the case of this image is the inscription "The old Home at / Fair Play Md / Knodles Band." Collection of Greg French.

92. ANON., SIXTH PLATE.

Though daguerreotypes of animals are scarce by comparison to daguerreotypes of people, they are common enough to suggest that Americans took a particular interest in their animals, especially dogs and cows. European daguerreotypes of animals are nearly nonexistent. There are French genre scenes of hunters with animals, including a famous one by Warren Thompson with a dead rabbit (see Janet E. Buerger, *French Daguerreotypes*, plate 156), and the occasional French nude with a bird or dog. There is a powerful still life by Gustave Dardel of a shot and bound chamois (see Sylvain Morand and Christian Kempf, *Le Temps Suspendu*, plate 43), a beautiful pastoral scene with bulls by Eynard-Lullin (see Fritz Kempe, *Daguerreotypie in Deutschland*, p. 88), a Claudet of two ladies with a dog (see Uschi Birr, *Hunde vor der Kamera: 150 Jahre Photographie aus der Sammlung Uwe Scheid*, plate 17), and a few similar images. But the European daguerreotype that is nothing but the pure celebration of the living animal is even still rarer; there is Stelzner's own dog (see Bodo von Dewitz and Fritz Kempe, *Daguerreotypien*, p. 76) and Louis-Auguste Bisson's marvelous portrait of a horse (see John Wood, *The Daguerreotype*, plate 77). Among the scarcest of American pet daguerreotypes are those of cats, probably because coaxing a cat to remain still was not easy. This quiet cat dreaming of the world beyond the window is remarkable both for the subject and the setting. The daguerreotype appears to have been made in someone's house, and we wonder if it might have been the daguerreotypist's cat or if a passionate cat fancier actually commissioned a daguerreotypist to come and make this portrait. Collection of Uwe Scheid.

93. ANON., HALF PLATE.
Backwoodsman II.
The bull's name and the date 1852 were inscribed in the case. Collection of Julian Wolff.

94. ANON., SIXTH PLATE.
This is one of the most unusual images in early American photography; I know of nothing else like it. It does not appear to be a staged scene with a stuffed frog and fake plants, as one occasionally sees in French stereo daguerreotypes—little genre studies of the ferret in the barnyard or the swooping hawk and so forth. This still originally sealed and clearly American image is not half of such a stereo daguerreo-

type either. Considering the difficulty of actually daguerreotyping a frog in the wild, it is hard to believe it is not a studio product, a display in a natural history museum, or an odd pet or prized jumper, at the very least. Collection of Jane Lenharth.

95. ANON., QUARTER PLATE.

I know of only one American pastoral scene, a shepherd tending his flock (see Rudisill, *Mirror Image*, plate 102), that approaches the lyricism of this image. Though clearly American, it looks more like the work of one of the great European amateurs, Eynard-Lullin or Biewend or Humbert de Molard. American farm scenes are seldom so pictorial; they usually look more like advertisements: Blue-Ribbon Prized Bull for Sale, $500. Though this daguerreotype certainly presents prized cattle, its rich pictorial quality is seldom seen in American photography until much later. This fact should not, however, suggest that Americans were more commercial and less poetic than Europeans—only that we had not yet developed a leisure class large enough to indulge in the pleasures of amateur photography. The development of American pictorialism had as much to do with the development of American economy as it did with the existence of an international photographic style and powerful advocates for it like Alfred Stieglitz. The mere existence of Stieglitz and the style was not sufficient to create a wave of Mexican or Haitian pictorial photography, for example. Had the style and the technique for producing it been developed in the mid-nineteenth century, even the energy of a few leisured gentlemen like Stieglitz and Holland Day could not have created the kind of fertile atmosphere necessary for its propagation without the entire society being at a higher level of economic opportunity than it was in 1850. Collection of Charles Schwartz.

96. ANON., SIXTH PLATE.

Here is an image of harmonious balance and classic restraint both in architecture and in photography. Collection of George S. Whiteley IV.

97. ANON., QUARTER PLATE.

Congress Spring Pavilion, Saratoga, New York.

One would not expect such a pretty little classical temple to be an important piece of Americana, but this is the earliest (circa 1845) photograph from Saratoga Springs, America's most popular watering spot of the nineteenth century. One can see gentlemen in high hats in the Pavilion probably sipping draughts of water and feeling

healthier and more Roman with each draught. The Saratoga identification is courtesy of the insightful and clear eye of Sally Pierce of the Boston Athenaeum. Collection of Matthew R. Isenburg.

98. GILMAN JOSSELYN, WHOLE PLATE.
Faneuil Hall, Boston, 1839.
This imposing daguerreotype by an amateur who was the first maker of school globes in the United States is one of the earliest taken in Boston. It is inscribed "May 1839" on the back. One can also make out the signs of a "Bedding Warehouse" and "Faneuil Clothes." Collection of the Massachusetts Historical Society.

99. ROBERT SHLAER, HALF PLATE.
Robert Shlaer is one of the finest of modern daguerreotypists. His work is included in museum and private collections around the world and is the subject of essays in several leading photographic journals. In looking at this powerful, erotic study, one naturally thinks of comparisons to the work of other contemporary and modern photographers. At first it seems to suggest Herb Ritt's nudes, but the cropping is more daring. There is a ripeness, a kind of overabundant sexuality, that suggests Helmut Newton, but the rusticity and invitation of Shlaer's vision would be alien to those urbane, unapproachable monoliths of desire that Newton photographs. The luminosity of the image makes one think of the glowing prints of Edward Weston and Robert Mapplethorpe, but Shlaer's work in both cases is more physical and less concerned with form than the sexual potential within the form. Finally, it is clear to the viewer in both this and Shlaer's other nudes that his vision is unique and that in addition to being a master daguerreotypist he is also one of the new masters of the erotic photograph. Collection of Uwe Scheid.

100. ROBERT SHLAER, MAMMOTH PLATE.
The power of Shlaer's photographic vision is not limited to the erotic, as this image clearly demonstrates. In fact, this is an example of one of those arresting visions I spoke of in the note to accompany plate 1. Here is the pure craft of the eye at work, the seizure of the unique—not merely the uniquely bizarre—but the unique through which the archetypal and the universal speak. Collection of Thurman F. Naylor.

Contributors

JOHN F. GRAF is curator of history at the Neville Public Museum in Green Bay, Wisconsin, president of the Daguerreian Society, the author of over a dozen scholarly articles on aspects of nineteenth-century material culture, and a recipient of the Daniel Malkovich Award presented by the Congress of Illinois Historical Societies and Museums to an "Outstanding Young Museum Professional."

BROOKS JOHNSON is curator of photography at the Chrysler Museum in Norfolk, Virginia, where he has organized such successful exhibitions as "Mirror of an Era: The Daguerreotype in Virginia" and "Daguerreian Masters: Past and Present." He is the author of numerous publications including *Nineteenth Century French Photography*, *The Portrait in America*, and *Photography Speaks*, an Aperture book.

DOLORES A. KILGO, assistant dean of the College of Fine Arts at Illinois State University and associate professor of art history, has for several years been researching the life and extensive body of surviving work left by Thomas Easterly. Her forthcoming book will be the first study of this important master,

and she will also curate a traveling exhibition of his work organized by the Missouri Historical Society. Her research has been supported by fellowships and grants from the Smithsonian Institution, the Newberry Library, the A. D. Wallace Trust, the Missouri Historical Society in St. Louis, and Illinois State University.

PETER E. PALMQUIST, the author of *Carleton E. Watkins: Photographer of the American West*, has written or edited some twenty volumes, published over one hundred and fifty scholarly articles, and curated thirty exhibitions. He is the editor of the *Annual of The Daguerreian Society* and was a recipient of the Edward B. Berkowitz Memorial Award from the National Stereoscopic Association for Outstanding Achievement in Writing.

DAVID E. STANNARD holds a doctorate from Yale University and currently is professor of American studies at the University of Hawaii. He is a Guggenheim fellow and a fellow of the American Council of Learned Societies. His books include *Death in America*; *The Puritan Way of Death: A Study in Religion, Culture, and Social Change*; *Shrink-*

ing History: On Freud and the Failure of Psychohistory; and *Before the Horror: The Population of Hawaii on the Eve of Western Contact.* His most recent book is *Many Millions Gone: Native Peoples and the Legacy of 1492.*

JOHN R. STILGOE is Robert and Lois Orchard Professor in the History of Landscape at Harvard University and author of several books on the American landscape, including *Borderland: Origins of the American Suburb* and *Common Landscape of America, 1580 to 1845,* which received the Francis Parkman Prize for literary distinction in the writing of history.

JEANNE VERHULST, curatorial assistant at the International Museum of Photography at George Eastman House, has written and published on the contemporary daguerre-otype and organized the highly successful 1989 exhibition "A Salute to Daguerre: The Contemporary Daguerreotype." She has also contributed to three major exhibitions and books organized by the museum, including historical surveys of advertising and photojournalism and the work of photojournalist Mary Ellen Mark.

JOHN WOOD is professor of English and director of the Master of Fine Arts Program in Creative Writing at McNeese State University, the founding president of the Daguerreian Society, and a recipient of a Photographic Resource Center/Logan Foundation Grant for his work on the daguerreotype. His book *The Daguerreotype: A Sesquicentennial Celebration* won the American Photographic Historical Society's 1989 Photo History Book Award for the outstanding book of the year.

Selected Bibliography

Field, Richard, and Robin Jaffee Frank. *American Daguerreotypes from the Matthew R. Isenburg Collection.* New Haven: Yale University Art Gallery, 1989.

Moore, Charles LeRoy. *Two Partners in Boston: The Careers and Daguerreian Artistry of Albert Southworth and Josiah Hawes.* Ann Arbor: University Microfilms, 1975.

Newhall, Beaumont. *The Daguerreotype in America.* New York: Dover Publications, 1976.

Pfister, Harold Francis. *Facing the Light: Historic American Portrait Daguerreotypes.* Washington, D.C.: Smithsonian Institution Press, 1978.

Rinhart, Floyd, and Marion Rinhart. *The American Daguerreotype.* Athens: University of Georgia Press, 1981.

Rudisill, Richard. *Mirror Image: The Influence of the Daguerreotype on American Society.* Albuquerque: University of New Mexico Press, 1971.

Sandweiss, Martha A., Rick Stewart, and Ben W. Huseman. *Eyewitness to War: Prints and Daguerreotypes of the Mexican War, 1846–1848.* Fort Worth and Washington, D.C.: Amon Carter Museum and Smithsonian Institution Press, 1989.

Sobieszek, Robert, Odette Appell, and with the research of Charles Moore. *The Daguerreotypes of Southworth and Hawes.* New York: Dover Publications, 1980.

Stapp, William, Marion S. Carson, and M. Susan Barger. *Robert Cornelius: Portraits from the Dawn of Photography.* Washington, D.C.: Smithsonian Institution Press, 1983.

Wood, John, ed. *The Daguerreotype: A Sesquicentennial Celebration.* Iowa City: University of Iowa Press, 1989.

Franklin Pierce College Library

00062997

DUE DATE

DEC 30 1991
NOV 2
1993
DEC 1 9
OCT 0 8 2003

Printed
in USA